CW00547936

THE ART AND MAKING OF

RAMPAGE

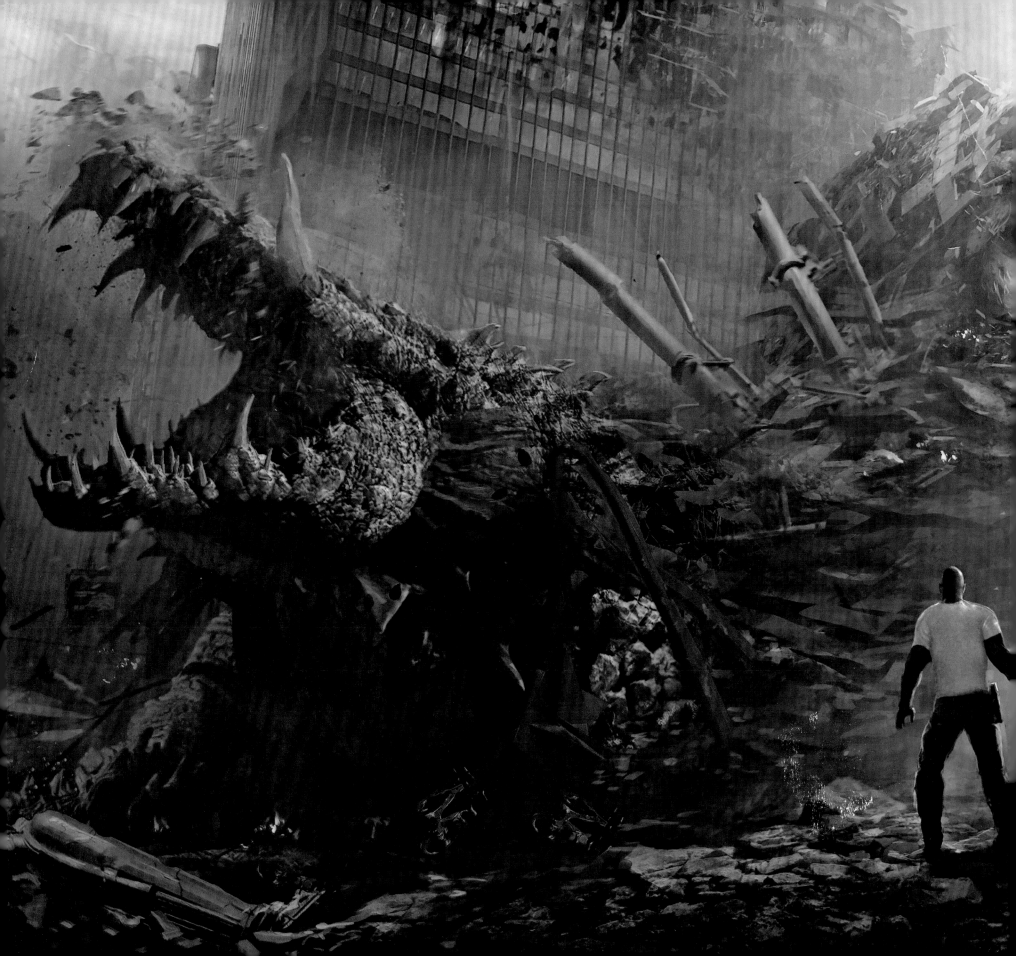

THE ART AND MAKING OF
RAMPAGE

WRITTEN BY **ELLEN WOLFF** FOREWORD BY **DWAYNE JOHNSON**

INTRODUCTION BY **BRAD PEYTON**

INSIGHT ◉ EDITIONS
San Rafael, California

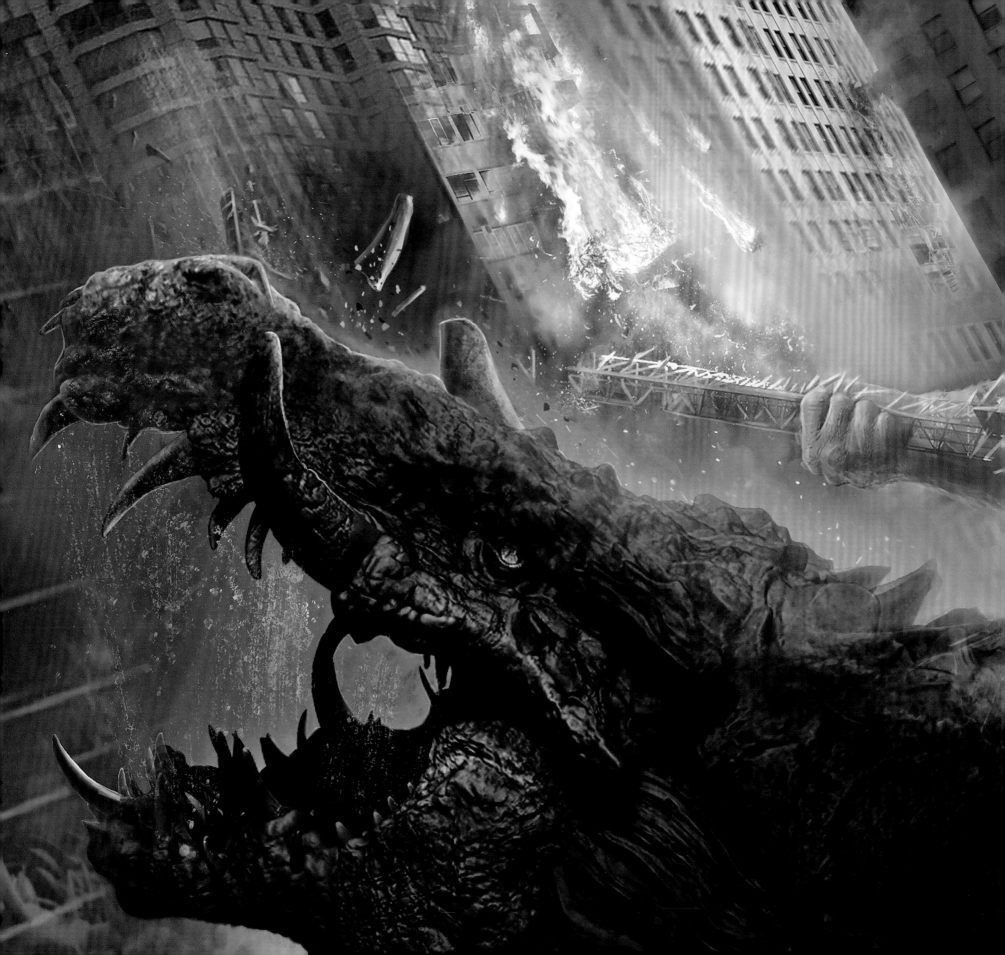

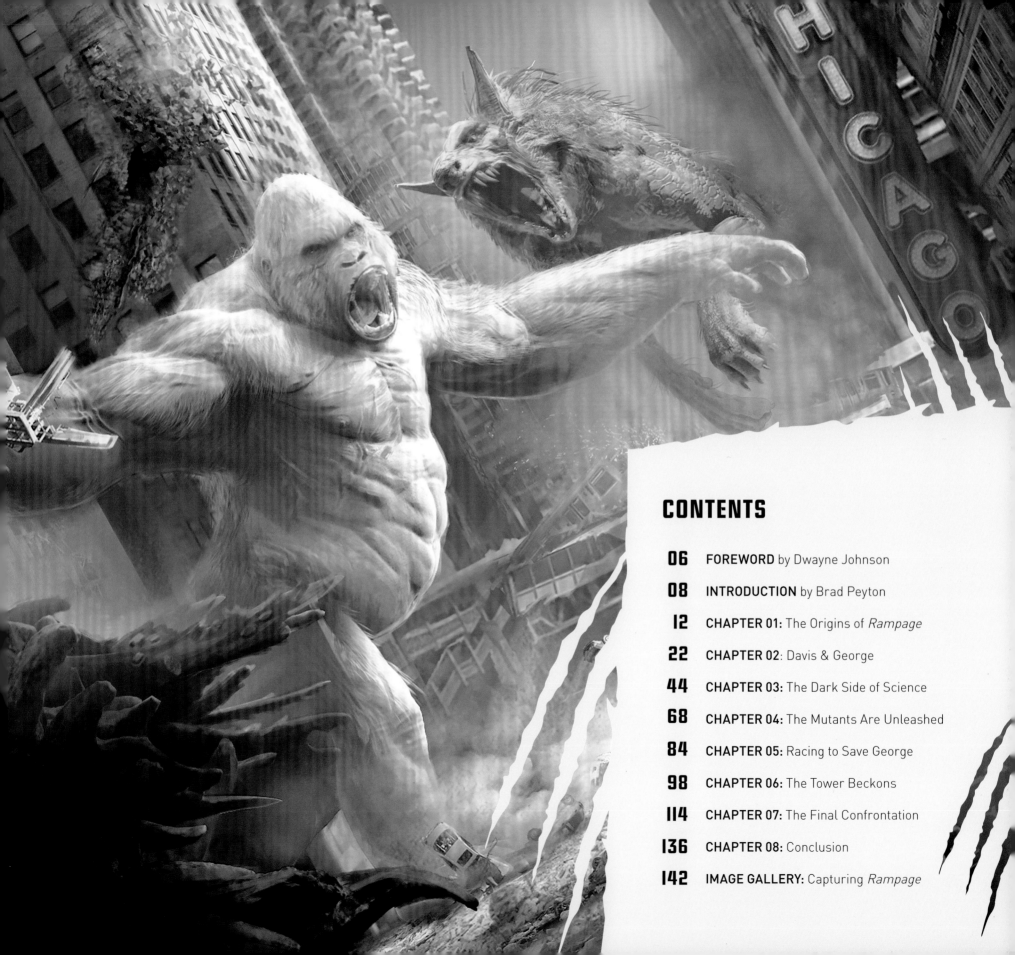

CONTENTS

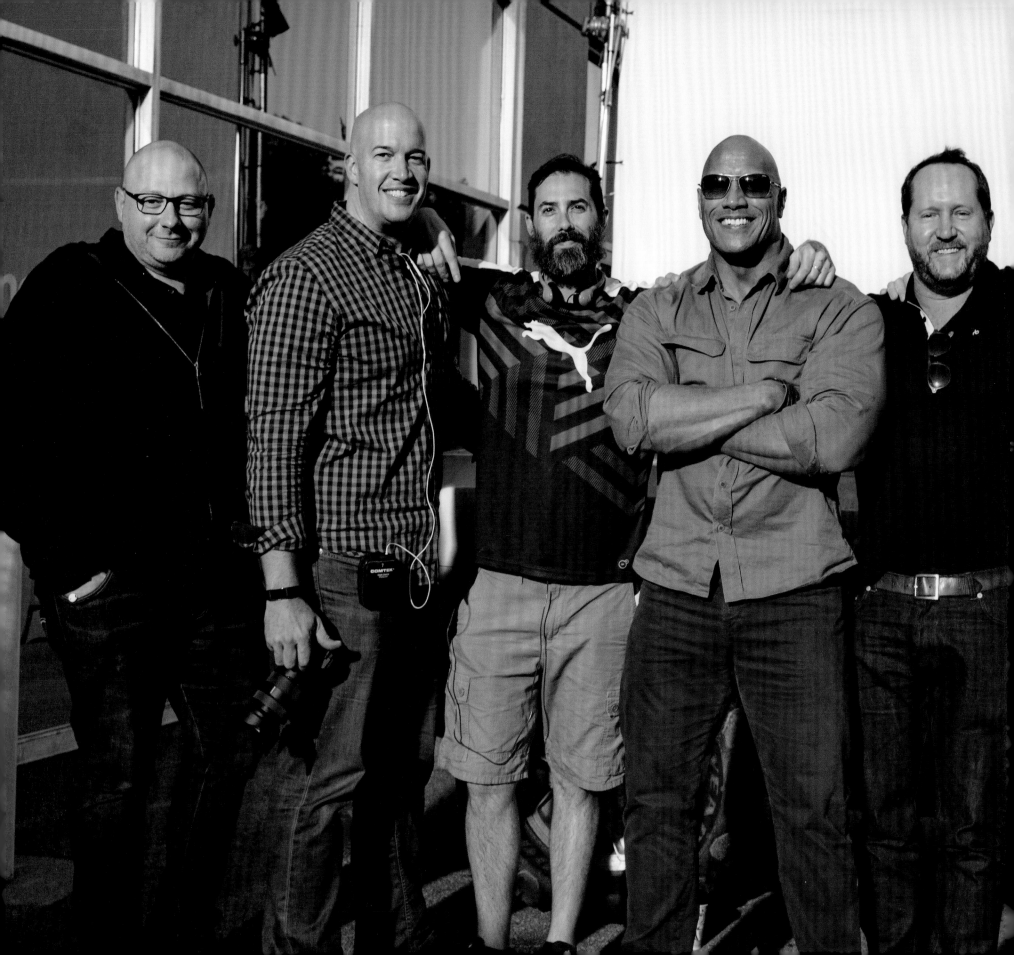

FOREWORD

by Dwayne Johnson

RAMPAGE IS MY THIRD collaboration with director Brad Peyton and producers Beau Flynn and Hiram Garcia. These guys all come to the table wanting to do things that are bigger and—more importantly—better than our previous collaborations. *Rampage* gave us the opportunity to create something epic, fun, and never-before-seen for the global audience.

The groundbreaking visual effects in *Rampage* create a cinematic experience that's on a whole different level. When you see our monsters in action, it creates a visceral feeling. The creatures continually mutate throughout the film, becoming more and more aggressive, intelligent, and unpredictable—leaving you on the edge of your seat! They never stop growing over the course of the film either, which also gives *Rampage* a massive scale and scope.

But what really sets this film apart is the relationship and genuine friendship between my character, Davis, and the albino gorilla, George. Typically in monster movies, the hero is trying to kill the monster, but in *Rampage* he's trying to save the monster. At its core, this is a movie about a man trying to save his best friend. Since I'm an animal lover in real life, it was appealing to me to play a character that embraces the honesty and authenticity of animals. Davis appreciates that "when an animal likes you, they lick you. And if they don't like you, they eat you!"

Rampage was one of my favorite arcade games growing up, and to this day, nobody plays it better than me . . . at least that's what I tell

myself. When I got together with Brad, Beau, and Hiram to make a film based on the *Rampage* game, our goal was to make a monster movie that was different from all those before it, and if luck was on our side, maybe even raise the bar.

Thankfully, we were able to assemble an incredibly talented cast and top-notch crew for this very special project, our third collaboration with New Line Cinema and Warner Bros. Everyone involved worked tirelessly and poured great passion into making *Rampage* so that we could deliver an exciting, kick-ass, and fun experience that the world could enjoy. We're thrilled that *The Art and Making of Rampage* will showcase the creative process that helped bring these enormous monsters and this epic story to life.

OPPOSITE (LEFT TO RIGHT): Executive producer Jeff Fierson, producer Hiram Garcia, director Brad Peyton, actor Dwayne Johnson, producer Beau Flynn, and producer John Rickard.

ABOVE: Dwayne Johnson performing stunts during the filming of *Rampage*.

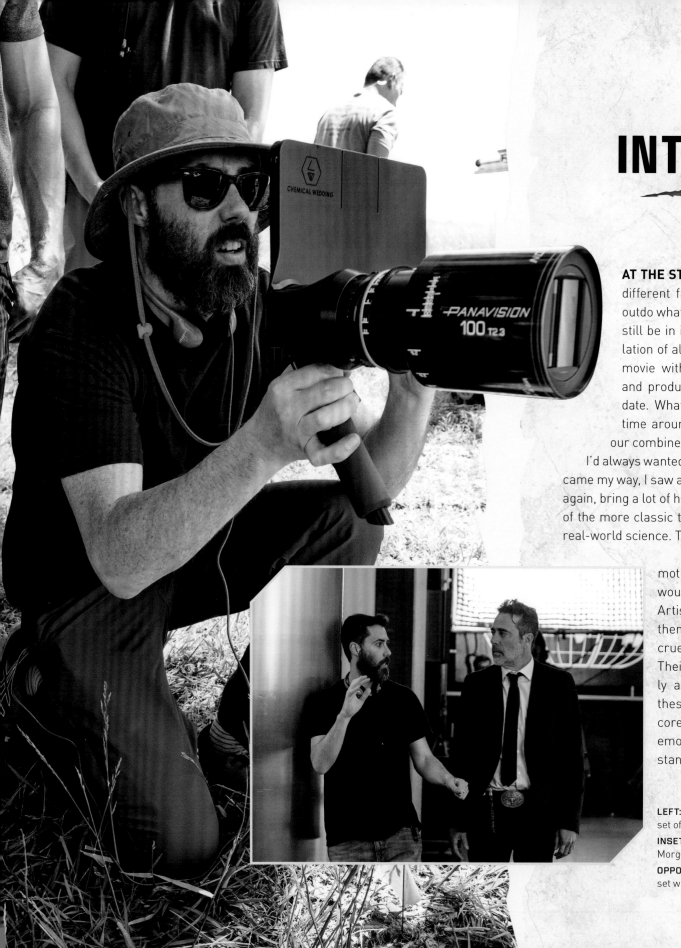

INTRODUCTION

by Brad Peyton

AT THE START OF ANY PROJECT, I ask myself, "Is this different from anything I've done before, and will this outdo what I've done last?" While I consider my career to still be in its infancy, *Rampage* represents an accumulation of all that I've strived for thus far. This is my third movie with New Line Cinema, star Dwayne Johnson, and producer Beau Flynn, and it's our biggest film to date. What excited me most about the reteaming this time around was that I knew it would take the best of our combined efforts to recognize this film's full potential.

I'd always wanted to make a monster movie, so when *Rampage* came my way, I saw an amazing opportunity—to work with Dwayne again, bring a lot of heart to the concept, and also modernize some of the more classic tropes and ground them by drilling down into real-world science. That's how I knew I had to make this movie.

Technically, I was excited to work with our motion capture actors who, when fully realized, would be seen by the world as "the creatures." Artistically, *Rampage* allowed me to explore themes that resonated with me, such as animal cruelty and antipoaching. Animals are innocent. Their nature has no maliciousness, which is largely an aspect of human behavior. Representing these ideas was crucial to me, and this was the core concept that I used to establish the film's emotional spine, which would hopefully help it stand out.

LEFT: Brad Peyton directing on the set of *Rampage*.

INSET: Brad Peyton with Jeffrey Dean Morgan.

OPPOSITE: Brad Peyton working on set with Dwayne Johnson.

The Art and Making of Rampage reveals how our team took a logistically complex script and crafted a movie that is just as emotional as it is visually exciting. The heart of *Rampage* is the friendship between Dwayne's character Davis and an extremely rare albino gorilla named George, whom Davis saved from poachers. This unique relationship was the driving force behind all our efforts, uniting the filmmakers and crew into a singular vision, from script stage, through production, and finally through the digital artistry and complex CG that brought George and the other creatures to life.

The desire of a man to save a dear friend propels all the action in *Rampage*, and we wanted to bring a scope of action that only modern movies can convey while also making it surprisingly funny and heartfelt.

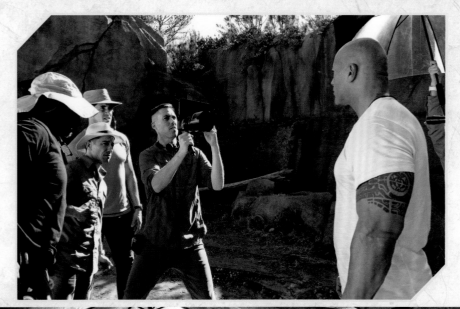

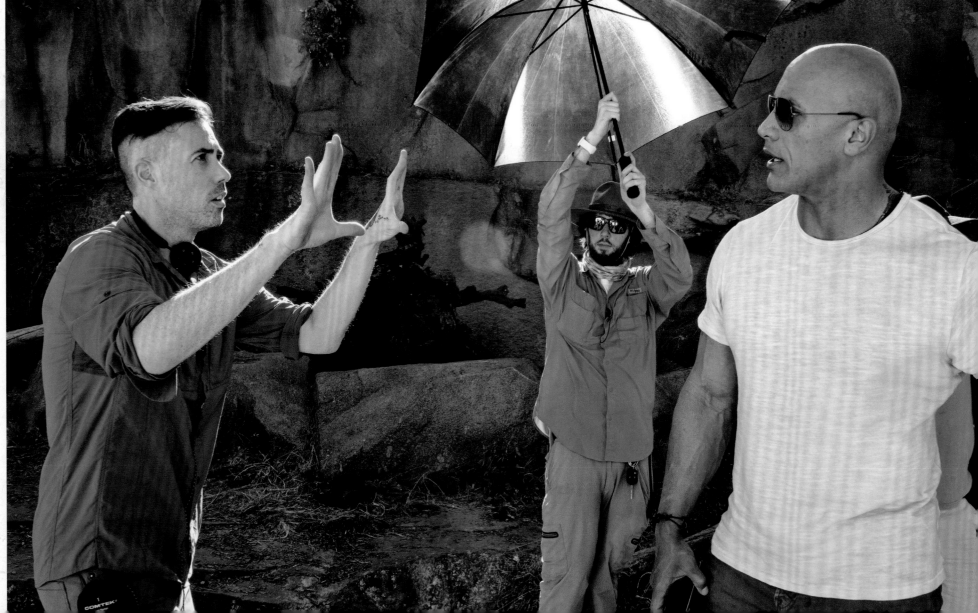

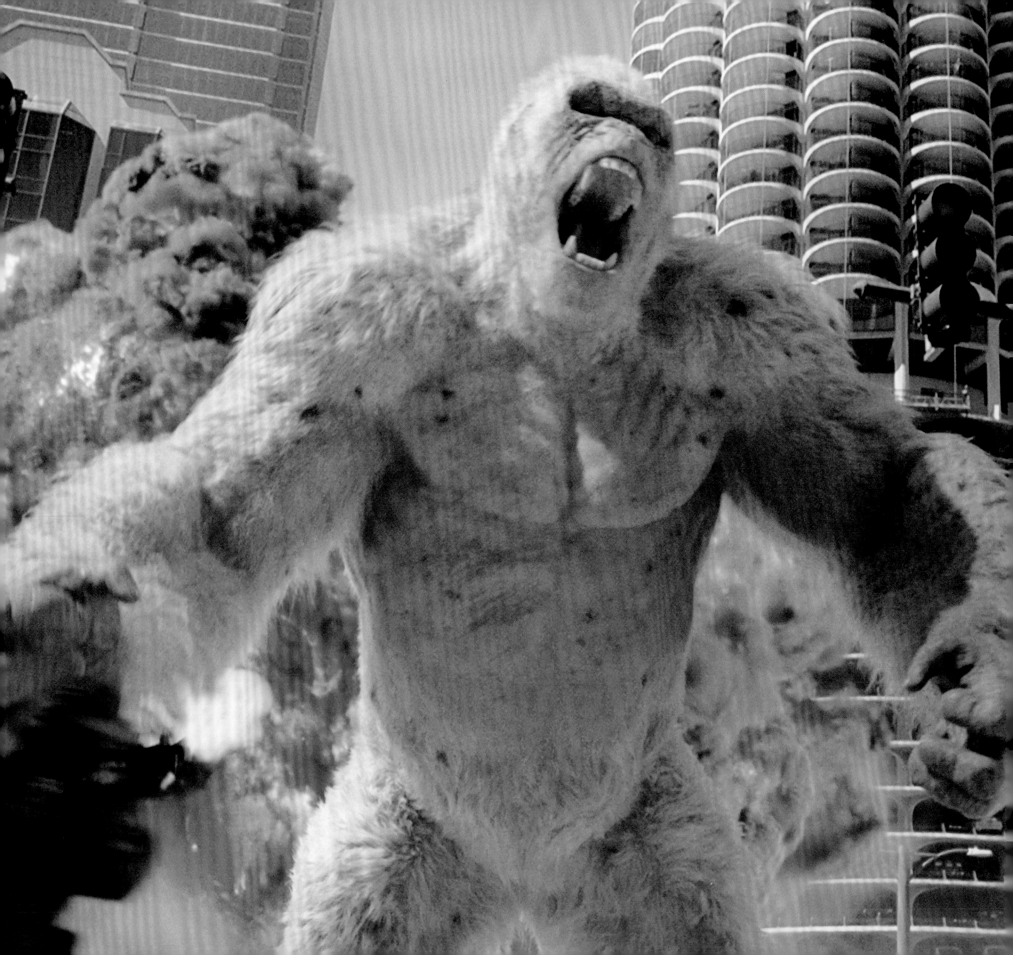

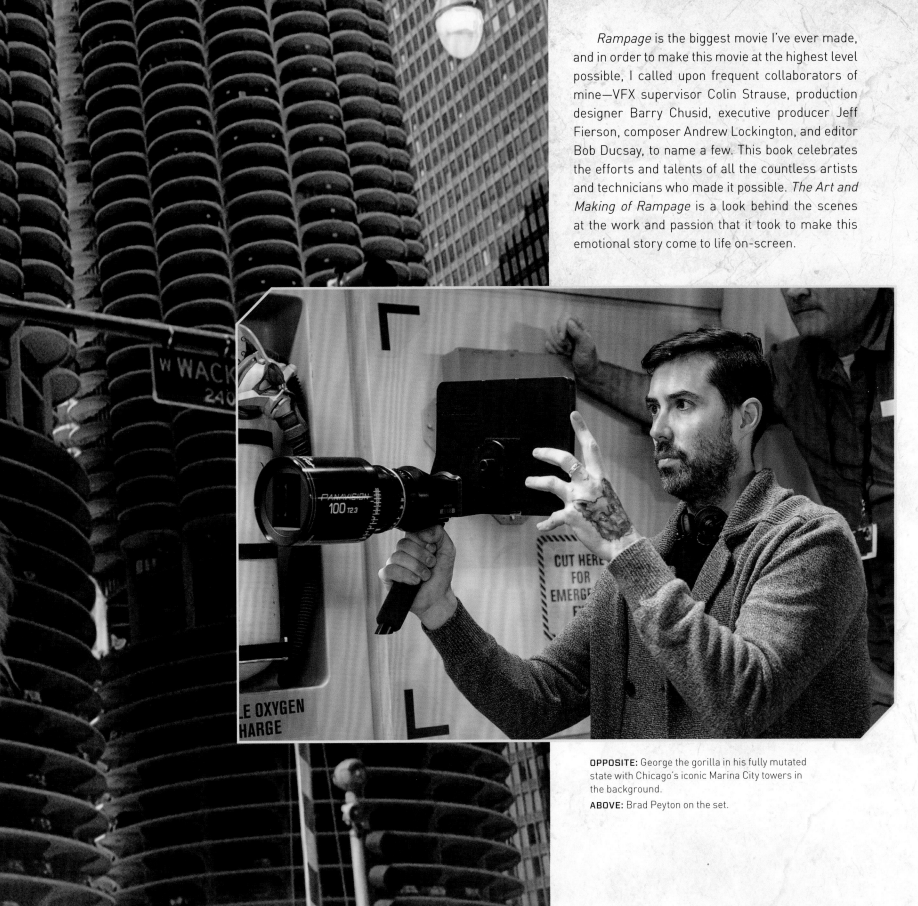

Rampage is the biggest movie I've ever made, and in order to make this movie at the highest level possible, I called upon frequent collaborators of mine—VFX supervisor Colin Strause, production designer Barry Chusid, executive producer Jeff Fierson, composer Andrew Lockington, and editor Bob Ducsay, to name a few. This book celebrates the efforts and talents of all the countless artists and technicians who made it possible. *The Art and Making of Rampage* is a look behind the scenes at the work and passion that it took to make this emotional story come to life on-screen.

OPPOSITE: George the gorilla in his fully mutated state with Chicago's iconic Marina City towers in the background.

ABOVE: Brad Peyton on the set.

CHAPTER 01
THE ORIGINS OF
RAMPAGE

THE MIDWAY ARCADE GAME *Rampage* was all the rage in the 1980s, challenging players to control giant monsters in order to reduce cities to rubble as military forces attempted to stop the creatures. *Rampage* proved so popular that several console versions followed, attracting even more gamers.

A few of those avid players couldn't have predicted back then that they'd have the chance to bring these epic monsters to the giant screen—actor Dwayne Johnson, director Brad Peyton, and producer Beau Flynn. Peyton remembers playing *Rampage* in a mall near the small Canadian town where he was raised, while Johnson and Flynn also recall being hard-core aficionados.

As Flynn remarks, "I was a giant game nerd. I had the first sit-down *Pong* game in all of Miami. So the chance to adapt *Rampage* was a huge opportunity. I pitched it to Dwayne and we brought it to Brad, who had a really good take on it. We thought, 'Let's keep it going.'"

Rampage marks the group's third collaboration following the blockbuster movies *Journey 2: The Mysterious Island* and *San Andreas*. In fact, Johnson and Flynn have made six films together. Johnson says of Peyton and Flynn, "Not only are they both amazing creative partners, but they've become damn good friends as well. When you dance that many times with someone in this business, you naturally develop a shorthand. We're all so in sync tonally that the slightest nod, look, or point can communicate exactly what one of us is thinking." He adds with a smile, "If for some reason they still aren't understanding what I'm saying, a good slap in the face will make my point clear."

Johnson's unique ability to combine warm humor with his imposing stature made him ideal for the lead role in *Rampage*. He plays Davis Okoye, a primatologist at the San Diego Wildlife Sanctuary who in his prior military career rescued a rare albino gorilla from poachers in Africa. Davis has built a deep friendship with the gorilla he named George, communicating with him using American Sign Language. "This movie is about their friendship in many ways," explains Peyton. "They're both alpha males who don't have to even *think* about being big and strong. The ideas of transcending their differences, and creating lifelong bonds through mutual respect, were big reasons to make this movie."

PAGES 12–13: Concept art showing the military battling the mutated creatures in Chicago.

LEFT: A *Rampage* video game cabinet.

RIGHT: The original *Rampage* video game was a favorite game for many of the filmmakers and served as the inspiration for the film.

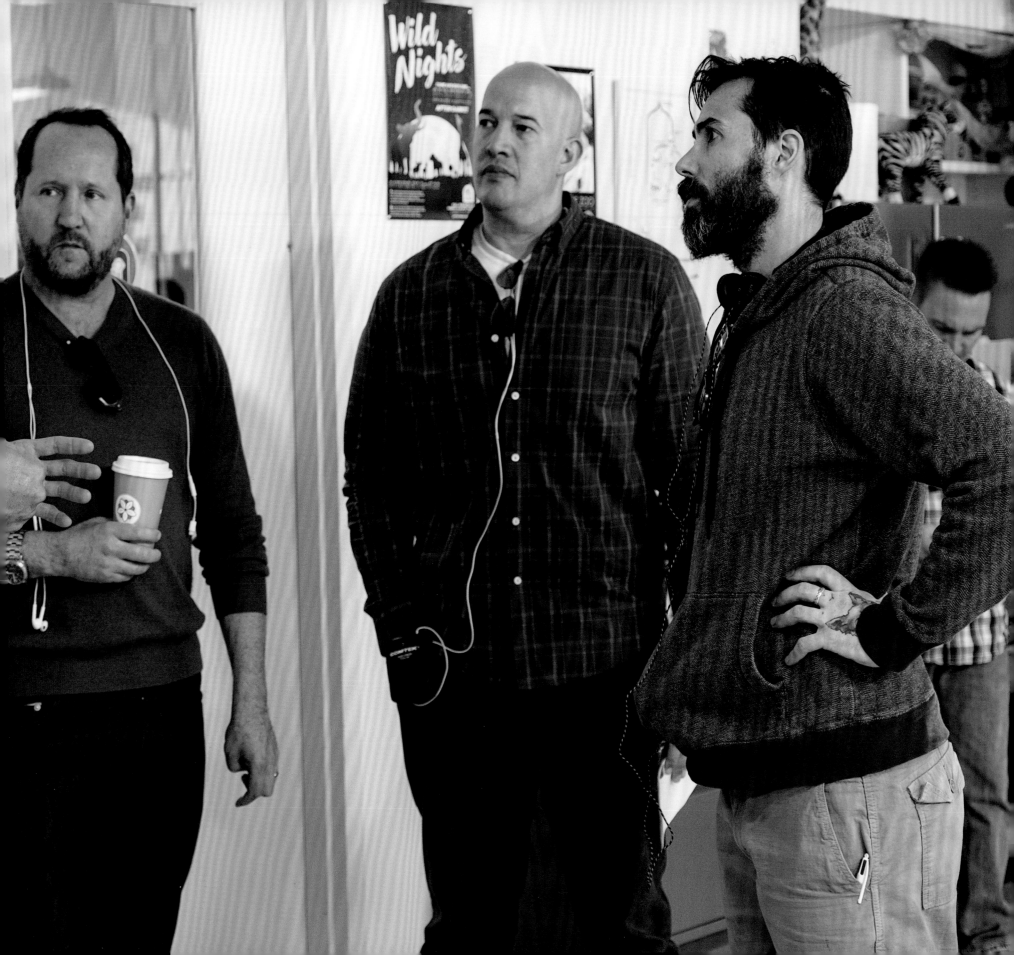

Rampage producer John Rickard saw the story's potential when he noticed that Warner Bros. owned Midway's game titles. "That took me back to pumping quarters into the *Rampage* arcade game and having so much fun. Through that nostalgia, a fantastic concept for a movie with three huge creatures attacking a sleek cityscape began to form." More pieces began falling into place when Rickard heard screenwriter Ryan Engle's ideas for turning the game into a movie.

Engle, another self-described gamer, recalls, "I had a desire to do a love letter to movies I grew up with, like *Jaws* and *Jurassic Park*. But how do you do a movie about mutated animals and tell an emotional story? What would happen if a genetically engineered pathogen was unleashed on these animals that caused them to grow to huge sizes and become aggressive?"

Brian Colin was a video game animator and game designer on the original *Rampage* video game developed by Bally Midway. When he first heard *Rampage* was going to be made into a movie, he said his initial reaction was to grin all of the time while thinking about it. "After seeing Dwayne Johnson sign on and hearing more and more about what the movie was going to become, the grin just kept getting bigger and bigger," he recalls.

Colin met with John Rickard and learned how the team planned to bring the game to life. "I, on every level, was impressed," he remarks. "John gave me a little background about how the story developed and immediately some things started resonating with me. The movie has a heart beyond anything else you expect from a huge blockbuster, along with all of the action and thrills. *Rampage* was a fun thing for me to do thirty years ago, but now, watching all of the best people coming together to work on this incredible production—it's tremendous."

"To have the technology now to bring something like the original *Rampage* game to life is one of the best things about making movies," producer Hiram Garcia notes. "In the game, the city the creatures attack is contained. For us to apply real-world rules to our movie and have the creatures travel across the country is a ton of fun. Plus, it's mind-blowing to see what the destruction actually looks like when you place creatures of that size in an urban setting."

CRISPR-Cas9 Genome Engineering

The Rat subject was chosen for it's unique adaptabilty to genetic manipulation. Coupled with ideal breeding rates allows the animal to continue to produce continued subjects for further testing use.

Subject 214 - 09 AKA "Mr. Crispers" has proven to be a durable subject and has tested positively with CRISPR gas, continued testing on the subject will commence. Mr. Crispers has also shown remarkable resiliency to the rigorous demands of zero gravity, though more testing may be required.

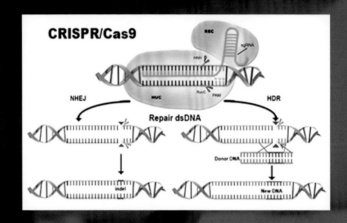

PAGES 16-17: Brad Peyton and his team spent a year and a half planning *Rampage* and created previsualization for the entire movie.

ABOVE: A graphic detailing why the Wydens chose to use a rat as their first test subject for the CRISPR gene-editing technique.

RIGHT: *Rampage* is director Brad Peyton, producer Beau Flynn, and actor Dwayne Johnson's third movie together.

The team behind *Rampage* was united in one goal: They needed to find a scientific basis for the animals' mutations. That's where the emerging field of DNA manipulation came into play. Co-writers Carlton Cuse and Ryan Condal had been researching a gene-editing technology called CRISPR. "Science grounds this movie and gives us our anchor," notes Beau Flynn. "It's real technology. We didn't just make this up for entertainment. It's tremendously powerful, but in the wrong hands, it can also be incredibly dangerous."

Garcia explains, "With CRISPR technology, our creatures don't just become massive in size. They actually mutate with a hybrid of traits from different creatures. It's not just that a wolf and a crocodile start to pick up the abilities of other creatures that makes them dangerous foes. They evolve into creatures that are much more terrifying."

"*Rampage* poses the question," adds John Rickard, "what would happen if a scientist decided to use CRISPR as a weapon?" When that occurs and a CRISPR pathogen accidentally infects George the gorilla, the science becomes personal. It drives Dwayne Johnson's character to go to any lengths to save George, who begins mutating beyond recognition.

The urgency of this scenario sparks a host of compelling performances from remarkable actors like Naomie Harris, who was nominated for an Oscar for her role in 2016's *Moonlight*. Harris plays geneticist Dr. Kate Caldwell, whose CRISPR research has been manipulated for evil purposes, and she's drawn into the fight to rescue George. Rickard observes, "Naomie brought a gravitas to this character. You don't have to put glasses on her to know that she's smart."

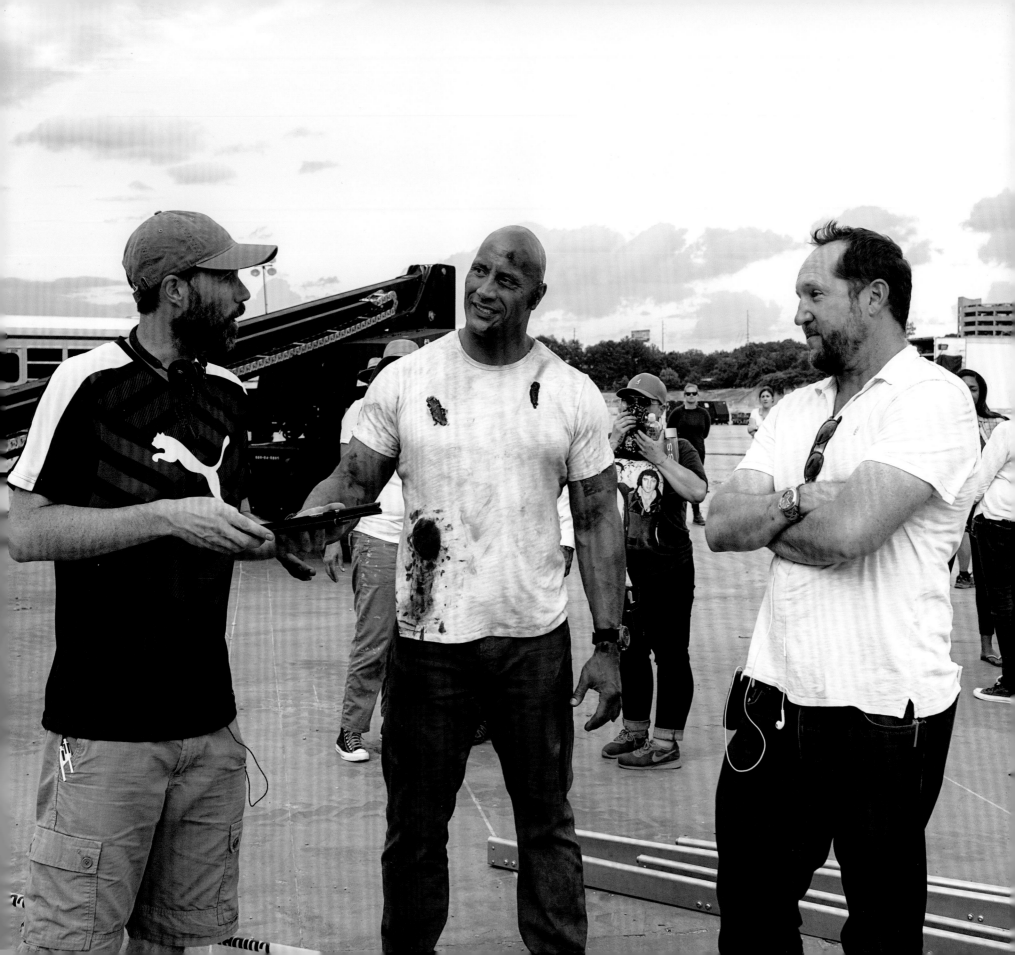

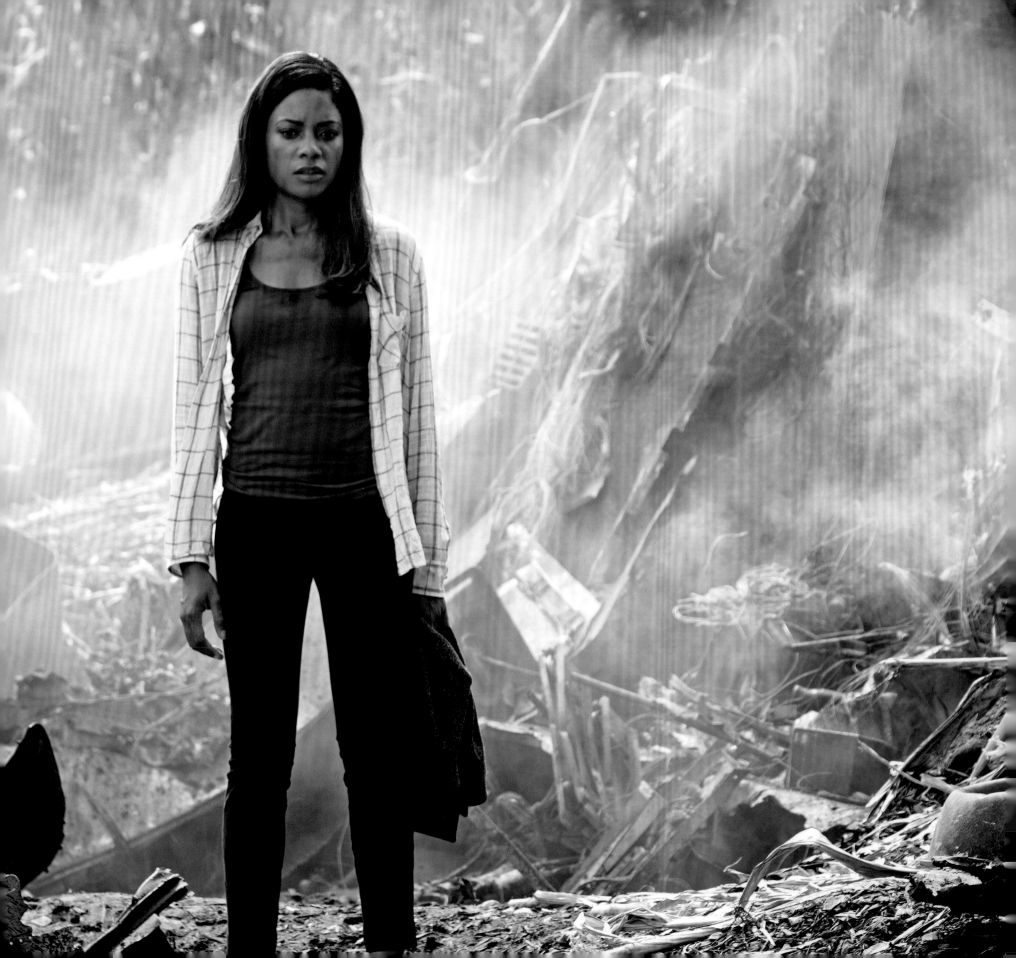

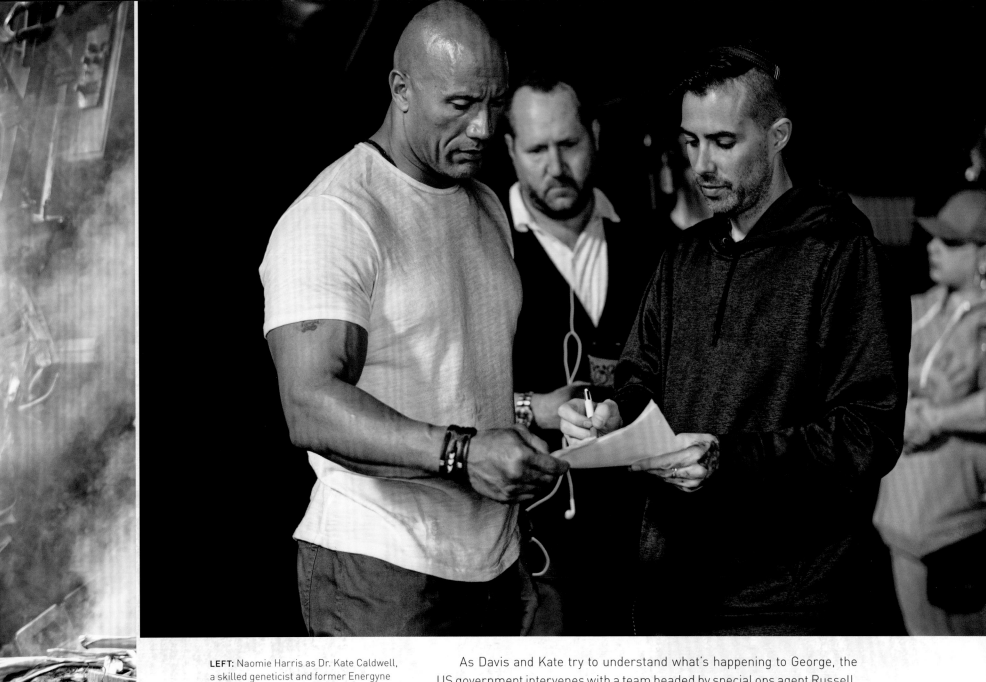

LEFT: Naomie Harris as Dr. Kate Caldwell, a skilled geneticist and former Energyne employee.

ABOVE: Peyton and Johnson review notes during filming. It was important to the filmmakers that the movie included a strong scientific base as well as emotional resonance.

As Davis and Kate try to understand what's happening to George, the US government intervenes with a team headed by special ops agent Russell. As played by Jeffrey Dean Morgan, well known for his role in *The Walking Dead*, Russell is a no-nonsense foil for Johnson's character, Davis. Hiram Garcia puts it simply: "He can stand toe-to-toe with a huge star like Dwayne Johnson and hold the screen."

Those human dynamics were essential to director Brad Peyton. "A strong emotional core is what grounds the cast and their performances. The more of a 'popcorn' movie that you have, the harder you have to work. I think audiences know that we're going to give them destruction and action. But it's the emotion and humor that I think will surprise and entertain them."

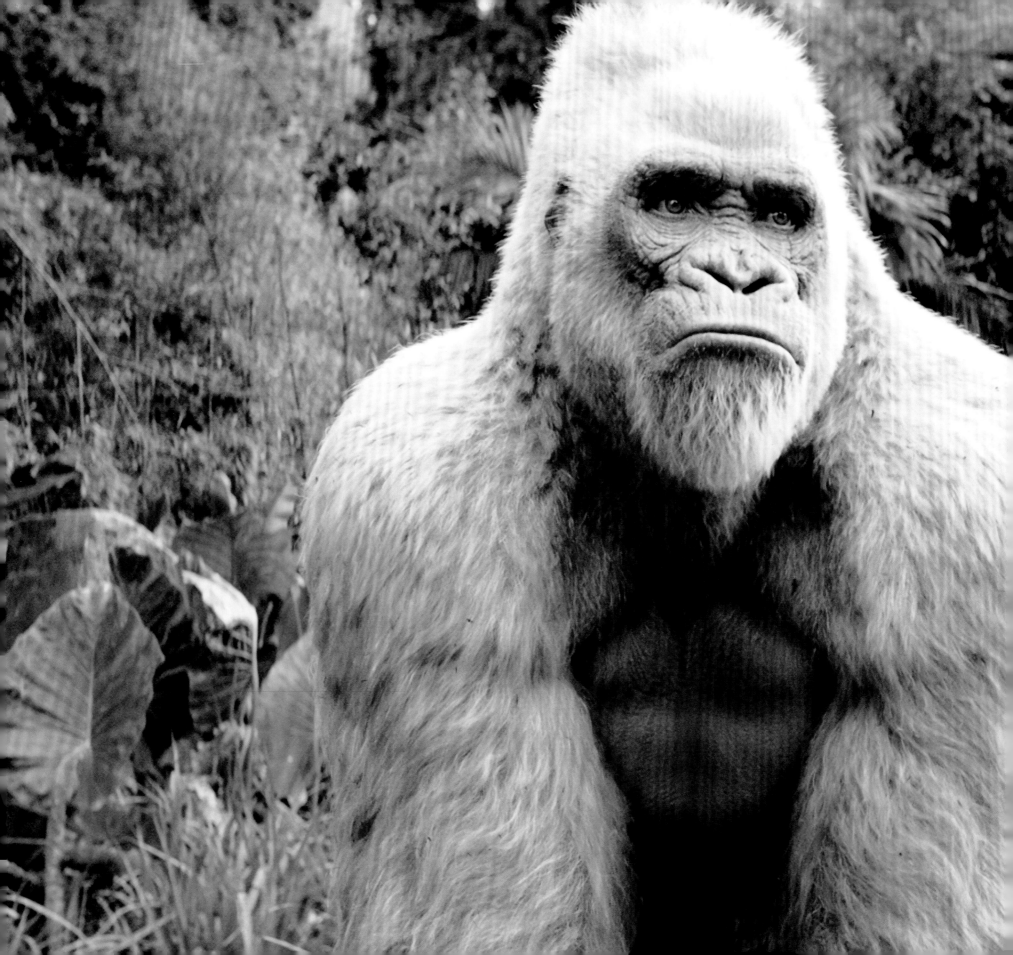

CHAPTER 02
DAVIS & GEORGE

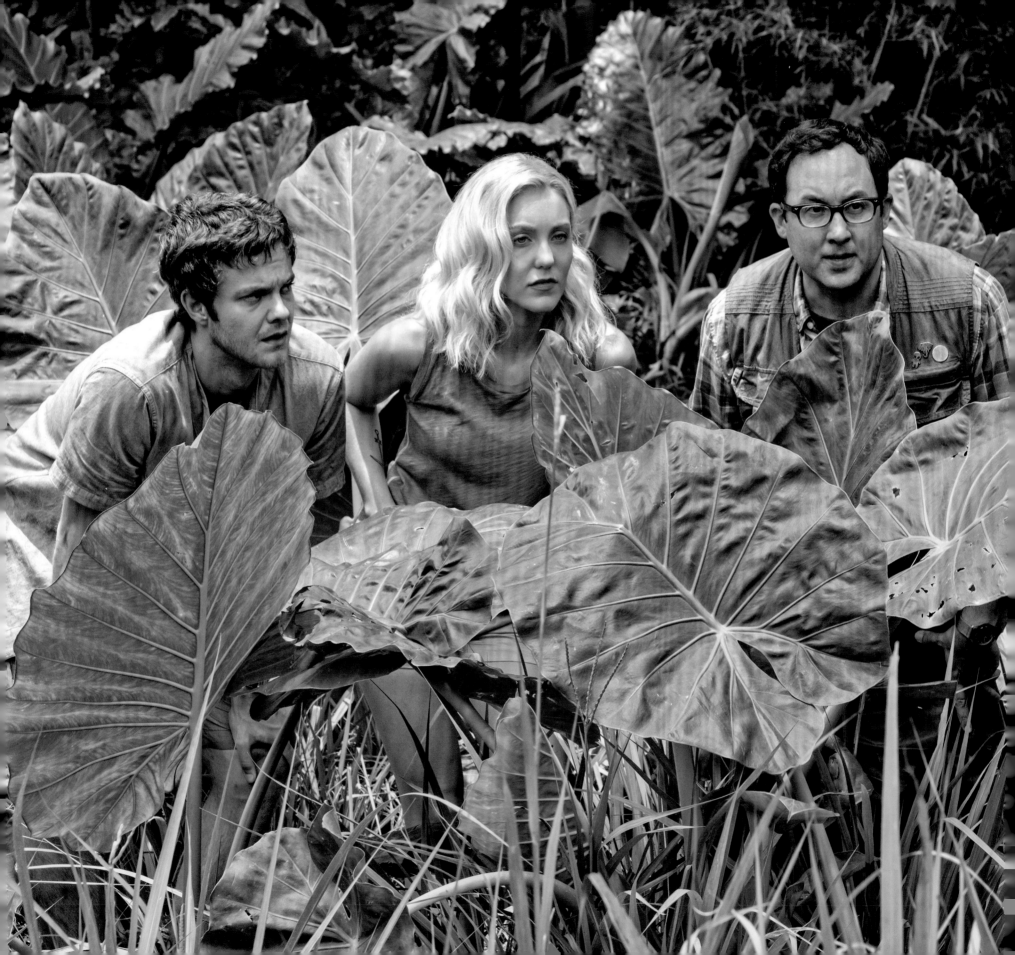

IN HIS EARLIER DAYS, when Davis Okoye (Dwayne Johnson) headed a military antipoaching unit in Africa, he made a decision that changed his life forever. He rescued an orphan animal that would have otherwise been doomed: It was a rare albino gorilla. Davis named his adopted friend George and raised the magnificent gorilla to adulthood. Within the safe confines of the San Diego Wildlife Sanctuary—where Davis became a primatologist after his military career—George and his band of gorillas thrived.

"Dwayne's character, Davis, is a really unique role for Dwayne, because he's a bit of a loner," explains director Brad Peyton. "His best friend is a gorilla that he rescued and raised. And, it's really interesting because they're very similar—they're both funny, they're both alpha males, and they're the biggest guy in the room at all times."

Perfecting the costume of Johnson's primatologist character was no easy feat. Costume designer Melissa Bruning knows one thing for sure: "Dwayne is not a typical size, so nothing could be off the rack. Everything had to be altered. I wanted to do a Steve McQueen everyman look. Davis was a primatologist at a zoo, so there's a level of grime that is utilitarian but still cool. I had a safari shirt tailored for him. We wanted to give him things that would root his character, and since Davis had spent time in Africa, I found bracelets made by African artists on the UNICEF website. We got several of them for Dwayne to choose from."

PAGES 22-23: A completed visual effects shot of George the gorilla.

LEFT: Actors Jack Quaid and Breanne Hill play primatology students Connor and Amy, who are being taught by Davis. P. J. Byrne portrays Nelson, one of Davis's fellow primatologists.

INSET: Costume designer Melissa Bruning had to account for Dwayne Johnson's height and physicality when creating his costumes.

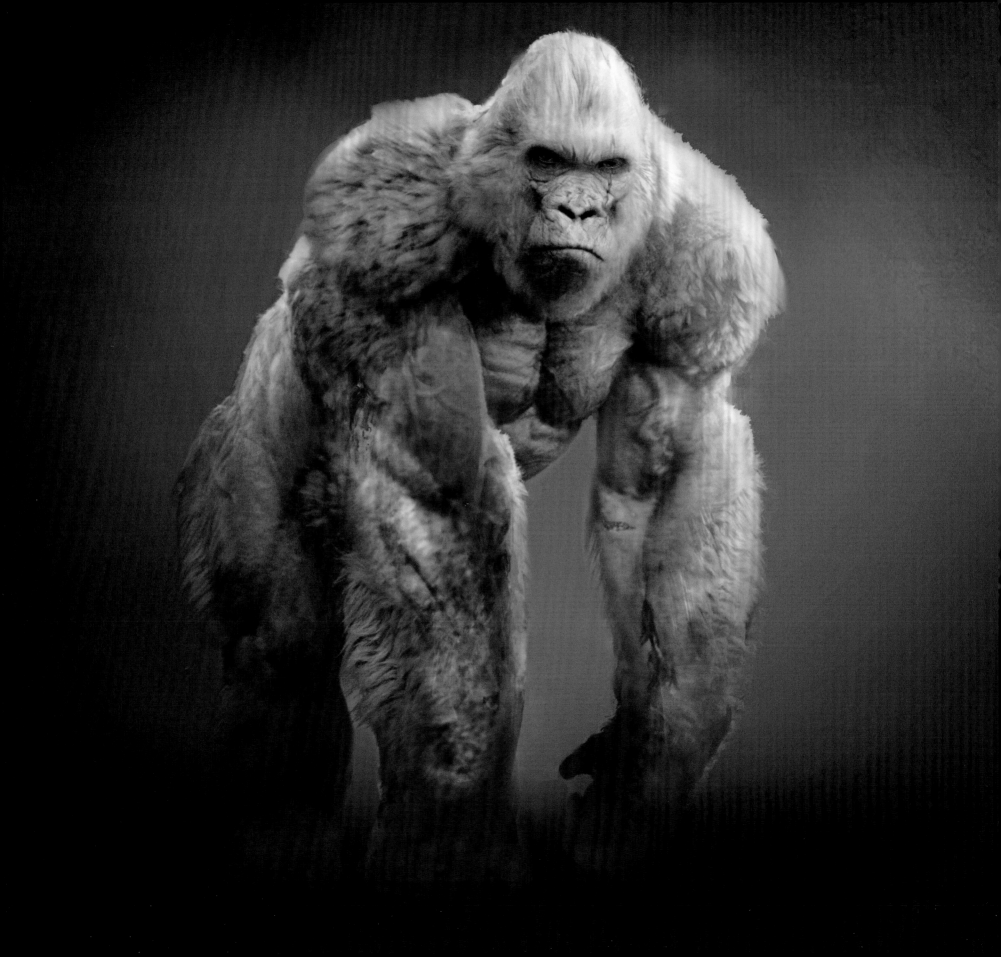

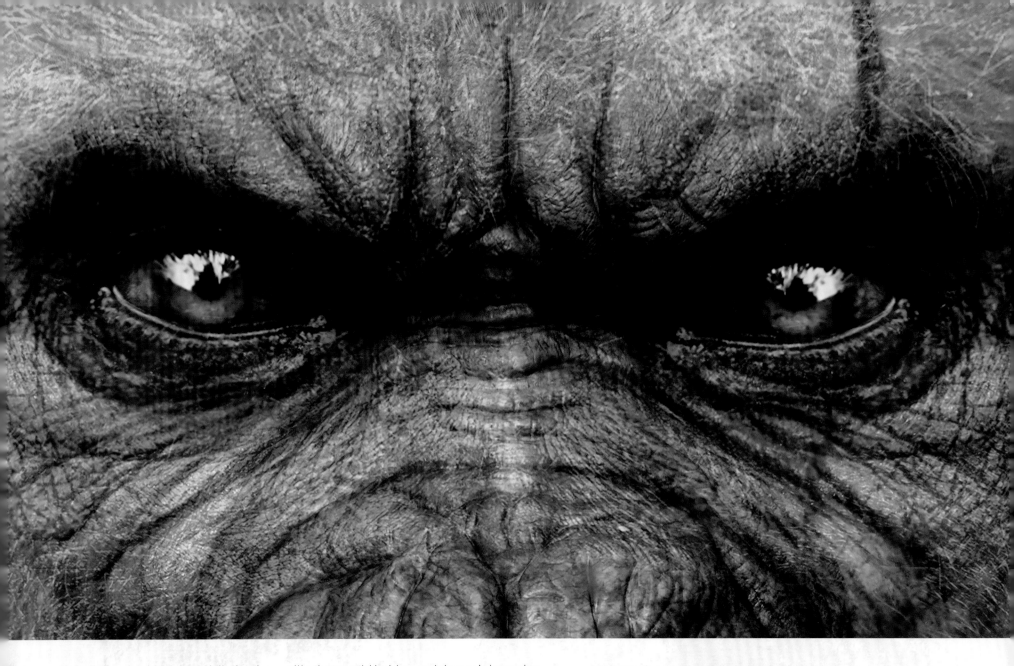

Creating a charismatic and distinctive gorilla that would hold up to Johnson's imposing stature was a test in creative thinking. Production designer Barry Chusid recalls, "When we were starting to draw George, he wasn't an albino. There's a scene when he basically attacks a bear and he gets scratched, and, quite frankly, it was really as simple as blood on brown or black fur being hard to see." As the team continued to explore the idea of an albino gorilla, Chusid recalls a request from director Brad Peyton: "Brad had me do two paintings—one with an albino and one with a sort of traditional silverback." When both versions of George were placed into a scene featuring Davis and some of the destruction in Chicago, Chusid notes, "The albino just really became a much more powerful image."

Visual effects supervisor Colin Strause observes, "People go to the zoo. They know what a gorilla or chimpanzee looks like. But there are hardly any albino chimpanzees or gorillas. So trying to make that look believable in bright daylight is actually a pretty big challenge."

OPPOSITE: George was initially designed with black or brown fur, but the filmmakers realized the albino coloring would make George exceptional and create a more powerful image.

ABOVE: The filmmakers chose to keep Jason Liles's blue eyes when designing George.

CREATING A FRIENDSHIP

To get a feeling for the zoo environment where Davis raised George, Dwayne Johnson and producers Beau Flynn and Hiram Garcia visited the gorilla enclosure at the Zoo Atlanta, near the Third Rail stages in Georgia where *Rampage* was filmed. Flynn recalls, "When Dwayne met the silverbacks, I could feel that the gorillas made a connection with him. The people from the zoo were surprised at how comfortable the gorillas were around Dwayne. I think it was because of his natural calmness and inherent confidence."

The decision to make George a main character with a close connection to Davis was a major revelation for the team. "In the early versions of the script, George and Davis didn't really have a relationship, and George was just one of the three creatures affected on this journey. The story was great, but something was missing," producer Hiram Garcia notes. "We didn't feel we had enough for the audience to become emotionally invested at the level we wanted them to be, but that changed once we developed their relationship and gave George a way to communicate. George wasn't just a mindless monster but an individual with feelings and struggling with something he couldn't control."

Davis and George are able to communicate through American Sign Language. As producer Beau Flynn remarks, "Dwayne learned sign language for the movie and he's very natural with it. It's stunning to watch."

TOP: Graphic logo created for the San Diego Wildlife Sanctuary, where George lives.

ABOVE: Johnson poses with staff from Zoo Atlanta.

RIGHT: Dwayne Johnson speaks with a primatologist. Johnson, Beau Flynn, and Hiram Garcia visited Zoo Atlanta to research and interact with gorillas.

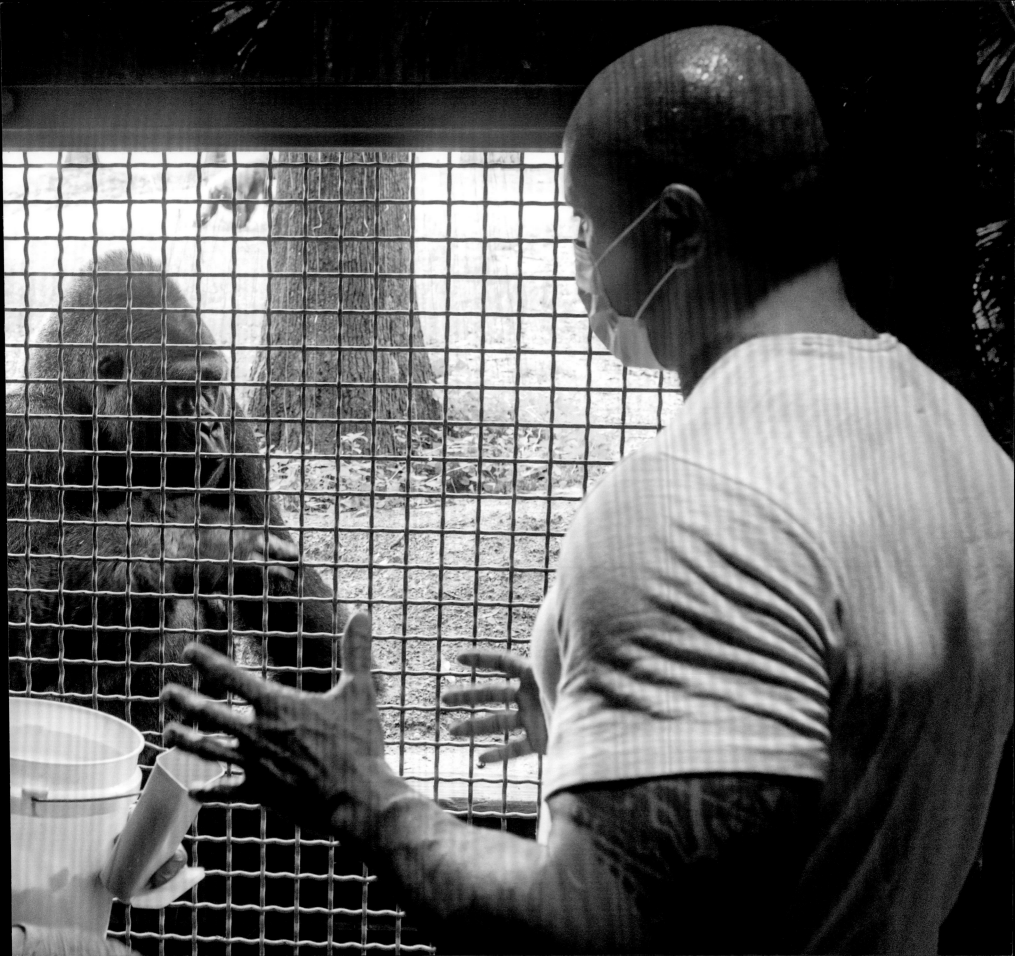

INTERSPECIES COMMUNICATION

American Sign Language (ASL) is best known as a communication method for the deaf and hard of hearing, but ASL is also a conduit for humans to communicate with other species. That's especially true for human-ape communication because the dexterity of apes' hands enables them to gesture clearly. Perhaps the most famous example is Project Koko, which began when Stanford University student Penny Patterson taught ASL to a gorilla named Koko. Decades later, Koko still communicates through sign language and has fascinated people worldwide.

Rampage director Brad Peyton explains that he did a lot of research on Koko and other signing animals while preparing for this movie. "I've been fascinated by the fact that they can know so many words and carry on complex conversations. That was built into the script early on and was a big touchstone for Dwayne."

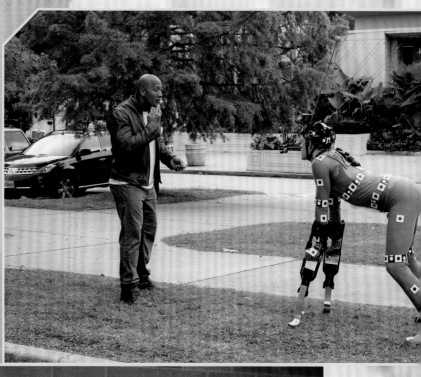

OPPOSITE AND ABOVE RIGHT: Johnson's character, Davis, uses American Sign Language during filming to communicate with George.

RIGHT: American Sign Language coach Paul Kelly teaches Johnson signs during filming.

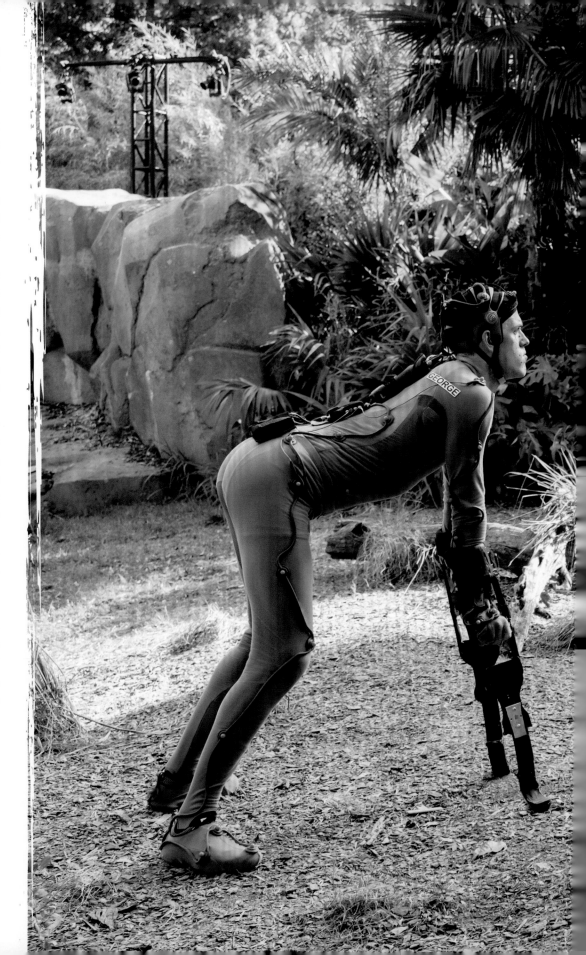

"I did spend a lot of time absorbing and learning as much as I could about sign language," Johnson says. "Every day on set we made sure to have sign language expert Paul Kelly standing by to assist with the signing scenes."

Paul Kelly explains, "There are quite a few scenes in the movie that have sign language. The communication between them is really important, and George really understands what Davis is talking about."

"Davis talks to George while he's signing to him," notes Brad Peyton. "So both the audience and George understand what he's communicating. It felt like a really organic way to tell the story of the two of them."

To achieve this natural feel, Paul Kelly also taught sign language to Jason Liles, the actor whose movements were the basis for the digitally animated version of George. Liles was outfitted with motion-tracking markers on his face, hands, and body, while tracking cameras around the set captured the nuances of his performance. The data from those tracking cameras would later form the basis of the digital gorilla animated by Weta Digital in New Zealand.

"This process is called an optical capture system," Colin Strause explains. "There are around thirty-two cameras that are optical-based, looking at reflective surfaces on the mocap performer's suit. Then, we also have four witness cameras, which are basically like feature film cameras that we shoot as backup reference. In this volume we actually can see, on the TV behind us, a representation of the gorilla so you can see how big he is, and how he compares to the different set pieces that we're putting them in. We can make sure that all the movements match."

"This is a two-vendor show," Strause also notes. "Weta is our main creature vendor, while Hydraulx is doing all the other noncreature work in the film. Weta was always our number one pick for the movie because of their work on films such as *Lord of the Rings*, *Avatar*, and *Planet of the Apes*. They're an amazing character company. They know how to add humanity. We need that if we are going to make you believe that George and Davis have this connection, and Davis goes through this whole journey to save his friend."

RIGHT: Davis communicates with George while Nelson (P. J. Byrne), Connor (Jack Quaid), and Amy (Breanne Hill) watch.

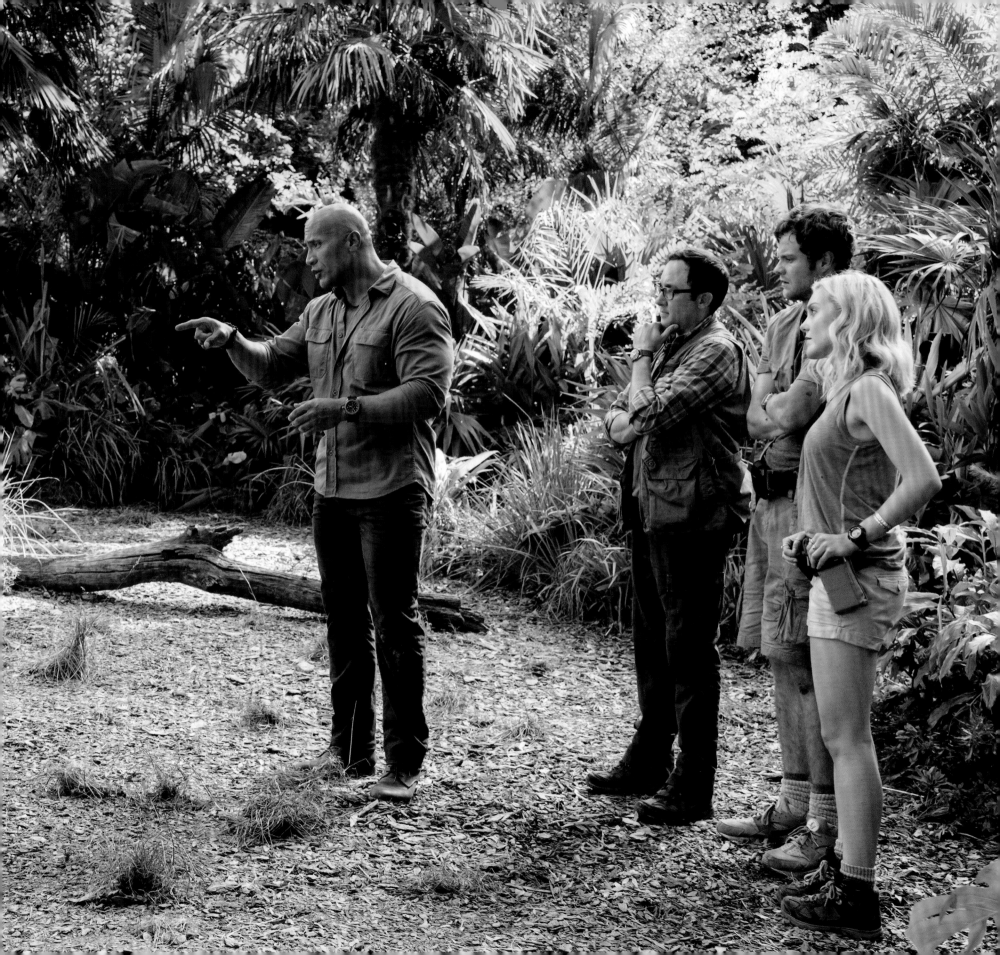

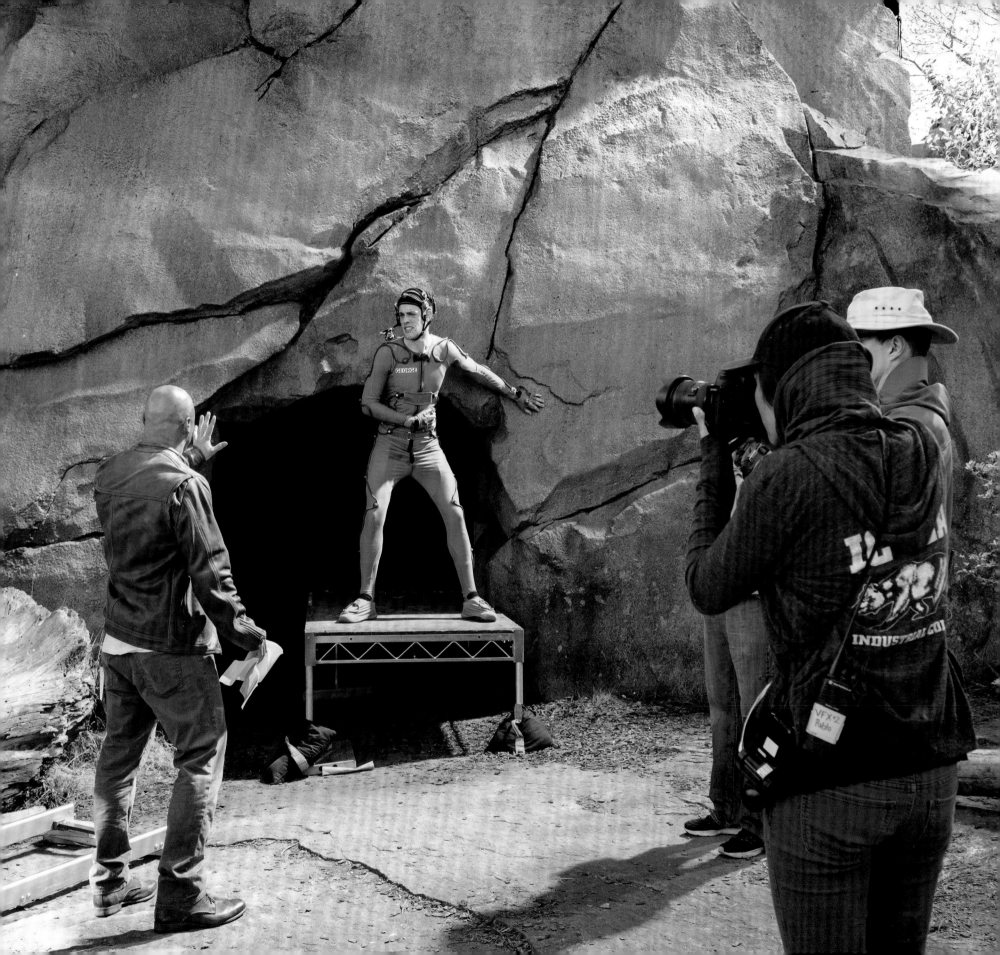

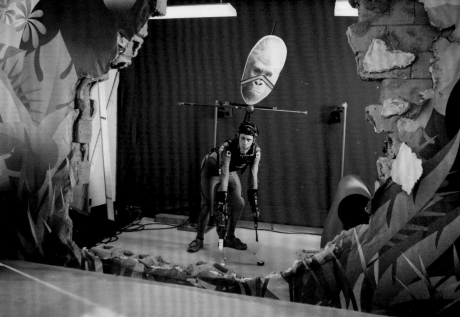

To give everyone a sense of what George would eventually look like, the Weta folks sent a physical model of the gorilla's head to the set. As Weta visual effects supervisor Erik Winquist explains, "Our sister company Weta Workshop made it out of fiberglass with white yak fur, silicone-casted pink albino skin, and glass eyeballs. It was incredibly helpful as a reference."

The ability to film Liles and Johnson together was also key to conveying the nuances of their friendship, observes executive producer Marcus Viscidi. "When Dwayne was on set with Jason playing George, Dwayne didn't have to act to empty air. They were really interacting." Winquist adds, "At Weta, we've found over the years that as soon as you put a performance-captured actor in with the other actors, you can get those off-the-cuff moments that really help establish a relationship. It was important to do that so audiences would empathize with George." Director Brad Peyton adds, "There's a real honest chemistry in the scenes which I know was so valuable for Dwayne and also for us. To have someone who's really emoting in those scenes with Dwayne gives real authenticity there."

"Jason played George as a cheeky gorilla and he was brilliant," remarks Winquist, an Oscar nominee in visual effects for *Dawn of the Planet of the Apes.* "I often find that there's an assumption that the actors do their performance and then we push buttons and feed data into a computer. But it's a much more collaborative process. We were very inspired by the performance that Jason gave as the character George. For example, if we literally mapped the way that Jason moved his mouth onto an animated character, the result would be comical instead of terrifying. There's always a translation involved between talented actors and talented animators to get the right emotional performance."

OPPOSITE: Jason Liles stands on a platform during his performance to indicate George's larger size after the initial mutation.

TOP LEFT: The interaction between Jason Liles and Dwayne Johnson created the basis for Davis and George's relationship.

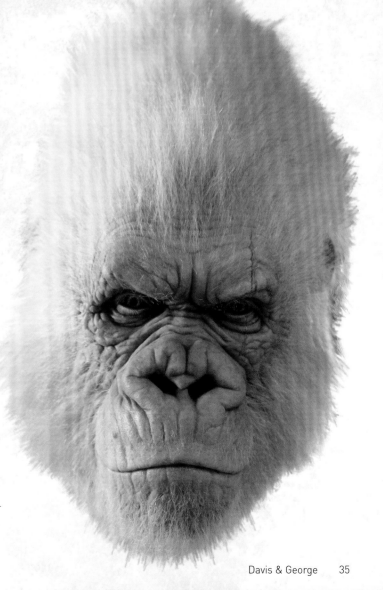

TOP RIGHT: A graphic of George's face is placed behind Liles to indicate where the animated gorilla's face will appear and help the actors know where to look.

BOTTOM RIGHT: Weta Workshop created a physical model of George's head for the actors and crew to reference.

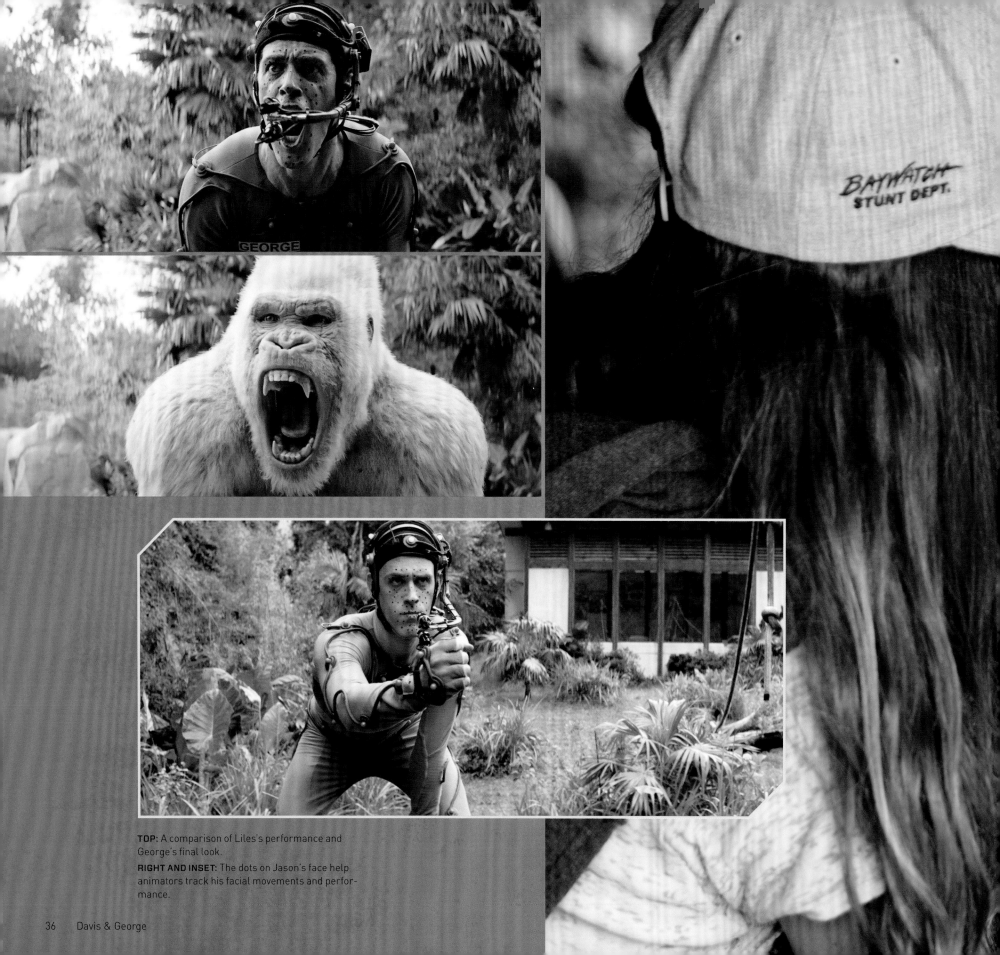

TOP: A comparison of Liles's performance and George's final look.

RIGHT AND INSET: The dots on Jason's face help animators track his facial movements and performance.

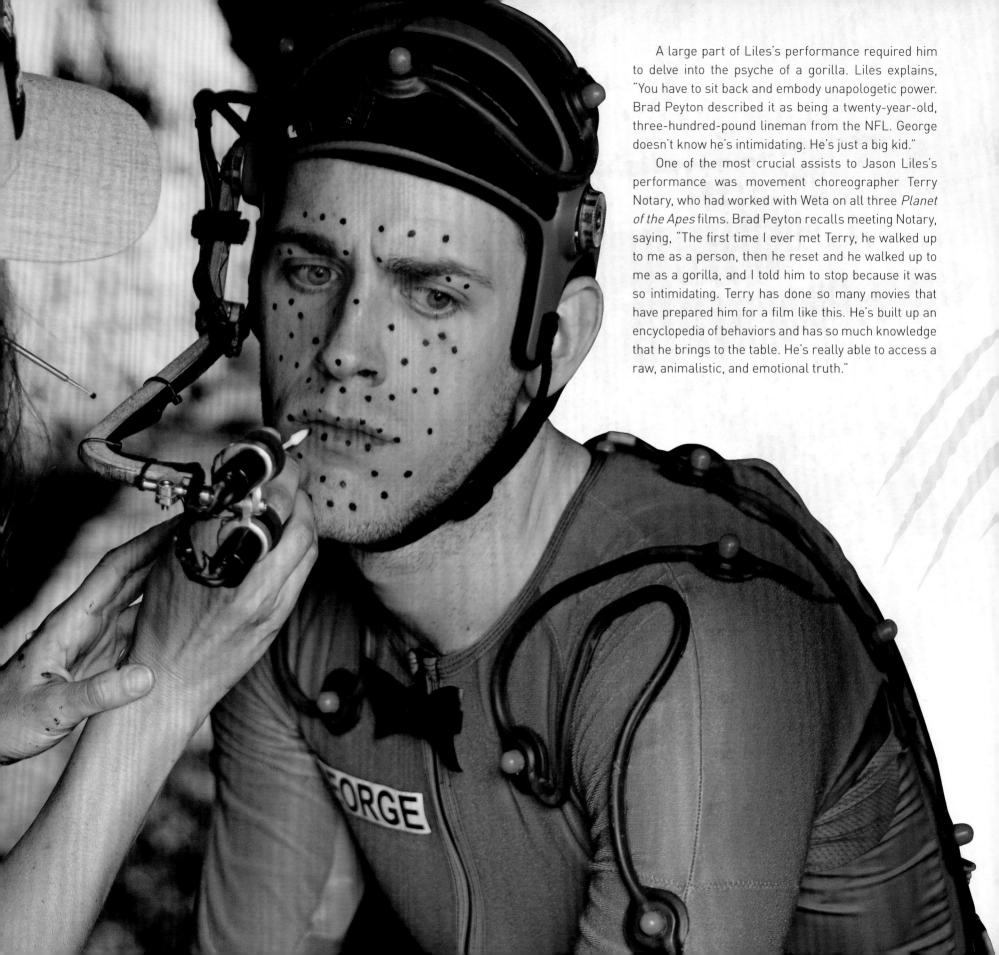

A large part of Liles's performance required him to delve into the psyche of a gorilla. Liles explains, "You have to sit back and embody unapologetic power. Brad Peyton described it as being a twenty-year-old, three-hundred-pound lineman from the NFL. George doesn't know he's intimidating. He's just a big kid."

One of the most crucial assists to Jason Liles's performance was movement choreographer Terry Notary, who had worked with Weta on all three *Planet of the Apes* films. Brad Peyton recalls meeting Notary, saying, "The first time I ever met Terry, he walked up to me as a person, then he reset and he walked up to me as a gorilla, and I told him to stop because it was so intimidating. Terry has done so many movies that have prepared him for a film like this. He's built up an encyclopedia of behaviors and has so much knowledge that he brings to the table. He's really able to access a raw, animalistic, and emotional truth."

To teach Jason to move like a gorilla, Notary outfitted the actor with his patented Quadrafit arm extensions. That made Liles's arms longer than his legs—just like a gorilla. During three weeks of prep sessions in Los Angeles, Notary and Liles would run on all fours along mountain trails. "I was just following him, running around like a baby gorilla. It was the sorest I've ever been in my life," admits Liles. Standing at six foot nine, Liles is physically taller than Johnson. "But he's still much bigger than me," Liles chuckles. "It was fun to play opposite someone who is an alpha male himself."

Winquist notes, "This is Jason's first motion capture performance. He's done a lot of prosthetic film work, where you don't see his face behind latex. He found it freeing as an actor to just be there to interact with the other actors. For us, that's hugely important. We found, over the years, going back to Gollum with Andy Serkis, that as soon as you put that actor's physical performance with the other actors—what can happen when everyone can interact. The off-the-cuff moments, finding the moment."

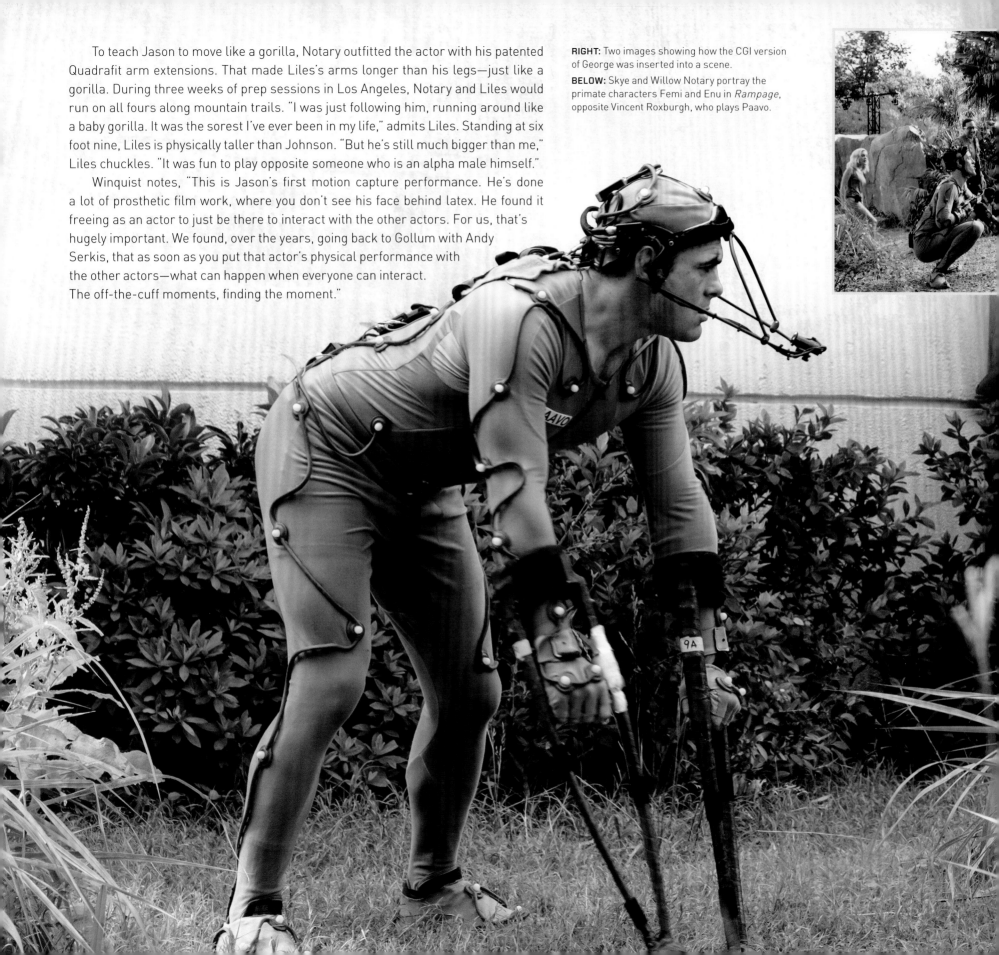

RIGHT: Two images showing how the CGI version of George was inserted into a scene.

BELOW: Skye and Willow Notary portray the primate characters Femi and Enu in *Rampage*, opposite Vincent Roxburgh, who plays Paavo.

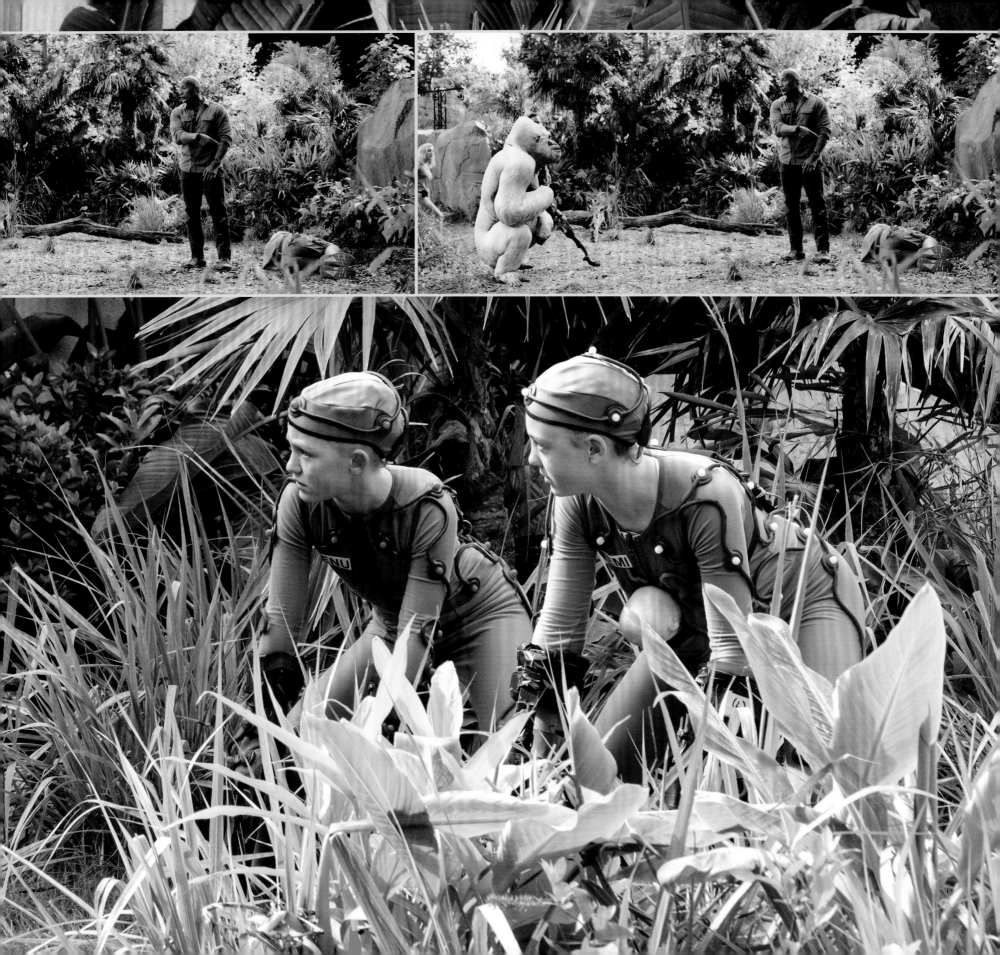

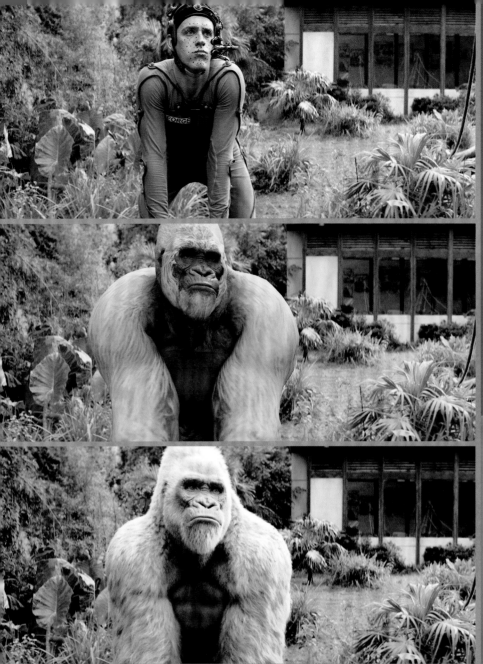

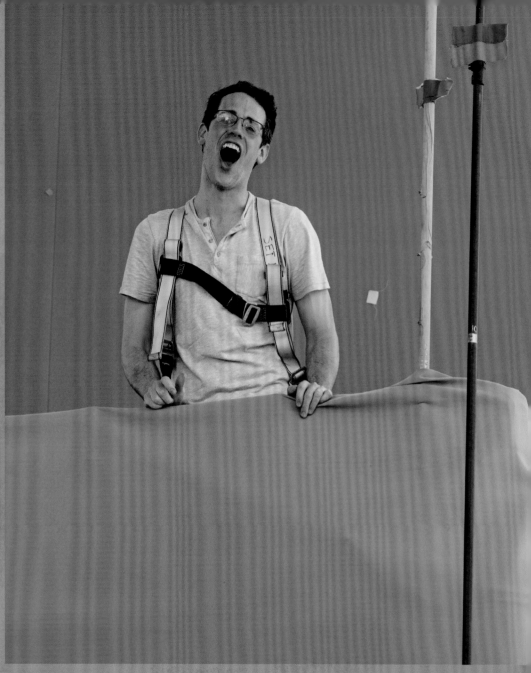

When the audience first sees Davis and George together on the screen, they are in for a surprise. As *Rampage* supervising art director Tom Reta remarks, "At the beginning we seem to be in a jungle. And then, Whoa! We realize we're actually in a zoo enclosure."

The gorilla habitat in which Davis has raised George is actually home to a family of gorillas. Performing two of the smaller animals in this group were Terry Notary's daughters Skye and Willow, who'd previously been in the *Planet of the Apes* movies. "They were amazing," says Liles. "It was great to play with kids who embody these gorillas so well, with their childlike imagination. I think that's the hardest thing for actors to remember as we grow older."

During this glimpse of life at the San Diego Wildlife Sanctuary, we see how Davis keeps the peace among the band of gorillas. To help George accept a new male that's joined the group, Davis signs *family*. As sign language translator Paul Kelly observes, "And when George signs *family* back to Davis, so much emotion is added to the story."

ABOVE LEFT: A series of progressive shots showing the animation of George.
ABOVE: Jason Liles in plainclothes during filming.
OPPOSITE: Detail of the motion capture suit worn by actor Jason Liles.
PAGES 42–43: Actor Jason Liles, outfitted in the motion capture gear that will provide the data needed to animate George, confers with director Brad Peyton.

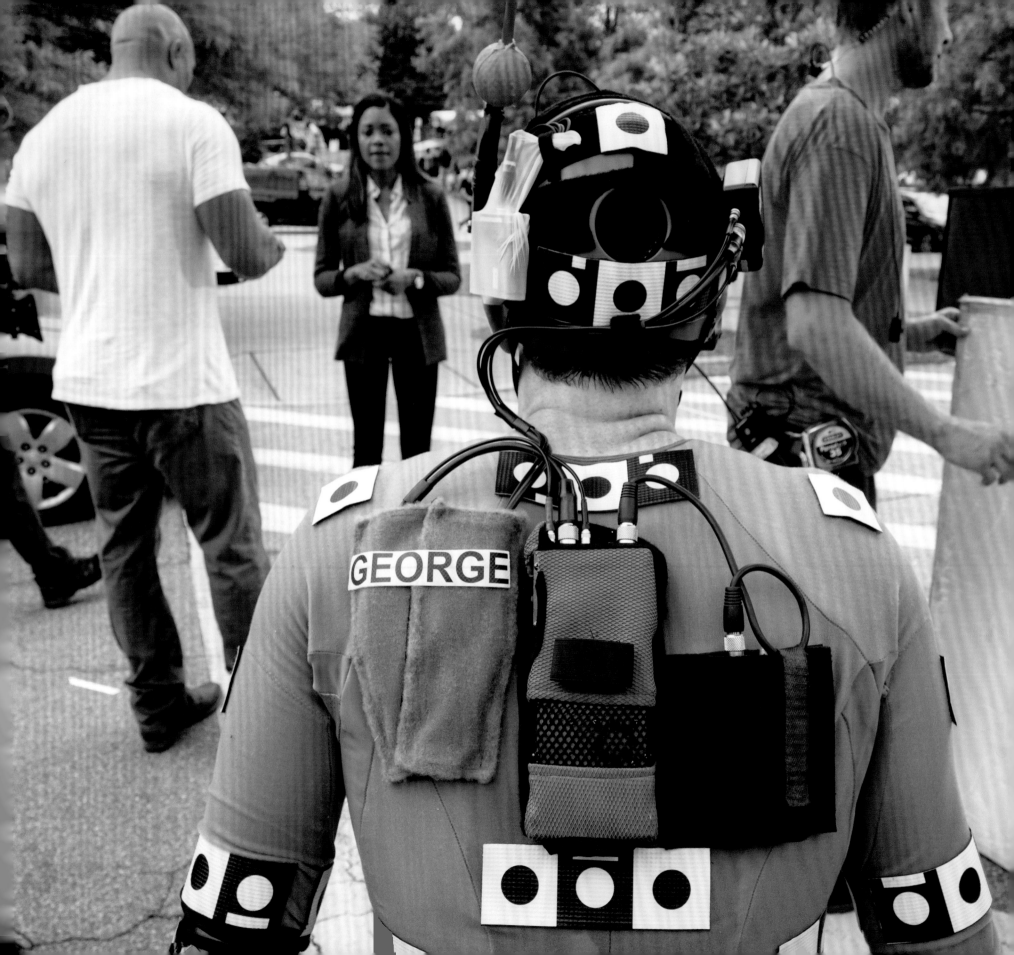

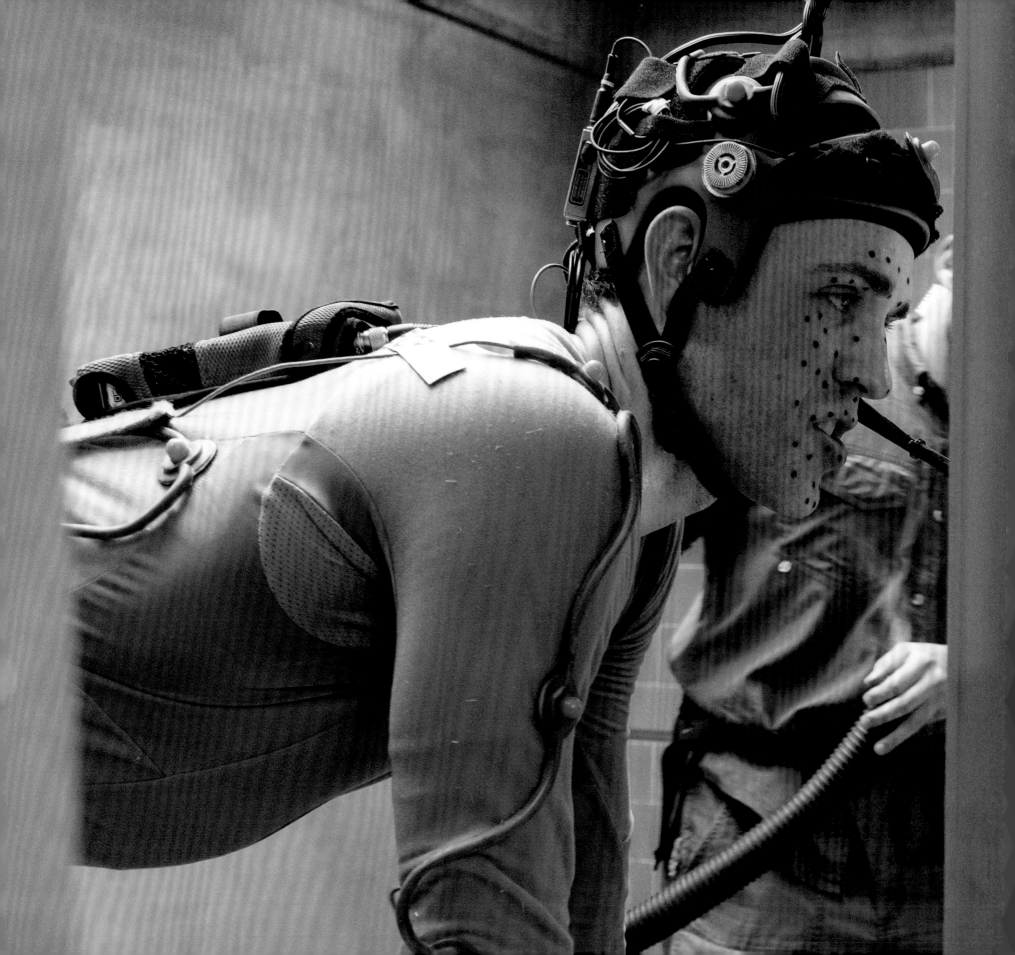

CHAPTER 03

THE DARK SIDE
OF SCIENCE

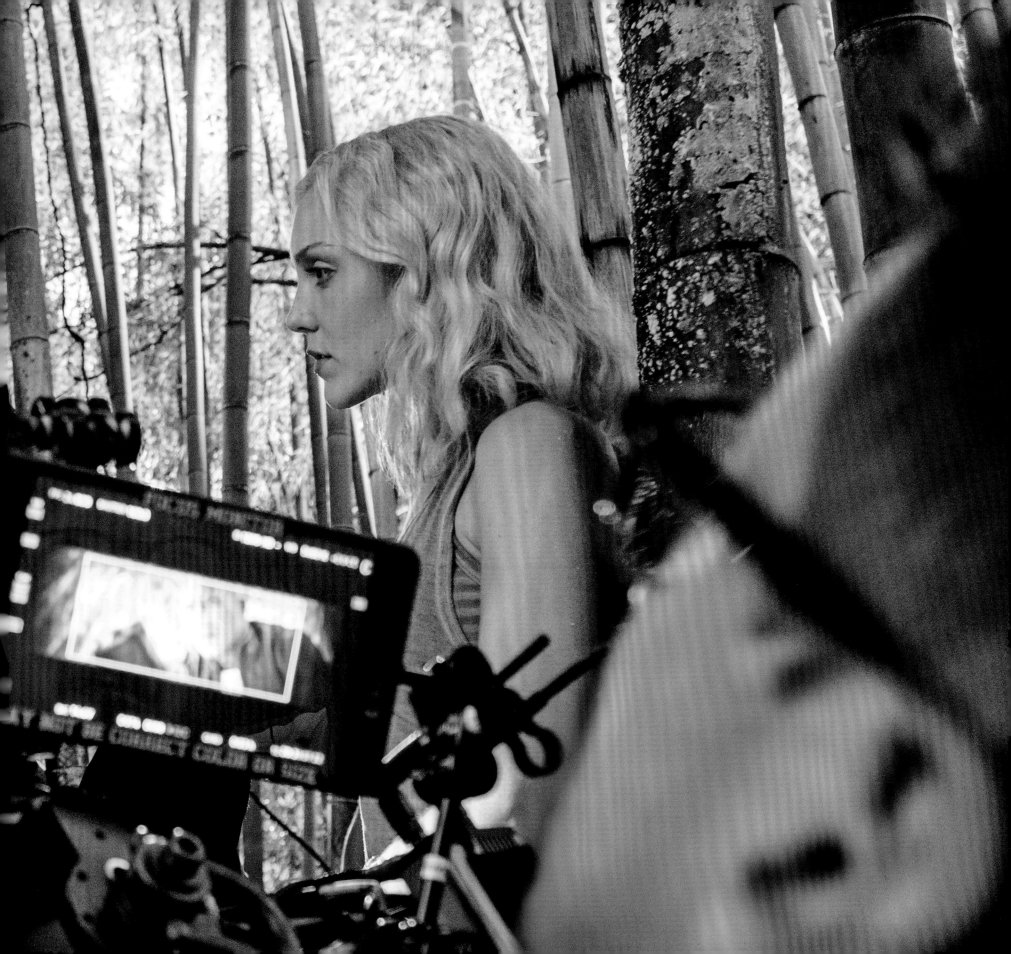

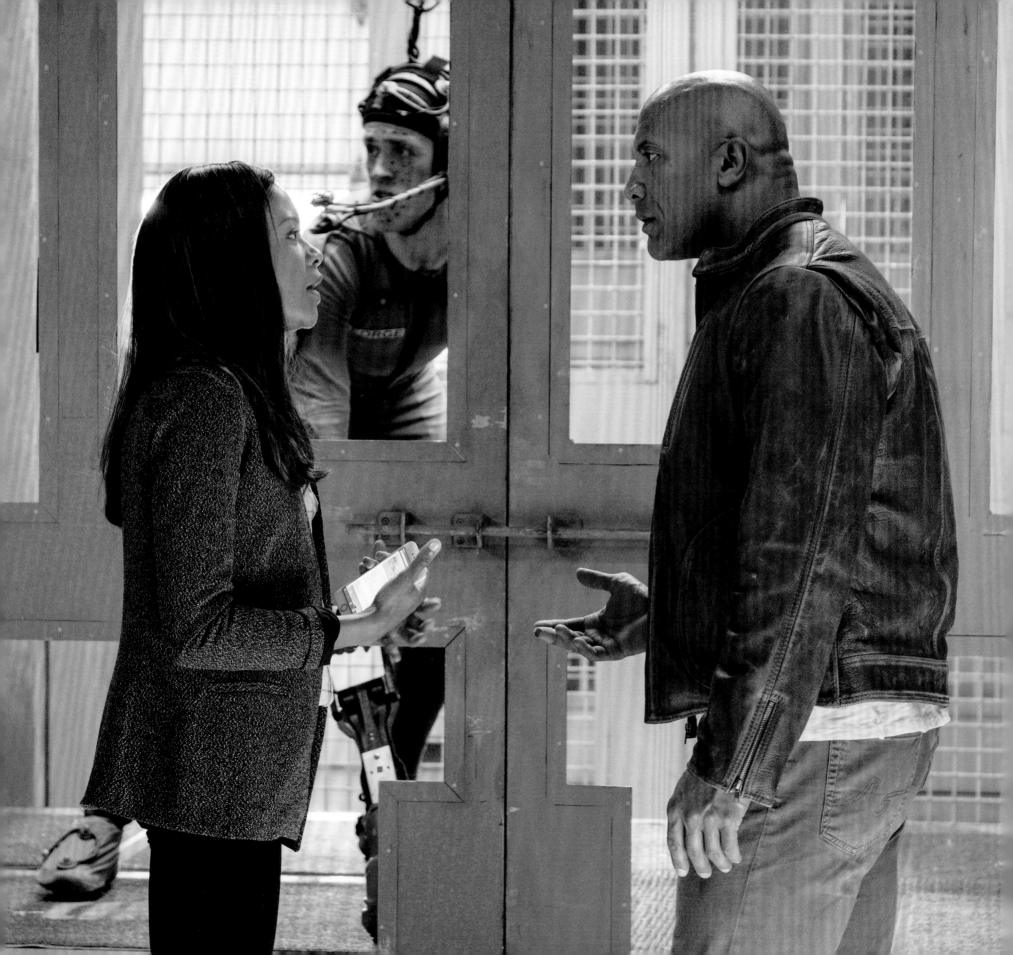

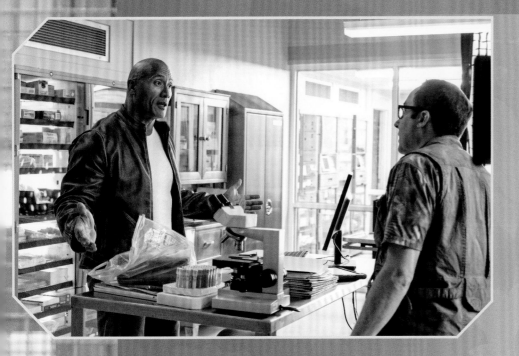

THE IDYLLIC SANCTUARY THAT GEORGE and Davis have enjoyed wasn't destined to last. When an unidentified metal canister falls into the gorilla enclosure, George picks it up and inhales an aerosol substance that is leaking from it. The next morning, Davis and his colleagues arrive at work to discover George has escaped his enclosure. "It is completely bizarre that George could get into the bear enclosure because those walls are 20 feet high," says P. J. Byrne, who plays Davis's fellow primatologist, Nelson. Byrne explains that the scientists are astonished to see the gorilla has grown noticeably bigger overnight. George is distraught and confused, and Davis tries in vain to communicate with him and calm him down. As producer John Rickard notes, "When George begins to mutate, he does not understand why he is becoming increasingly angry. However, he is still able to sign with his friend Davis in an attempt to ask what is happening to him."

According to Breanne Hill, who plays primatology student Amy, "George is going through great stress about the changes in his body that he doesn't know how to control." Hill, who also appeared in *San Andreas*, plays a member of the primate team that Davis oversees at the wildlife sanctuary. Along with her colleague Connor (played by Jack Quaid), Amy finds the broken canister that had fallen into the gorilla enclosure. "Amy and Connor sense that something in this canister might be what is making George go crazy," says Quaid.

PAGES 44–45: Davis Okoye (Dwayne Johnson) and primatology student Amy (Breanne Hill) discover the damaged CRISPR canister that fell into George's sanctuary habitat.

OPPOSITE: Dr. Kate Caldwell (Naomie Harris) talks with Davis Okoye (Johnson) about the condition of George the gorilla. Jason Liles, wearing a motion capture suit, portrays George in a containment cage behind them.

TOP: Davis (Johnson) discusses George's unexplained mutation with primatologist Nelson (P. J. Byrne).

BOTTOM: Inside the primatology laboratory, Davis (Johnson) checks on George's status.

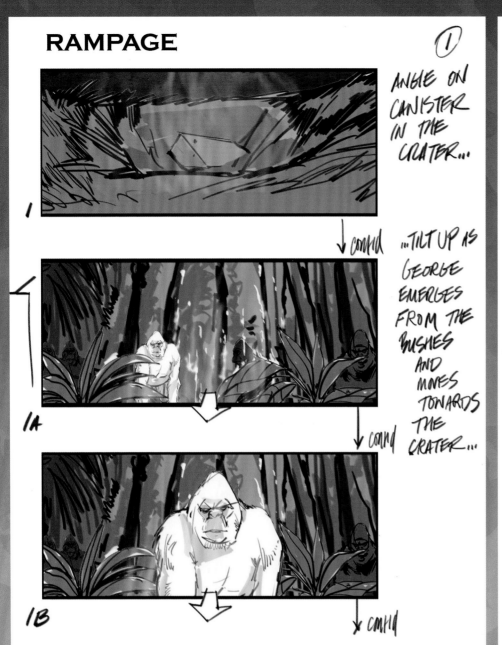

1 — ANGLE ON CANISTER IN THE CRATER...

1A — ...TILT UP AS GEORGE EMERGES FROM THE BUSHES AND MOVES TOWARDS THE CRATER...

1B — contd

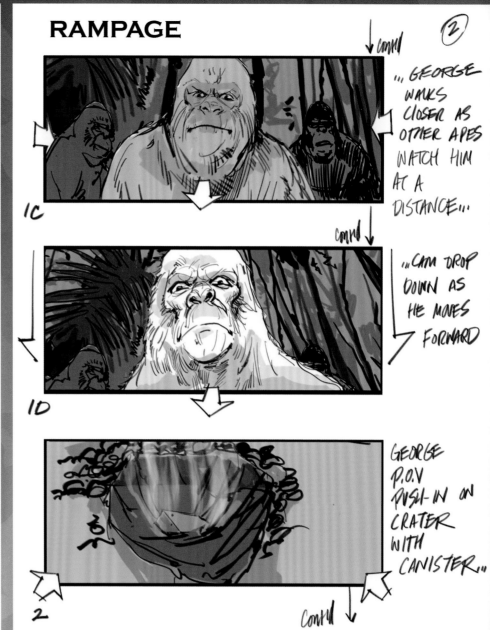

1C — contd — "...GEORGE WALKS CLOSER AS OTHER APES WATCH HIM AT A DISTANCE..."

1D — contd — "...CAM DROP DOWN AS HE MOVES FORWARD

2 — GEORGE P.O.V PUSH-IN ON CRATER WITH CANISTER..." — contd

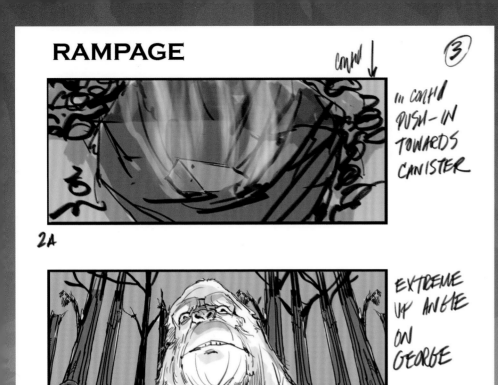

... CON'T'D PUSH-IN TOWARDS CANISTER

2A

EXTREME UP ANGLE ON GEORGE

3

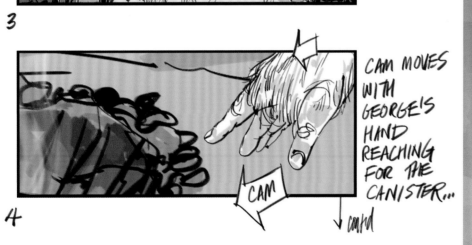

CAM MOVES WITH GEORGE'S HAND REACHING FOR THE CANISTER...

CAM

4

cont'd

cont'd

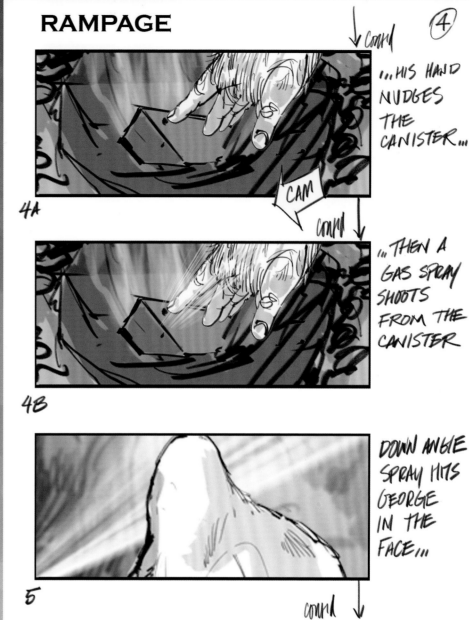

...HIS HAND NUDGES THE CANISTER...

4A

CAM

cont'd

..."THEN A GAS SPRAY SHOOTS FROM THE CANISTER

4B

DOWN ANGLE SPRAY HITS GEORGE IN THE FACE...

5

cont'd

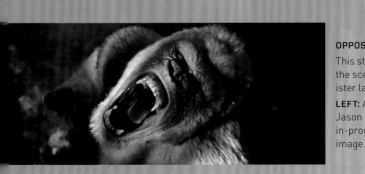

OPPOSITE TOP, ABOVE, AND RIGHT:
This storyboard sequence depicts the scene in which the CRISPR canister lands in George's enclosure.

LEFT: A series of images shows Jason Liles's initial performance, in-progress CGI shots, and the final image.

cont'd

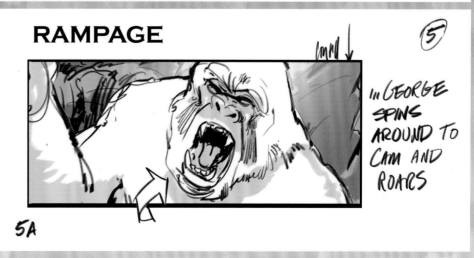

...GEORGE SPINS AROUND TO CAM AND ROARS

5A

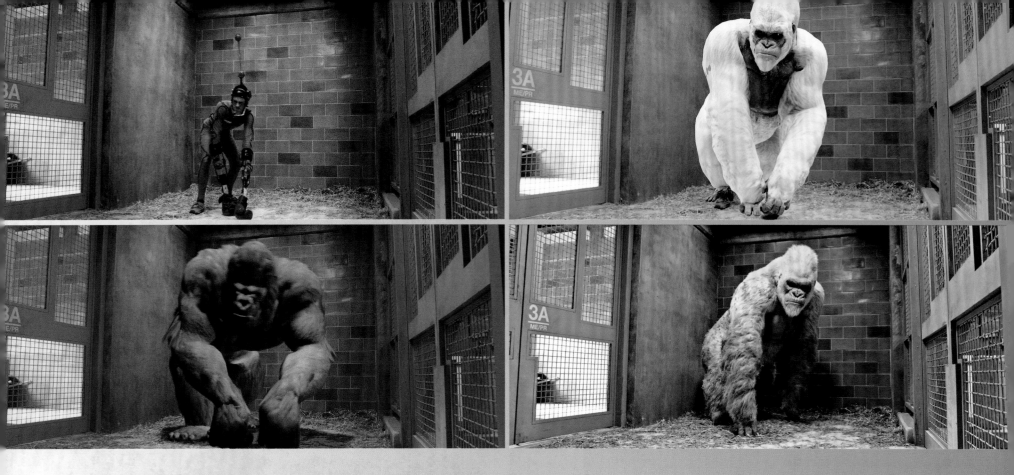

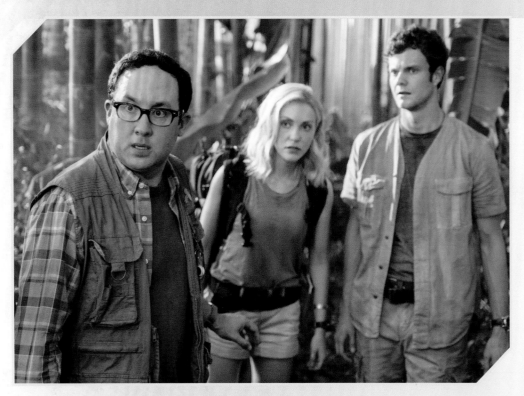

The producers of *Rampage* were careful to make sure that Davis's primatology team conveyed competence. They sought out people who had backgrounds in primate behavior to play the sanctuary's vet techs—including Joel Heller, Caitlin Johnson, and Brooke Allen. "We communicated how the lab should look, and the equipment that would be needed there," says Heller.

Caitlin Johnson, who works with chimpanzees in real life, adds, "They wanted to have people in the film who would know how to act around primates—especially imagining a situation where a 500-pound gorilla comes bursting through the walls." She goes on to praise Jason Liles's acting throughout the movie, noting, "His behavior and his body language and his vocalizations are really true to gorilla behavior. He's doing an amazing job."

TOP: This sequence of images shows the progression of George's animation. The orange markers Liles wears during his performance indicate where George's head will be located.

LEFT AND OPPOSITE: After discovering the mangled canister in George's enclosure, Davis, Nelson, Amy, and Connor must investigate what has happened to George.

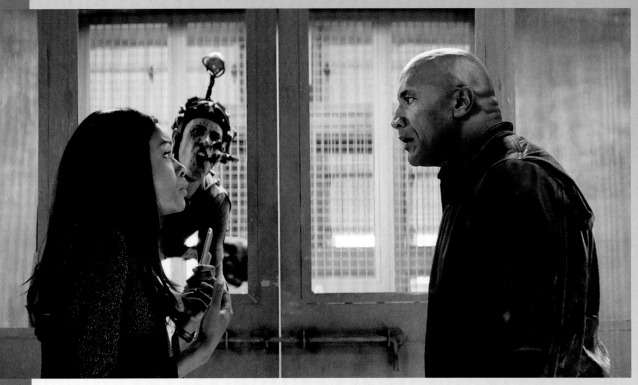

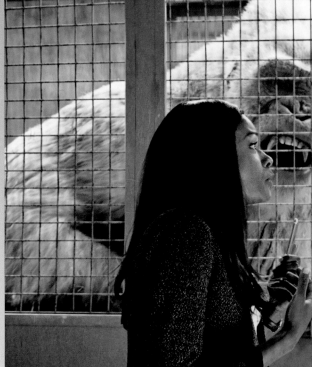

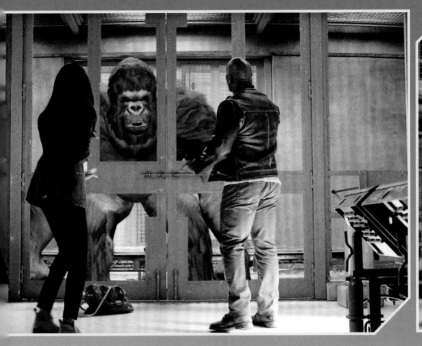

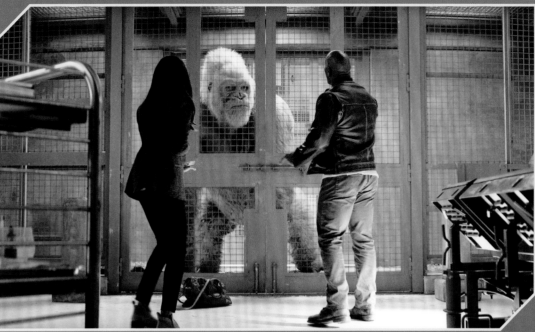

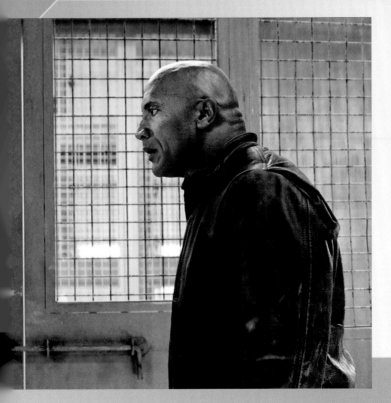

The filmmakers met with the CEO and chief scientific officer of the Dian Fossey Gorilla Fund, Tara Stoinski, during their research. Co-producer Wendy Jacobson says, "In all of our films, research, interfacing with experts, and authenticity play a vital role. While it's important our stories are entertaining, we always first make sure they're rooted in real-world science."

George simply cannot be contained. As actor P. J. Byrne remarks, "The pathogen that has been released from the canister into George is not only making him incredibly large; he's also got an insane appetite to fill his growing body." After escaping the San Diego Wildlife Sanctuary, he's a monster on the loose.

Dr. Caldwell (Naomie Harris) is the first character to guess what has happened to George. She had been a researcher at the Chicago-based biotech company Energyne, working on an advanced DNA manipulation technique called CRISPR to create medical breakthroughs. Harris says that when she started researching CRISPR for the role, she realized the technology's possibilities. "This technology has the potential to literally change the world," Harris says. "I thought it was really important to be a part of a movie that helps to educate people about that. And I love the fact that my character was so clued up on that and helps to educate Davis as well."

THESE PAGES: A sequence of images from storyboard to performance to final effects shows how the animated version of George was added into the scene.

TOP: Davis (Johnson) and Nelson (Byrne) discover a bear that has died under mysterious circumstances in the zoo.

LEFT: Jeffrey Dean Morgan as Federal Agent Russell.

ABOVE: Federal Agent Russell talks to Colonel Blake.

OPPOSITE: Davis, Dr. Kate Caldwell, and Nelson look up at the large and mutated George.

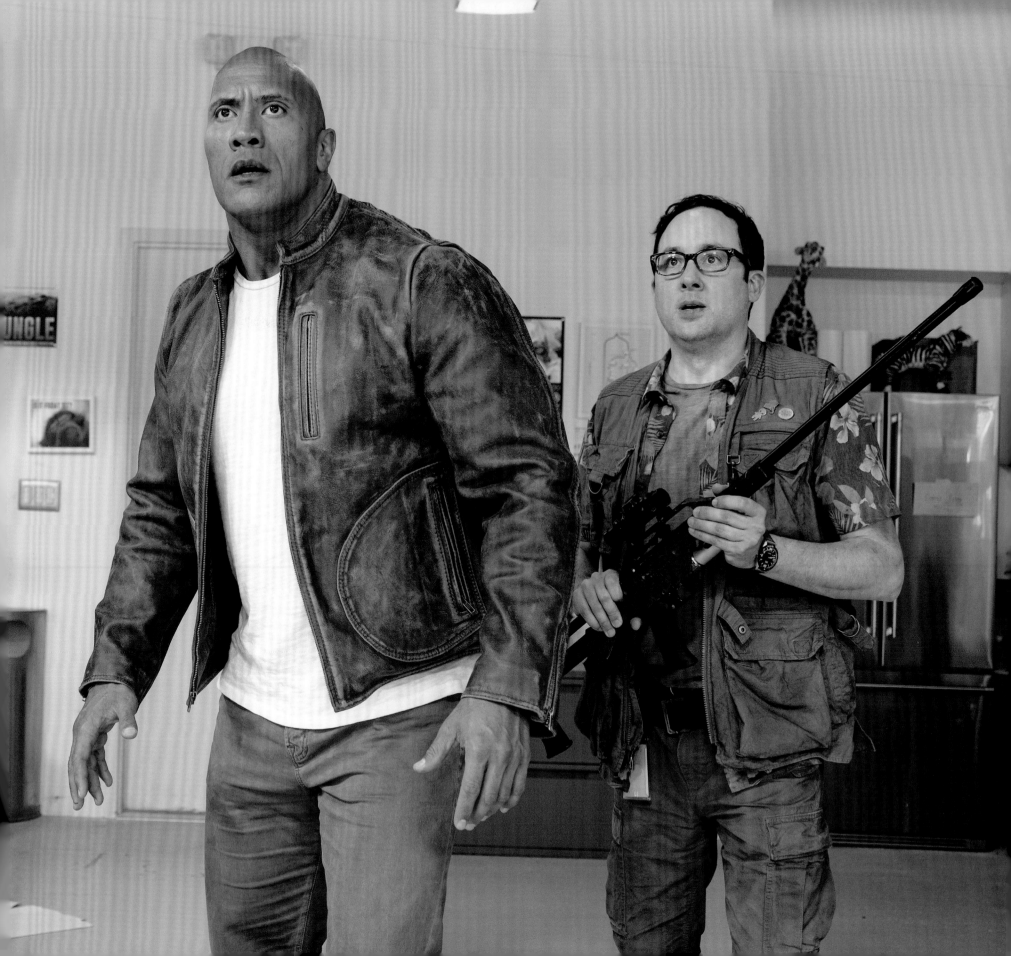

THE REVOLUTION CALLED CRISPR

At first glance, CRISPR may *sound* like the stuff of science fiction, but this gene-editing technology is very much a fact. CRISPR is an acronym for "Clustered Regularly Interspaced Short Palindromic Repeats," which is a technology that scientists are using to study and treat diseases.

Dr. James Dahlman of the Georgia Institute of Technology, who consulted on *Rampage*, explains, "The genetic code is what distinguishes one living thing from another. CRISPR technology allows us to edit that code very specifically. We can knock out or turn off a gene very easily, which allows us to study how a particular gene might affect, prevent, or cause a disease."

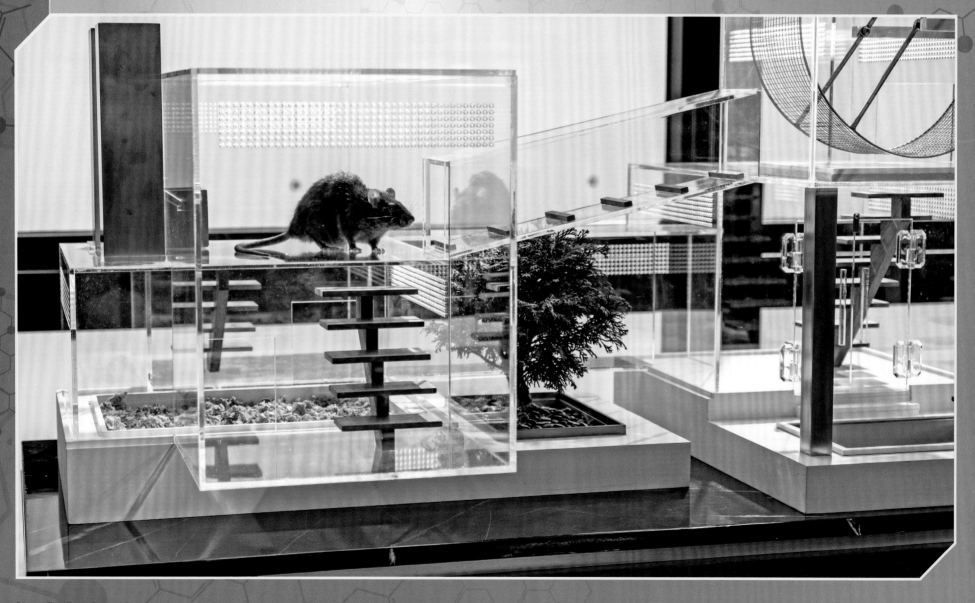

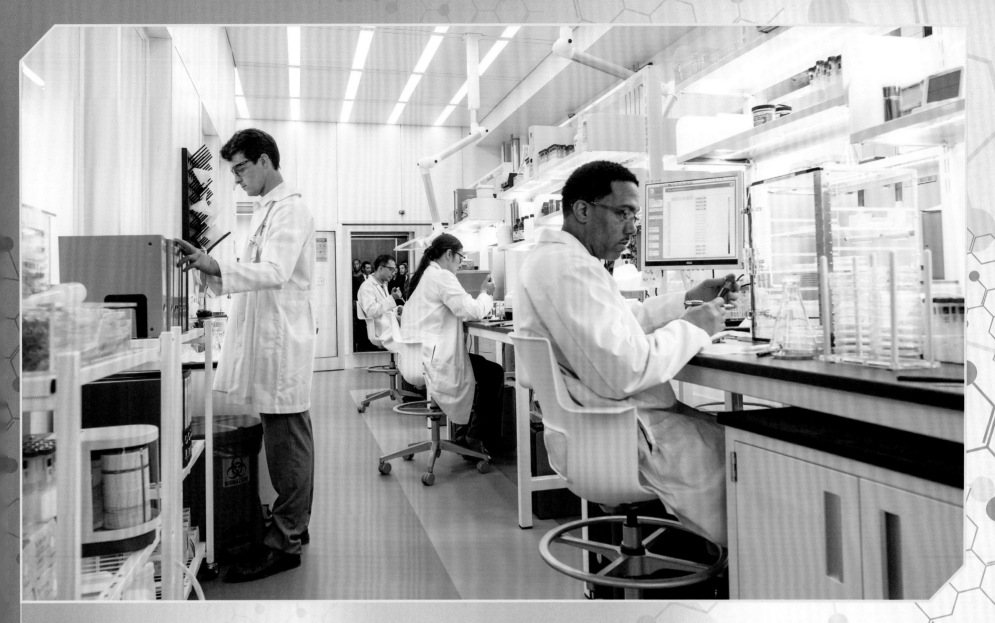

The promise of CRISPR is huge. Some scientists hope it will provide a way to bolster the populations of threatened species. Experts at Harvard Medical School have been using CRISPR technology to edit the DNA of modern elephants to create a creature with the traits of a woolly mammoth in an attempt to help combat global warming and climate change. Researchers around the world have actively embraced CRISPR, hoping to create everything from medical treatments, to hardier plants, to disease-resistant animals, and beyond. As the technique is inexpensive, numerous biotech companies across the world are utilizing it.

But wide use also makes the prospect of abuse enormous. Like any technique with the power for good, there exists a potential dark side. In *Rampage*, Energyne is manipulating the genes of animals to create hybrid creatures with unprecedented powers. This frightening prospect firmly roots the story of *Rampage* in scientific reality.

OPPOSITE TOP AND ABOVE: Variations of Energyne and Wyden Technology logos.

OPPOSITE BOTTOM: Energyne first tested their CRISPR technology on rats.

TOP: An Energyne lab.

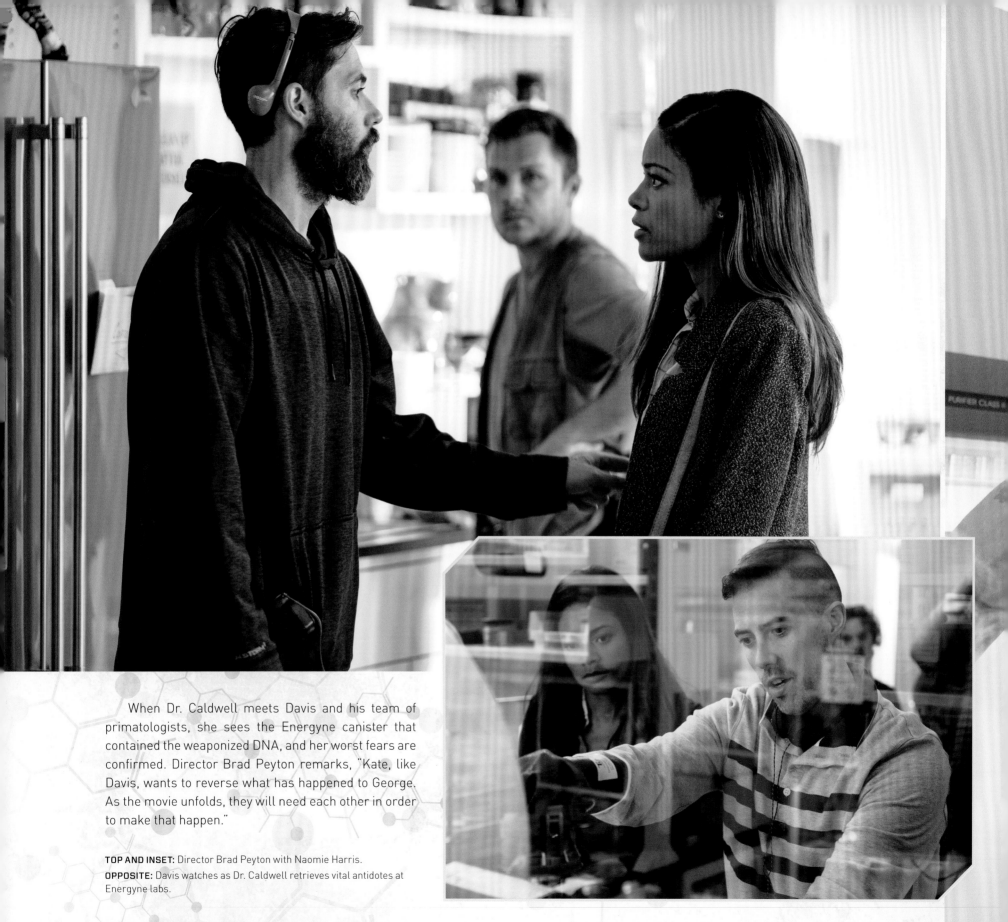

When Dr. Caldwell meets Davis and his team of primatologists, she sees the Energyne canister that contained the weaponized DNA, and her worst fears are confirmed. Director Brad Peyton remarks, "Kate, like Davis, wants to reverse what has happened to George. As the movie unfolds, they will need each other in order to make that happen."

TOP AND INSET: Director Brad Peyton with Naomie Harris.
OPPOSITE: Davis watches as Dr. Caldwell retrieves vital antidotes at Energyne labs.

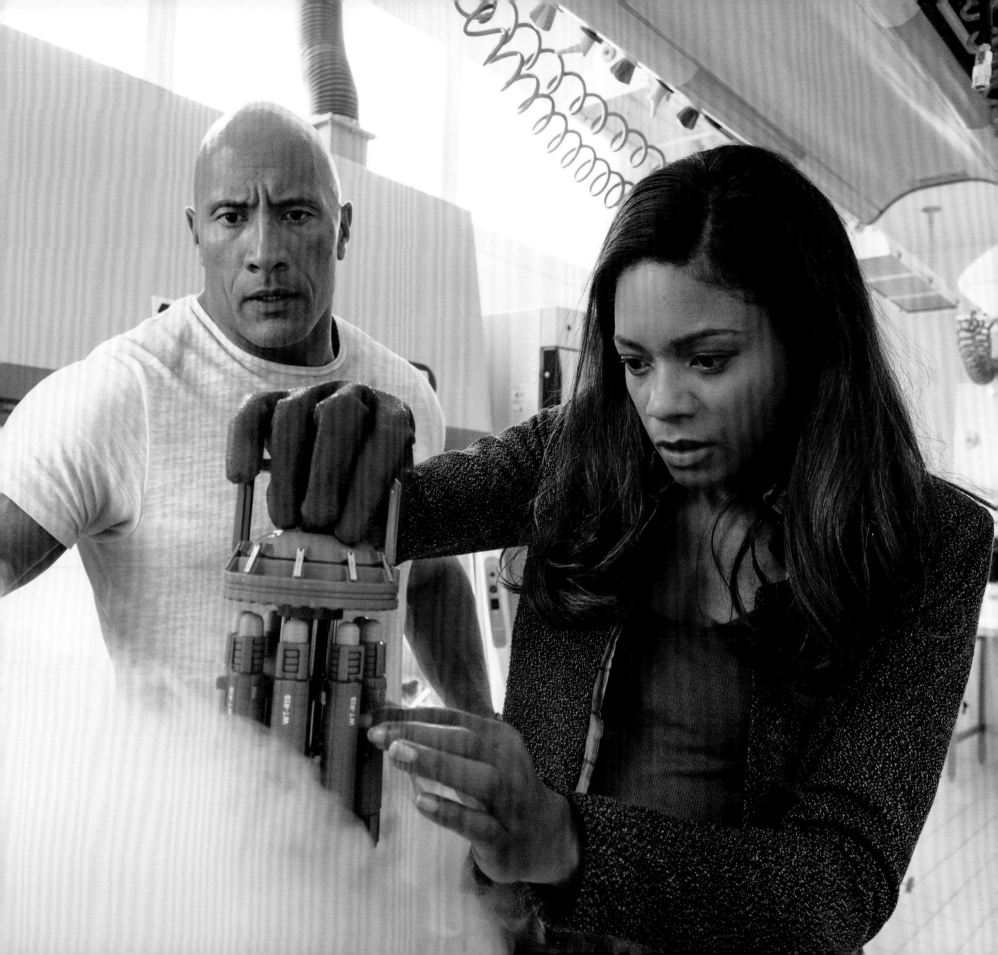

Government authorities arrive to take charge of the situation in San Diego, led by the no-nonsense Agent Russell, played by Jeffrey Dean Morgan of *Walking Dead* fame. As Morgan describes him, "Agent Russell is not FBI or DEA or DOJ. He's OGA—Other Government Agency. He's the fixer. He's a good Southern gentleman with some manners, but he has a wicked sense of humor."

Morgan, who has worked with producer Beau Flynn three times in the past, was a perfect foil for Dwayne Johnson. As Johnson puts it, "It was important to find someone that I could really go head-to-head with. You can feel the sparks fly when we are on-screen together. It's the kind of sizzle where the audience can't wait to see these guys clash on this journey."

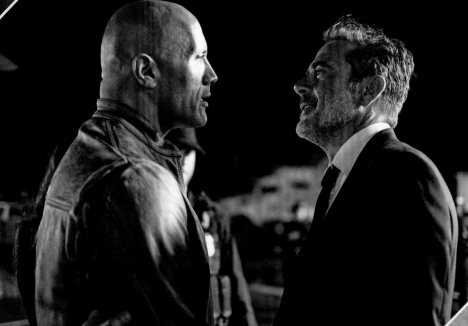

TOP AND INSET: Agent Russell faces off against Davis with swagger and a cutting sense of humor.

OPPOSITE: The reinforced cage Agent Russell's team uses to transport the tranquilized George.

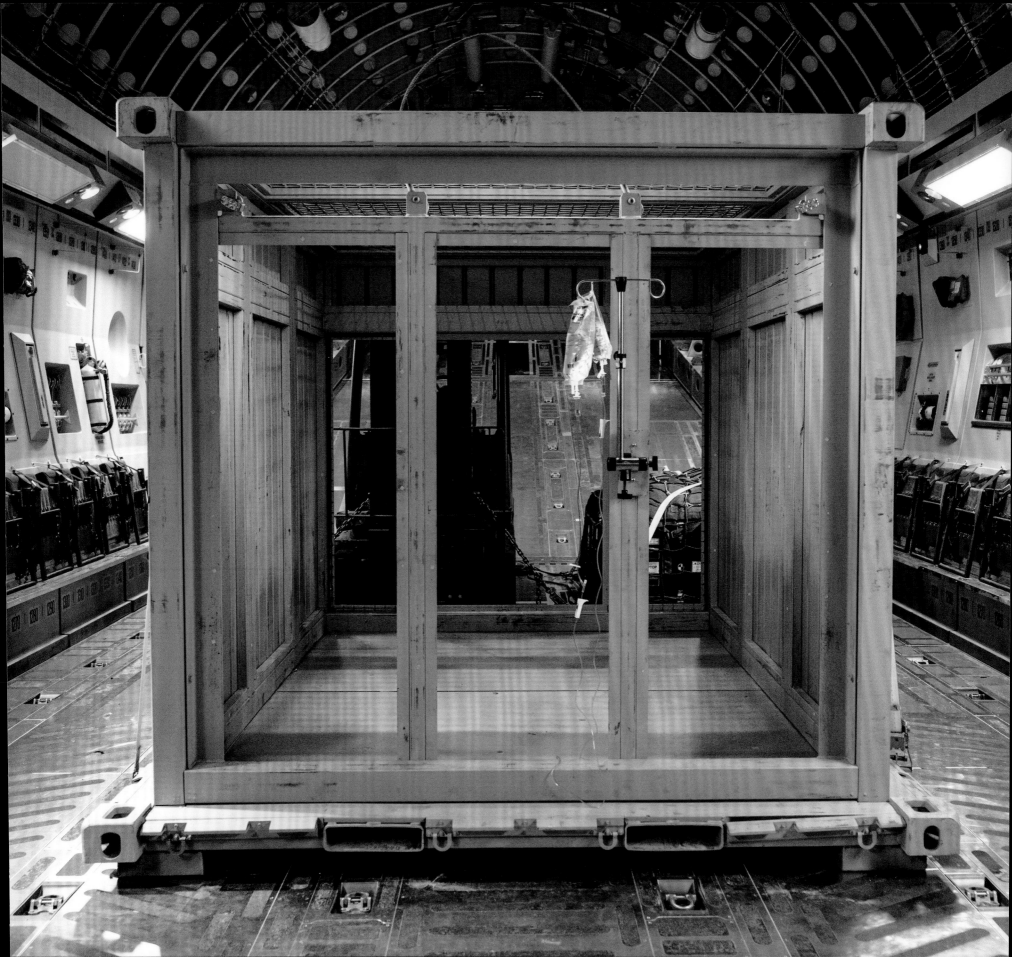

THE WYDENS

Energyne is run by sister and brother Claire and Brett Wyden, played by Malin Akerman and Jake Lacy. Akerman, whose many credits include the movie *Watchmen* and the television series *Billions*, states, "I was fascinated and curious about playing a villain. I've never done that before. Claire is not a crazy cartoon villain. She is smart and manipulative, and a wonderfully complex character to play. Energyne is a billion-dollar company, so she's got a bit of cash."

Akerman recalls that in her first session with fellow Canadian Brad Peyton, he urged her not to be too nice: "Claire is not a smiley person, so we've got to wash that Canadian smile off your face."

Producer John Rickard adds, "Claire is the calculating one, she's two steps ahead at all times. Brett wears his emotions on his sleeve, kind of a hothead. He isn't really on the same level as Claire throughout the movie."

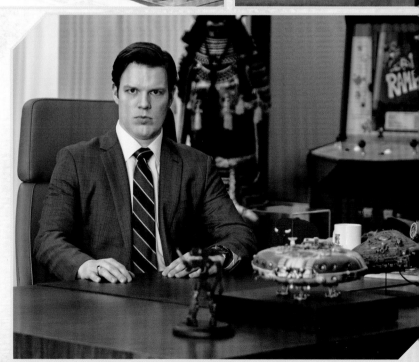

Actor Jake Lacy describes Claire's character as "someone who has seemingly no use for friends or family and is not just the brains of the operation, but also the visionary. She sees where this company can go, where this product can go."

While Claire is the brains of Energyne, her brother Brett is her opposite. "Brett isn't particularly helpful running the business," remarks Lacy, who is known for his role in *The Office*. "He's a fan of the lifestyle that the company affords him, and he's fun to party with. But as far as the science behind Energyne and its deal making, he doesn't have his hands on the controls. Brett has a tendency to be reactionary, and deal with the crisis at hand without being able to see the bigger picture. Claire, I think, sees almost exclusively the bigger picture to her own detriment."

"Jake really found a way to play off Malin," Garcia says. "She was so icy and so straight that Jake really found an opportunity to give a little bit of color, a little bit of fun."

Both Claire and Brett Wyden operate out of the penthouse at the top of the Willis Tower. "Being billionaires, you can't imagine that they would have anything less than the whole penthouse for themselves," Akerman says. "It's very clean and modern and high-end. It's funny to walk in and see Claire's desk versus Brett's desk. His is always a mess and just full of food wrappers and toys, and Claire is all business. They did a really good job of juxtaposing them and creating their characters through the sets."

OPPOSITE TOP: The Wyden siblings run Energyne, a billion-dollar biotech company.
OPPOSITE BOTTOM: Jake Lacy as Brett Wyden with a *Rampage* video game arcade cabinet behind him.
TOP: The Wyden siblings share a high-tech penthouse office atop Willis Tower.
BOTTOM: Malin Akerman as Claire Wyden.

Jake Lacy praises the details the set designers included in the siblings' penthouse, noting several small touches that can be seen in sweeping shots. "Claire always has spreadsheets on her computer," Lacy says, "while Brett has a different auction site for luxury items, and every time there's a Lamborghini, a Rolex, there's always a new toy that he's in the midst of attempting to purchase. Behind his desk there are arcade games, a basketball hoop, and different sports memorabilia. There's also a handful of Brett Wyden humanitarian awards—things that they included but the camera's never going to see—but it's such a lovely, for me, nod to the ability to purchase good favor in the public's eye without necessarily deserving it at times."

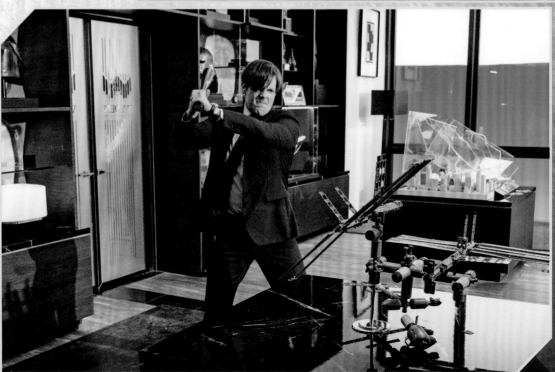

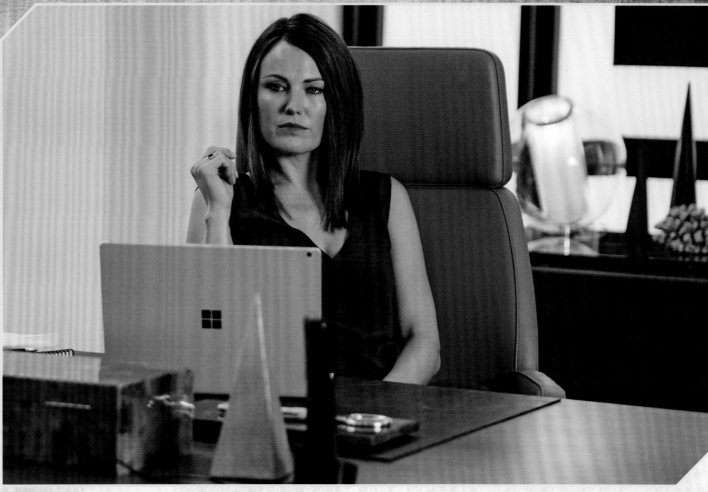

TOP LEFT: Brad Peyton films Malin Akerman as Claire Wyden.

TOP RIGHT: Despite the space station's destruction, Claire does not panic.

OPPOSITE BOTTOM: In contrast to Claire, Brett is the reactionary sibling, seen here smashing a model of the space station after the pair learns of its destruction.

PAGES 66–67: A wide view of the penthouse set's back wall. *Inset:* The intricate space station model.

The Wyden siblings are pouring their considerable resources into a research program known as Project Rampage. "Project Rampage is everything Claire lives for and she puts everything into it. The success of this project is life itself [to her]," says Akerman.

Weaponizing DNA is highly illegal, so in order to secure the project's success, Energyne's laboratory is established in an unconventional off-site location: an Earth-orbiting lab far beyond the oversight of authorities. "The space station contains all of the work that we've done because it's not legal, literally, on Earth anywhere so we've taken to space to conduct the research," Lacy explains. However, when news of an enormous escaped gorilla gets out, there can only be one explanation: The space station has experienced a catastrophic failure. Lacy notes that his character, Brett, becomes extremely upset when he discovers what has happened and focuses on the immediate losses the company has experienced. "The research is lost, the space lab cost us hundreds of millions of dollars, it's completely destroyed, we have the blood on our hands of the entire crew who was up there. Then Claire sees this as an opportunity to prove that the pathogen is successful and the product they've tried to create is valuable."

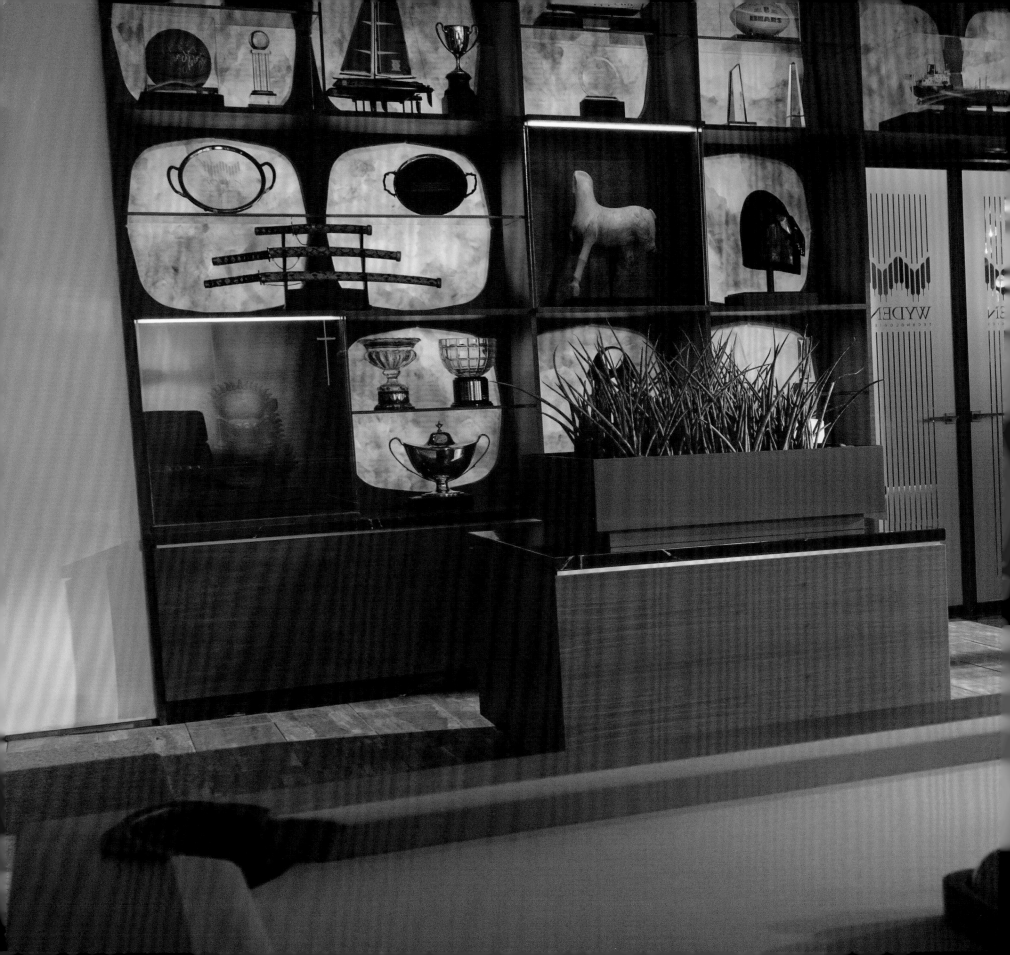

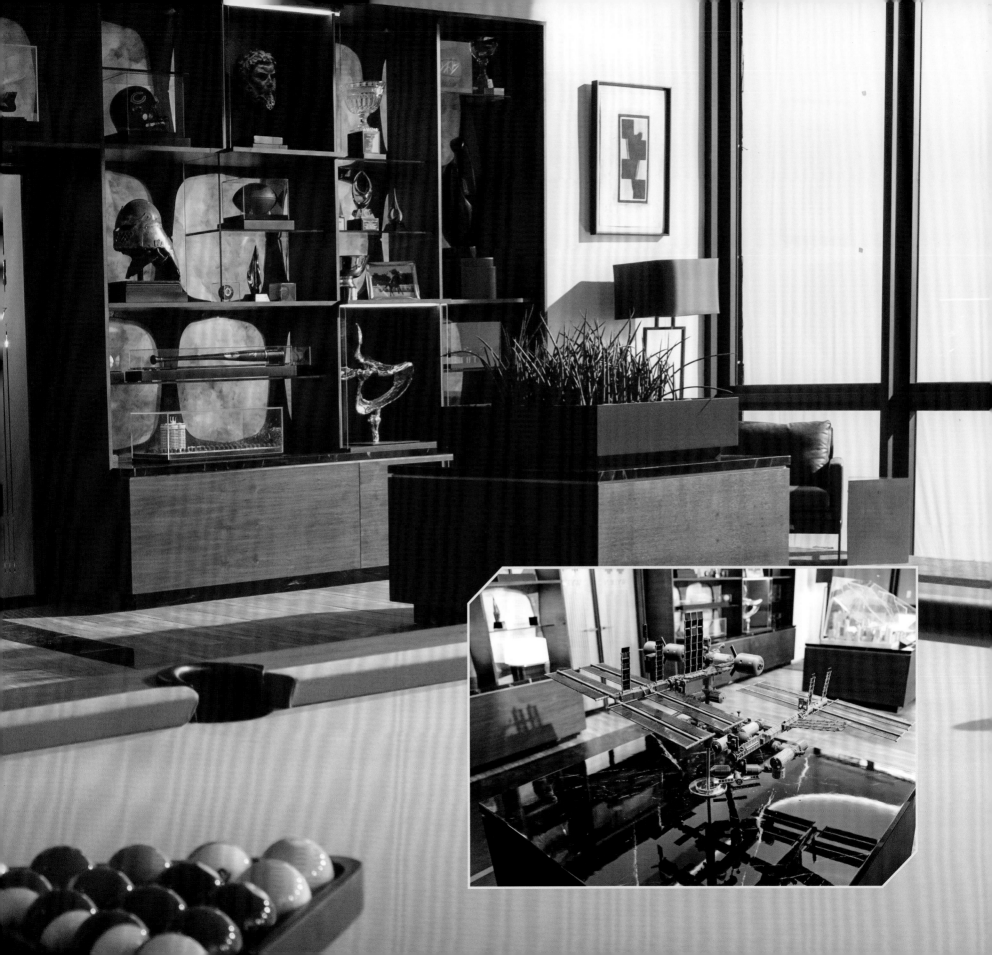

CHAPTER 04

THE MUTANTS
ARE UNLEASHED

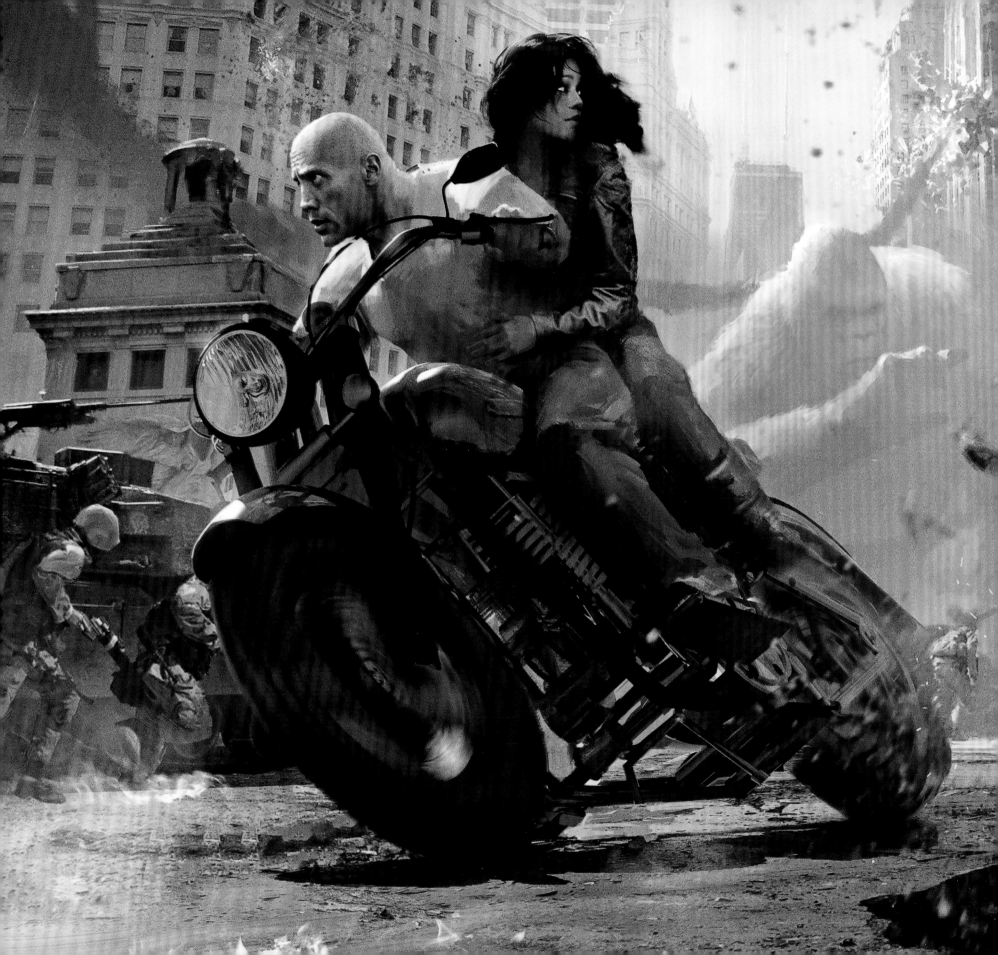

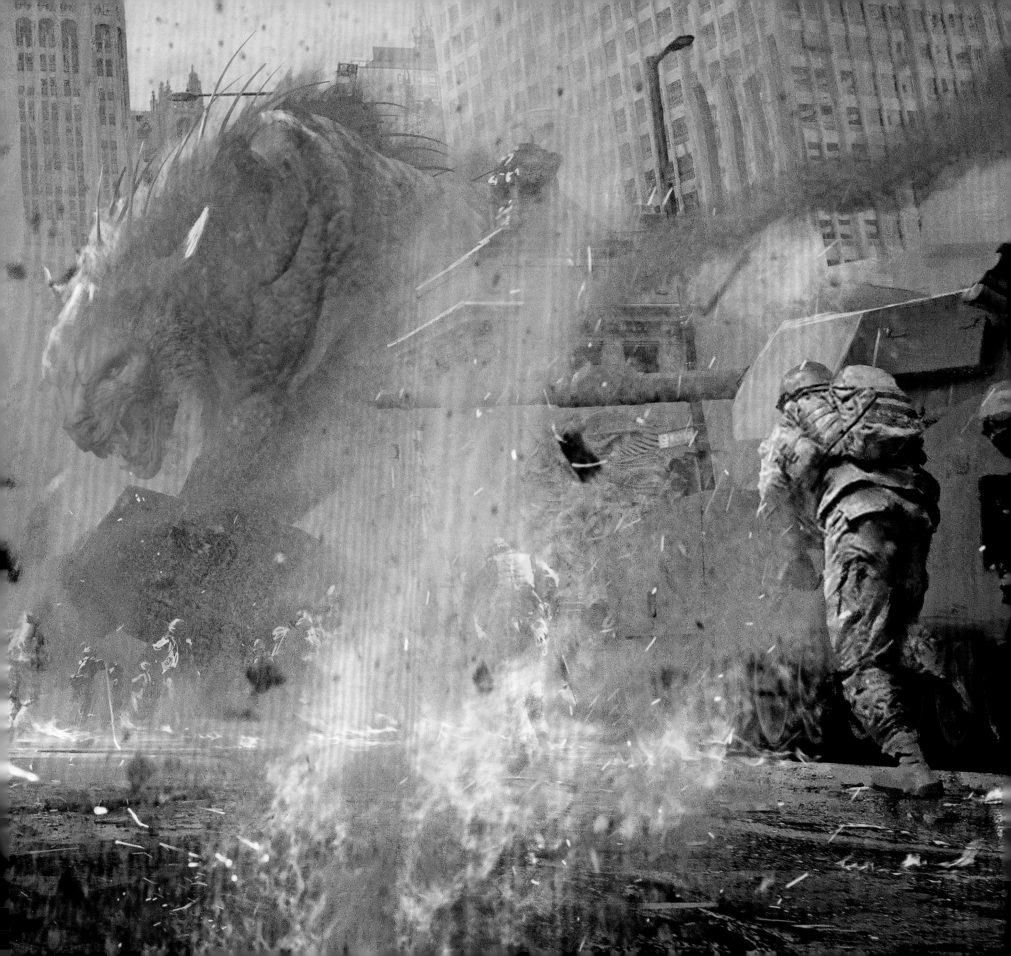

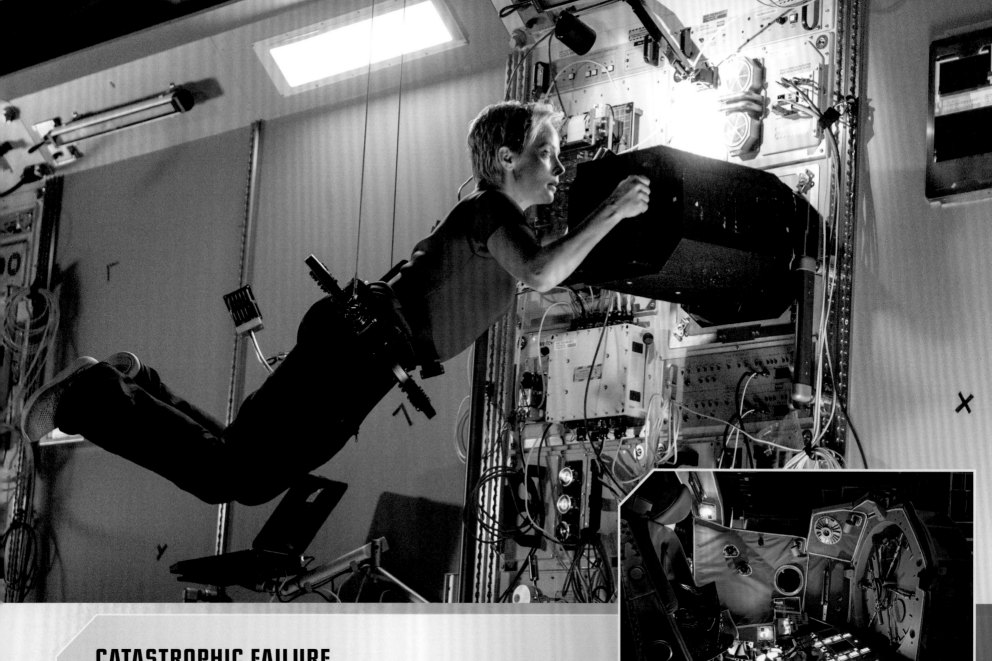

CATASTROPHIC FAILURE

Dr. Kate Caldwell's hunch about the leaking CRISPR canister proves to be true. Energyne's illegal space lab has indeed suffered a catastrophic failure. Dr. Atkins, played by Marley Shelton, is on board when an experiment goes horribly wrong. Shelton explains, "My boss, Claire Wyden, has ordered me—if I want to return to Earth—to go back and retrieve these priceless capsules of the pathogen so that she can have her research."

"With those marching orders, I have to float weightlessly through explosions and debris," says Shelton. "Brad Peyton came up with what was essentially a chase scene in zero gravity. His camera stays on me for a long period of time, floating through different corridors and explosions. It creates a feeling of reality because you never cut. He really pushed the limits."

PAGES 68–69: Detail of the mutated wolf's eye.

PAGES 70–71: Concept art of Davis and Kate riding away from the destruction caused by George and the wolf in downtown Chicago.

TOP: CRISPR scientist Dr. Atkins (played by Marley Shelton) works aboard Energyne's space-based laboratory.

INSET: Detail of Energyne's space station interior.

OPPOSITE: To create the illusion of weightlessness, Marley Shelton was held up by a system of pulleys and wires.

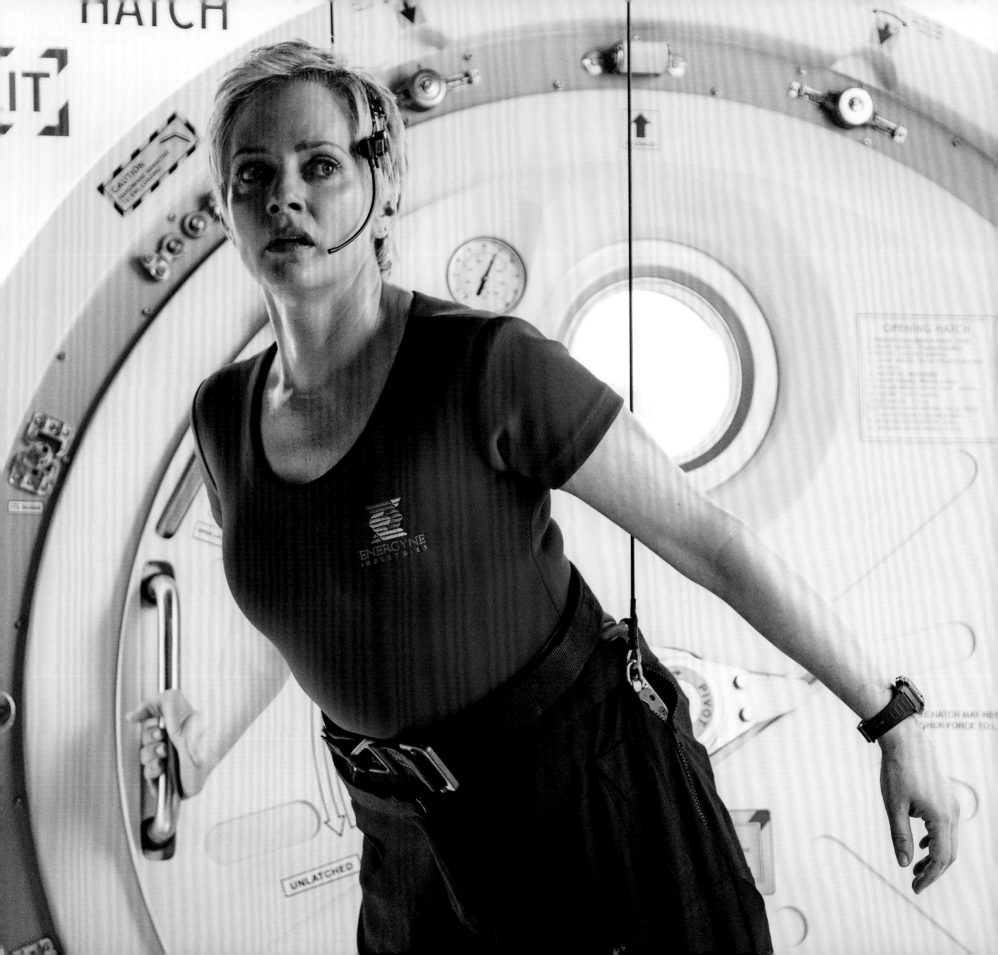

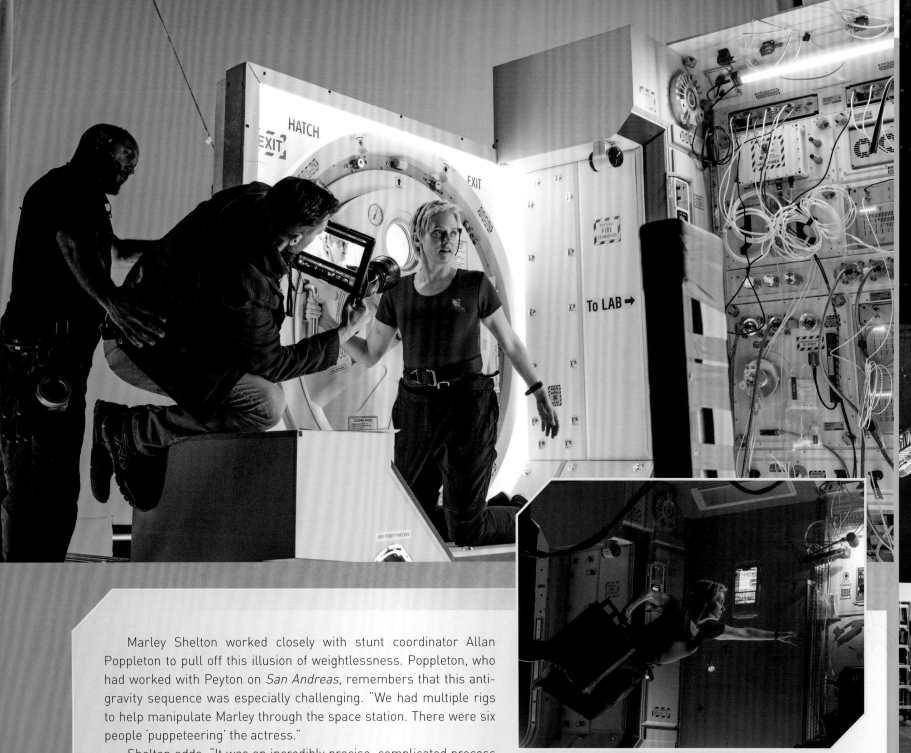

Marley Shelton worked closely with stunt coordinator Allan Poppleton to pull off this illusion of weightlessness. Poppleton, who had worked with Peyton on *San Andreas*, remembers that this anti-gravity sequence was especially challenging. "We had multiple rigs to help manipulate Marley through the space station. There were six people 'puppeteering' the actress."

Shelton adds, "It was an incredibly precise, complicated process involving pulleys that make sort of a marionette on tracks and wires, creating this illusion of weightlessness. It required a lot of body control. As an actor, it's not every day that you get to challenge yourself both emotionally *and* physically."

TOP: Director Brad Peyton frames a close-up shot of CRISPR scientist Dr. Atkins.

INSET: Marley Shelton glides along a track through the space station during a zero gravity chase scene.

OPPOSITE: The set's length allows the camera to stay with the actor for a long period of time during filming.

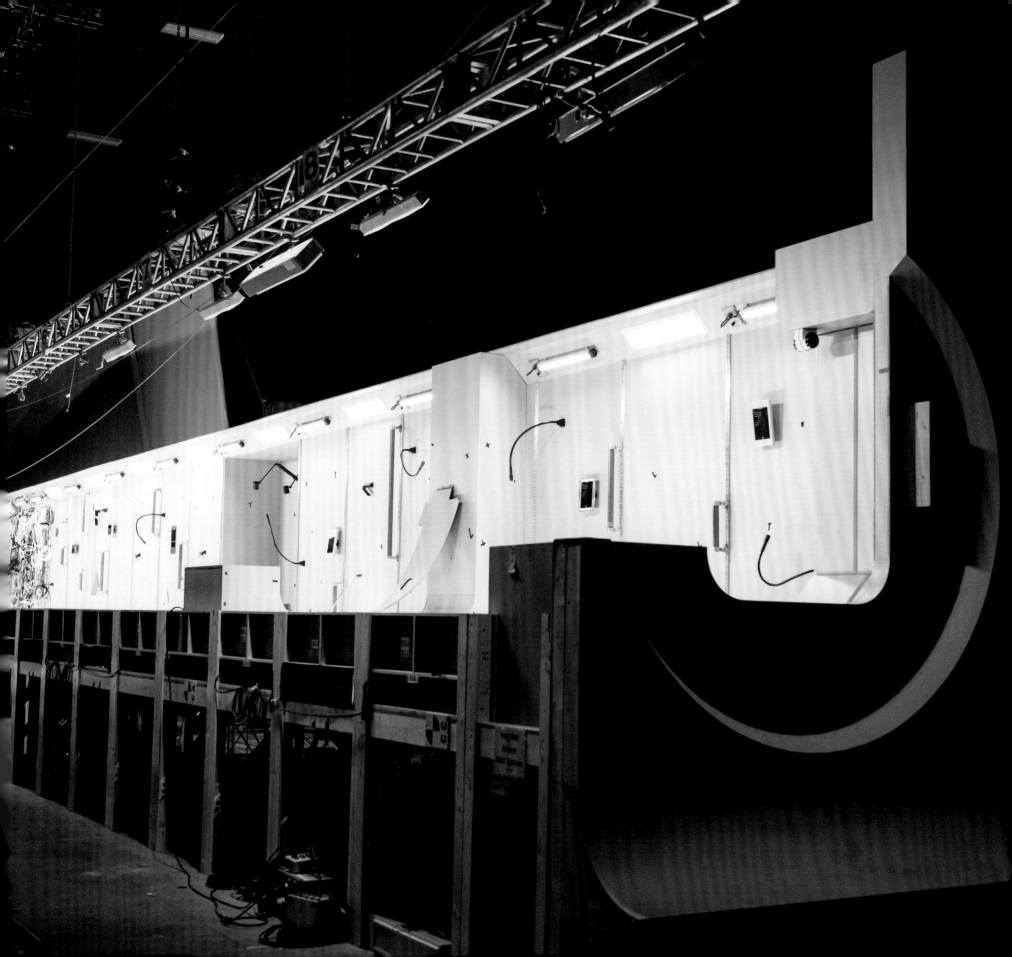

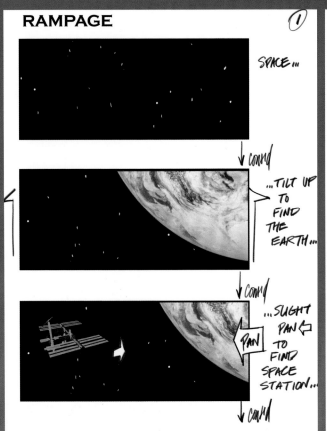

SPACE...

...TILT UP TO FIND THE EARTH...

↑ cont'd

...SLIGHT PAN TO FIND SPACE STATION...

PAN ←

↓ cont'd

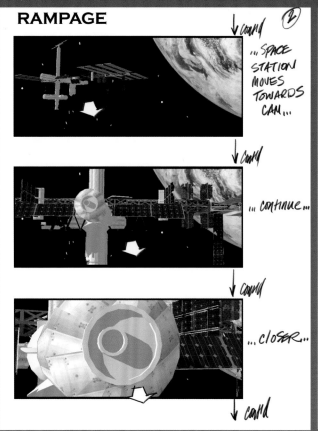

..."SPACE STATION MOVES TOWARDS CAM...

↓ cont'd

..."continue...

↓ cont'd

...CLOSER...

↓ cont'd

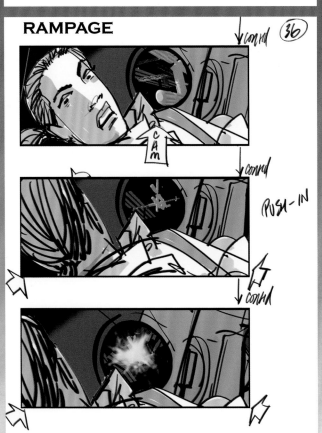

PUSH-IN

↓ cont'd

↓ cont'd

CUT:

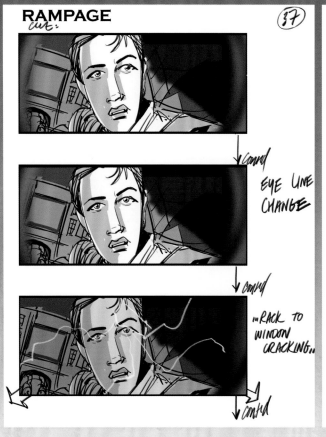

↓ cont'd

EYE LINE CHANGE

↓ cont'd

..."RACK TO WINDOW CRACKING...

↓ cont'd

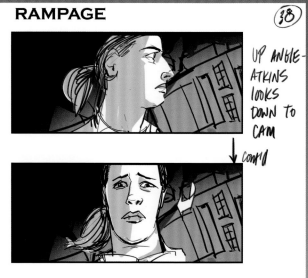

UP ANGLE- ATKINS looks DOWN TO CAM

↓ cont'd

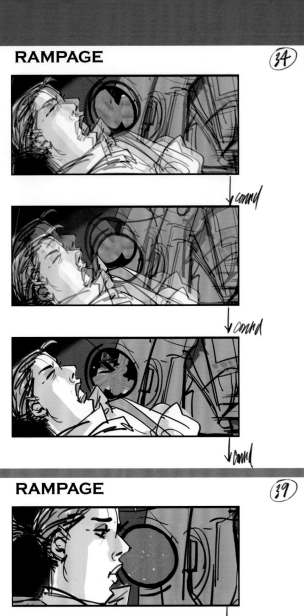

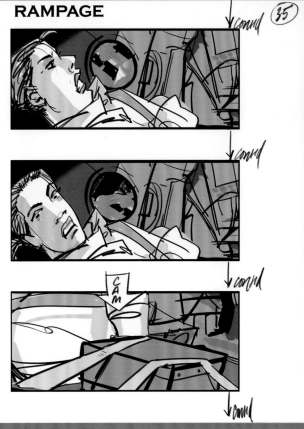

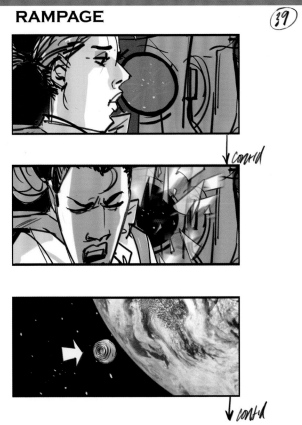

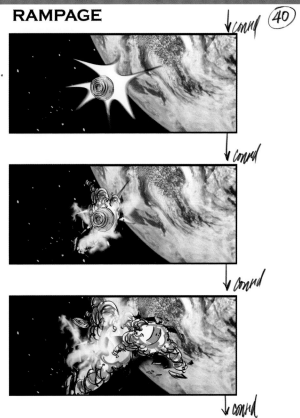

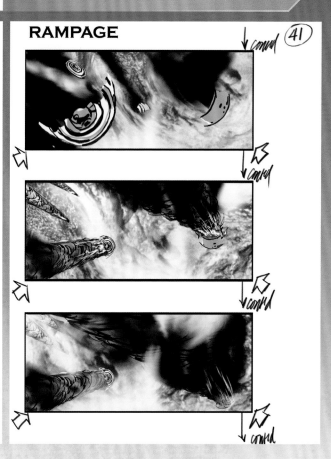

WOLF HUNT

The explosion prompts Claire Wyden to dispatch a team of mercenaries in helicopters to retrieve the Energyne canister that fell into the Wyoming wilderness. The group is led by a former Navy SEAL named Burke (played by Joe Manganiello) and also includes Garrick, played by mixed martial arts champion Urijah Faber. Manganiello, who's known for projects such as *True Blood*, says he arrived on set expecting the physical challenges. "We flew around for days in real helicopters, banking hard and staring at the ground a few feet below us.

"What was really interesting was the previs that Brad Peyton showed us about the action in this sequence," says Manganiello of the movie's previsualization. "Brad had an iPad with what looked like a video game from the '90s. We could actually see our characters, and understand the timing that we'd have per scene and per shot."

"One of the best things about working with Brad Peyton is his comfort level with visual effects," producer Hiram Garcia adds. "He had the movie clearly mapped out and previs'd which allowed us to be precise and efficient with our shooting schedule. It also afforded Brad the ability to immerse his actors fully into the world we were creating by showing them the scene they were stepping into."

Peyton and *Rampage* visual effects supervisor Colin Strause worked with previs company The Third Floor to create these animated draft versions of the film's action scenes. "We prepped for a year and a half," notes producer Beau Flynn. "I think that's the minimum it takes to pull off a movie like this."

The private army that Manganiello's character commands is modeled on the kind of private military-type outfits usually associated with war zones. "Brad had a strong opinion of how he wanted them to look," says *Rampage* property master Mychael Bates. "Their weaponry was vast, because they're funded by billionaires. They have the best of the best and the baddest of the bad. Really state-of-the-art machine guns, Black Hawk choppers, and .50 cals, just like what our armed forces have."

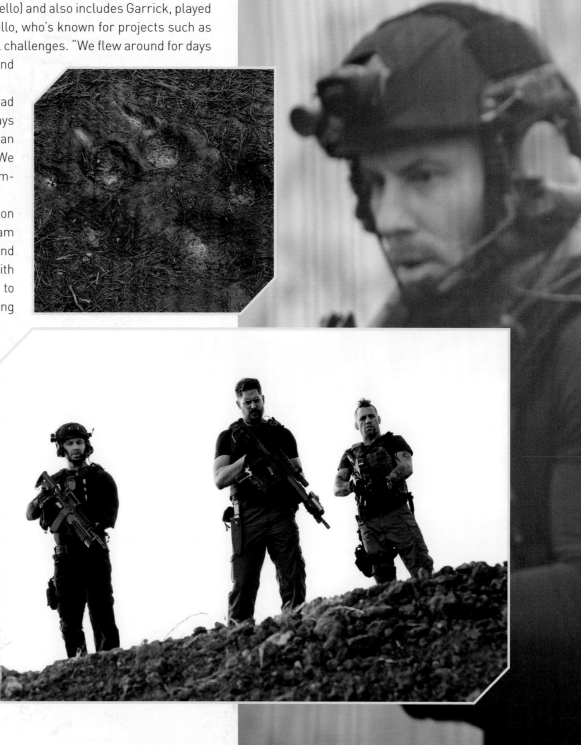

OPPOSITE: Soldiers from Energyne's Black Hill Private Security team hunt for the mutated wolf. The group is led by Burke (Joe Manganiello), seen here with Zammit (Matt Gerald).

TOP: Close-up of a clawed paw print.

BOTTOM: The mercenaries wield high-powered weapons designed to kill the wolf.

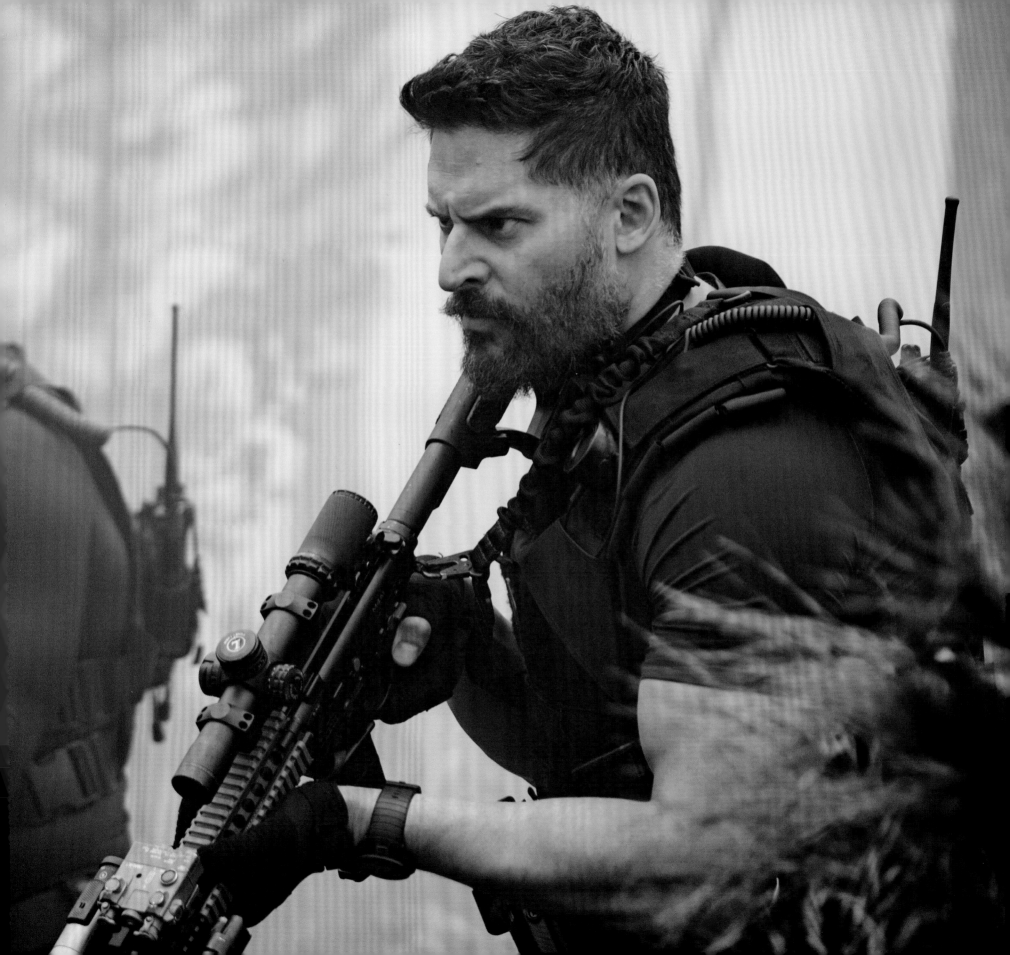

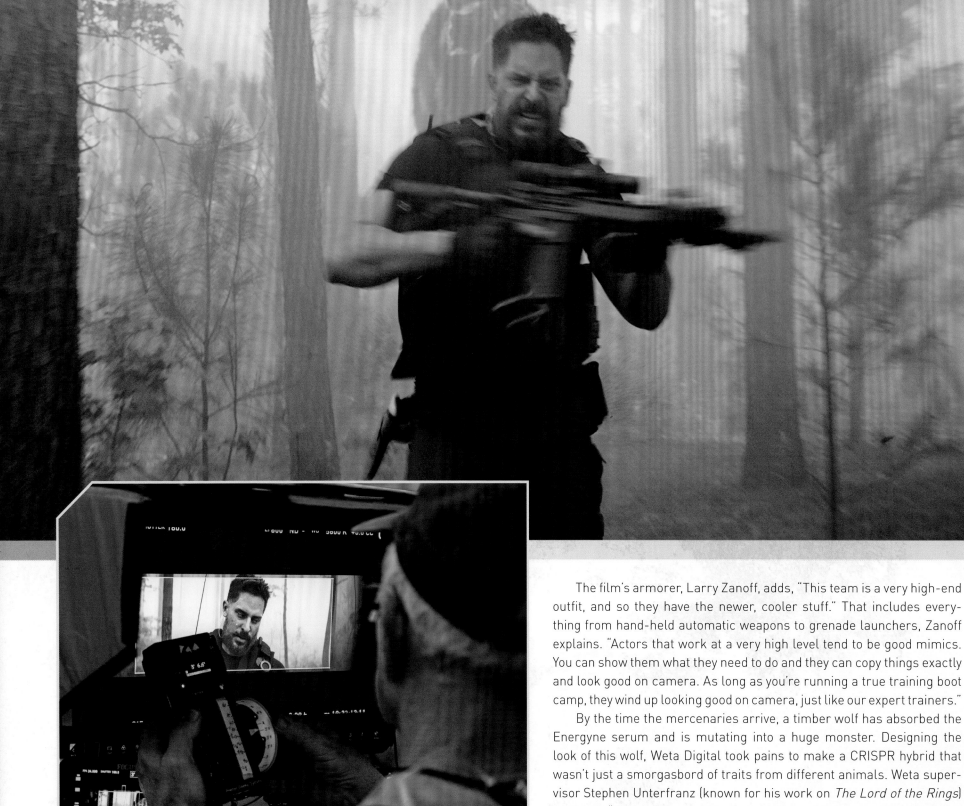

The film's armorer, Larry Zanoff, adds, "This team is a very high-end outfit, and so they have the newer, cooler stuff." That includes everything from hand-held automatic weapons to grenade launchers, Zanoff explains. "Actors that work at a very high level tend to be good mimics. You can show them what they need to do and they can copy things exactly and look good on camera. As long as you're running a true training boot camp, they wind up looking good on camera, just like our expert trainers."

By the time the mercenaries arrive, a timber wolf has absorbed the Energyne serum and is mutating into a huge monster. Designing the look of this wolf, Weta Digital took pains to make a CRISPR hybrid that wasn't just a smorgasbord of traits from different animals. Weta supervisor Stephen Unterfranz (known for his work on *The Lord of the Rings*) explains, "The wolf has a bit of pachyderm skin, so we looked at elephants and rhinos. This creature ranges from thick, armored elephant skin to furry gray wolf hair. Then it's got porcupine quills. The challenge was to juxtapose those different traits and still have it look believable."

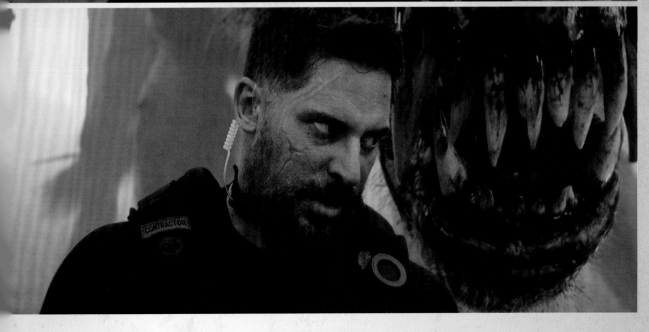

THESE PAGES: This series of images shows the insertion of the mutated wolf. Manganiello noted that because his scenes had been previsualized, he could see the characters interacting with the wolf, which helped him understand how the final shot would look.

ABOVE: Variation on the Rollcall military outfit's skull logo.

Brad Peyton was adamant about believability. "A lot of movies have some really far-fetched, made-up creatures. But ours are based on real animals that have been infected with a CRISPR pathogen. The way each animal mutates is different because they're very different species."

Production designer Barry Chusid and VFX supervisor Colin Strause—both of whom worked with Peyton previously on *San Andreas*—also collaborated with the Weta team to determine how the creatures could mutate. Chusid says, "We came up with a strategy as to how we could imbue each creature with the CRISPR technology. Depending on how much of the aerosol each creature takes in, they're more or less affected. We came up with categories—strength, speed, intelligence—and we took each one of those characteristics and we fed the strongest tendencies into each one of those things. You'll be able to see a common thread with all of them."

Producer John Rickard adds, "The wolf is pretty huge and badass, but at the same time he's all about speed and agility."

"One of the things that makes our movie so wildly different is that the three creatures are mutating and evolving over the course of the film," says Beau Flynn. "So the first time you see George, or the wolf, or the croc, they'll look and behave one way. The next time you see them, they'll have already changed, both physically and mentally. They become much more dangerous and vicious, too. We wanted to play with audience expectations and keep them looking forward to what's coming next."

BELOW: Black Hill Private Security's high-end equipment includes military-grade weapons and helicopters.
OPPOSITE: Images showing the progression and development of the mutated wolf's attack on the airborne helicopter.

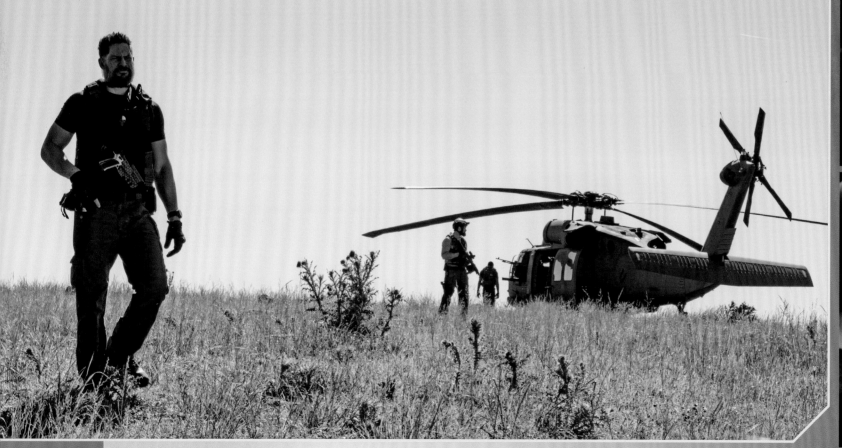

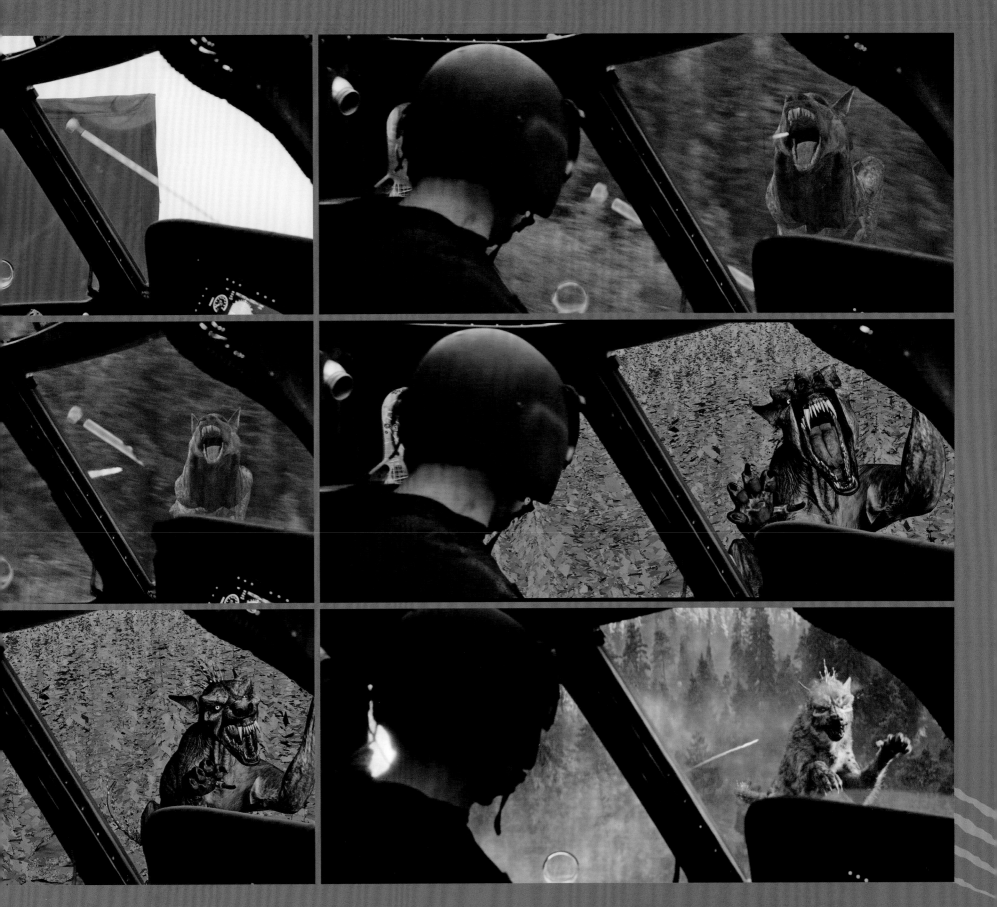

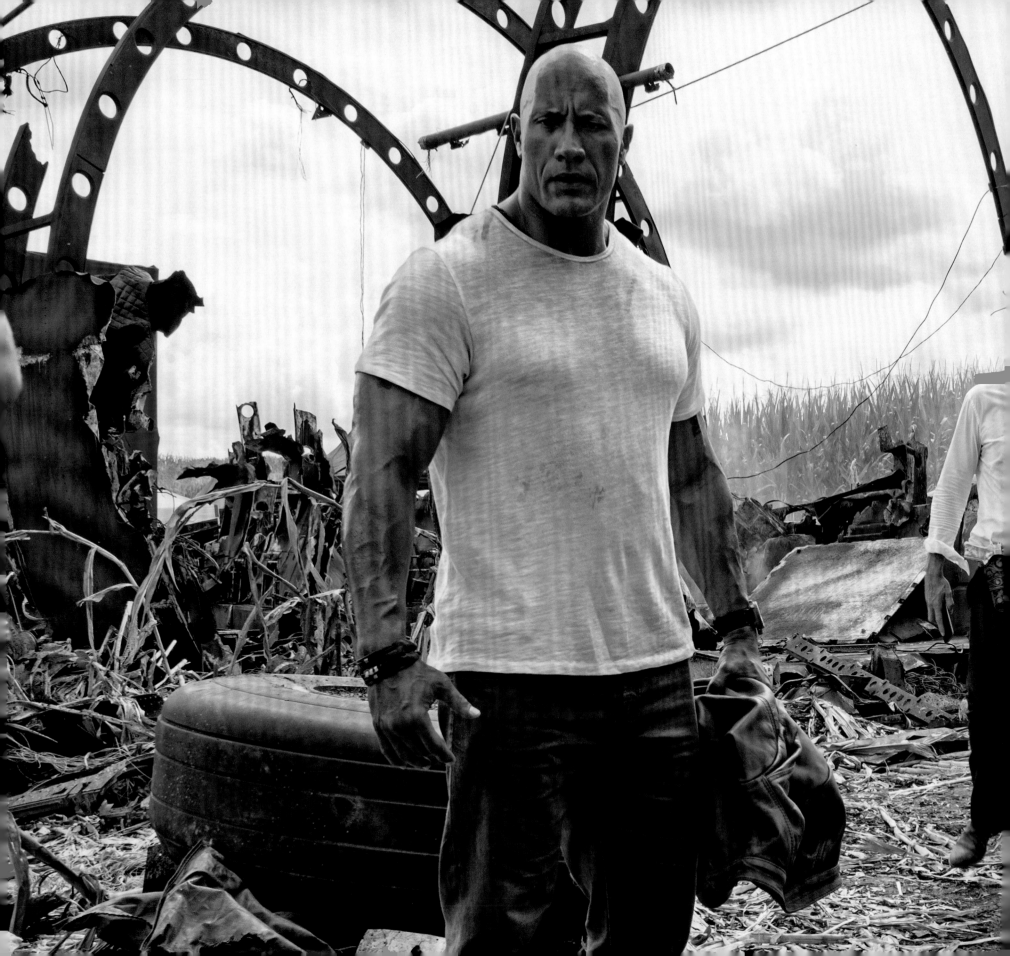

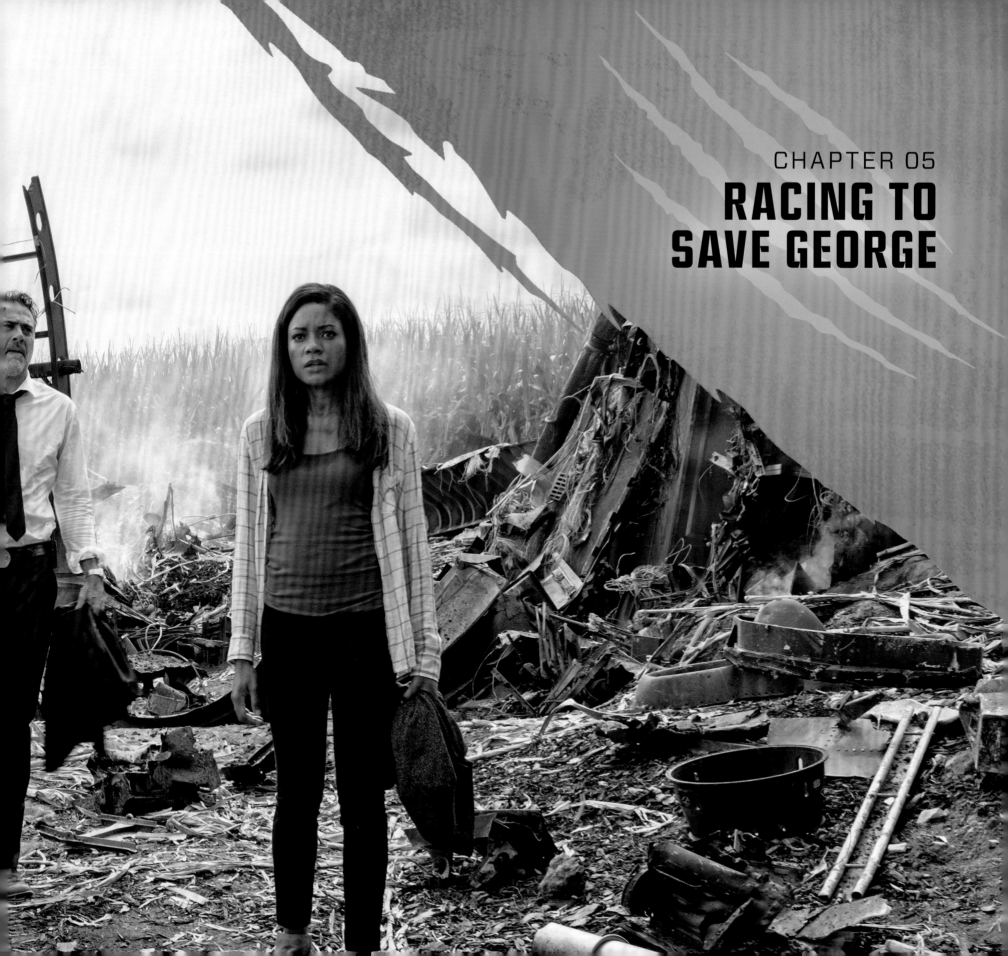

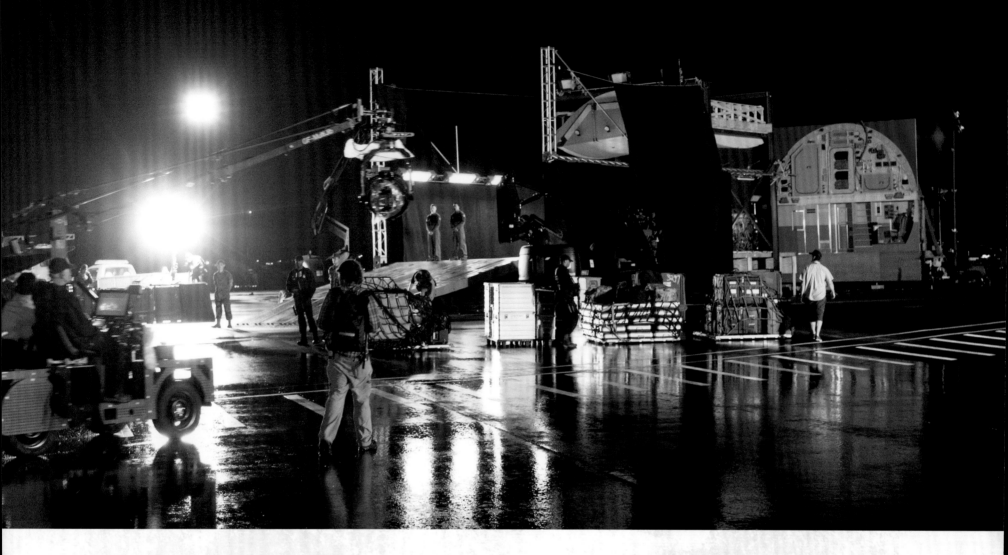

AS GEORGE CONTINUES TO GROW rapidly in size, government agent Russell believes that this extremely dangerous creature needs to be contained.

"Russell is the guy the government sends to deal with the weirdest crap in the world," remarks Brad Peyton. "Nothing fazes him. Even when Davis gets in his face, Russell doesn't shrink. He's the best-funded spook that the government has."

To manage the oversized gorilla on the brink of rampaging, Russell's team deploys a high-powered tranquilizer gun. "It was really interesting because a tranq gun like this doesn't exist," says property master Mychael Bates. "We took the body of an AR15 and manufactured it with assembled parts to completely camouflage what it really was. It was all imagination."

The tranquilizer gun knocks out George so that Russell's team can cage him aboard a giant C-17 cargo plane. Notably, this scene was not filmed against a green screen, as often happens in visual effects films wherein a CG plane would be added later. This giant cargo plane was a life-size replica. As Dwayne Johnson explains, "Brad does a great job of having us immersed in real sets. That puts us in a position where we can give strong performances."

Rampage special effects supervisor J. D. Schwalm recalls, "Our production designer Barry Chusid had the vision of making this entire fuselage as massive as a real one. We wanted to go full-scale, and bring George's cage and forklifts onto it."

"We took about fourteen weeks to build this. It was over 100 feet long and barely fit on our stage," recalls construction coordinator Jonas Kirk. "It was about 20 feet tall and it needed to shake. It was certainly one of our biggest engineering challenges."

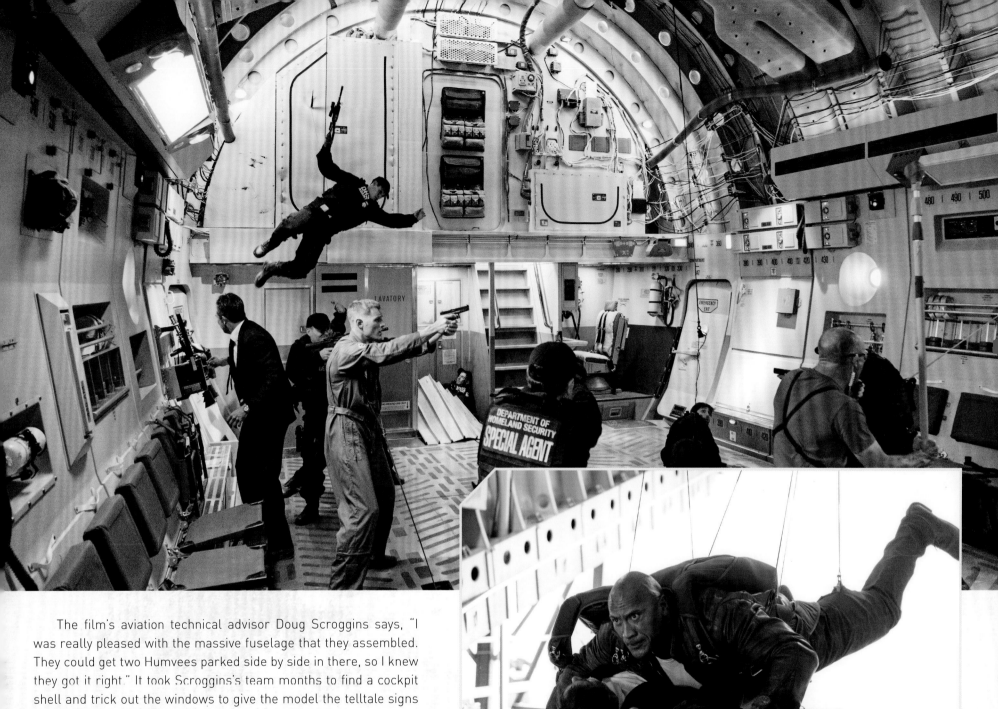

The film's aviation technical advisor Doug Scroggins says, "I was really pleased with the massive fuselage that they assembled. They could get two Humvees parked side by side in there, so I knew they got it right." It took Scroggins's team months to find a cockpit shell and trick out the windows to give the model the telltale signs of a C-17 cargo plane. Finally, the cockpit window was rigged with a moving video display that allows viewers to see what the plane's pilot would see. "It ran on a control stick, much like a PlayStation, which was really neat."

It wasn't sufficient for the C-17 to simply *look* real; it also had to handle some extreme movements. So the special effects team built the plane on a movement base. According to J. D. Schwalm, who previously worked on *The Fate of the Furious*, the special effects team created a big wedge that would allow the plane to tilt up over 40 degrees.

PAGES 84–85: Davis, Agent Russell, and Kate stand amid the C-17 wreckage.
OPPOSITE: The C-17 cargo plane set was a 20-foot-tall life-size replica.
TOP: The C-17 set was built to handle major action sequences.
INSET: Dwayne Johnson performs while suspended on wires.

"We put the entire set on a series of airbags," Schwalm said. "We had fifty airbags under it, and every one had a little sensor on it to control its height. It took a lot of hydraulic power to move this. When the whole thing was engineered, it came in weighing around 300,000 pounds."

However, what goes up must come down, and the *Rampage* team knew they wanted to find a way to make a plane crash bigger and more spectacular than anyone had ever seen. In the movie, George awakens in a rage and the plane pitches and rolls as he punches the fuselage in an attempt to break free. "We wanted to challenge ourselves to somehow take it to the next level," producer Hiram Garcia says. "We were on a tilt rigged in the studio, our actors were hanging from wires and being thrown around, and there was also performance capture of the gorilla happening at the same time. I don't think I've ever seen a sequence like this."

Stunt coordinator Allan Poppleton notes, "Since George had gotten bigger, Jason Liles wore a backpack to indicate how much higher up his head had become." This helped the actors know where to look and helped the camera crew keep the gorilla in the frame.

Brad Peyton was getting his wish to capture as much physical reality on set as possible. "The actors were flying around on rigs and we were blasting the set with massive airplane fans that kicked up debris. Dwayne was jumping from one place to another, getting people untangled and grabbing onto things to avoid being sucked through holes in the plane."

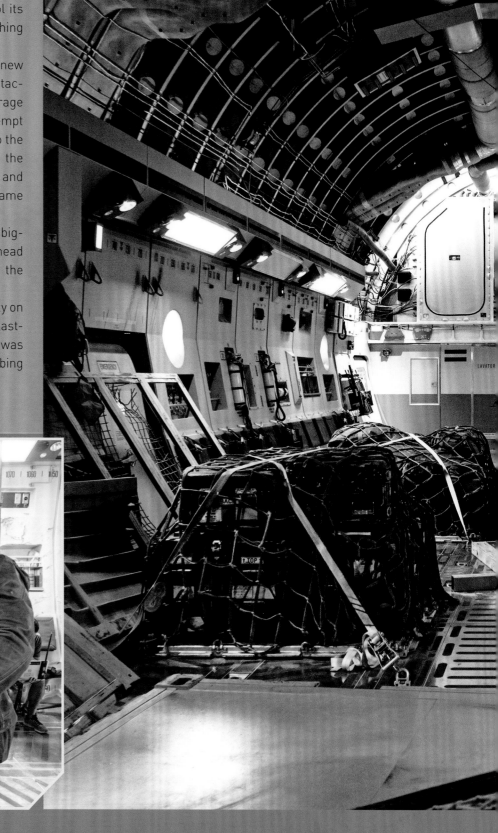

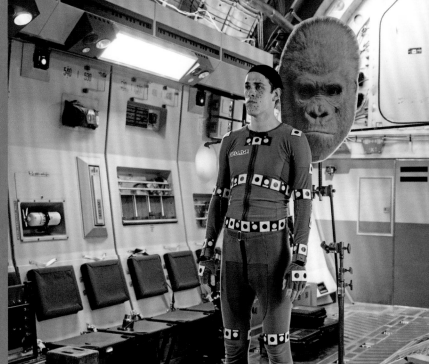

OPPOSITE FAR LEFT: The cast and crew reviews previsualization shots.

LEFT: The interior of the C-17 set was large enough to fit two Humvees side by side.

ABOVE: Dwayne Johnson and Jason Liles (performing as George) in the C-17.

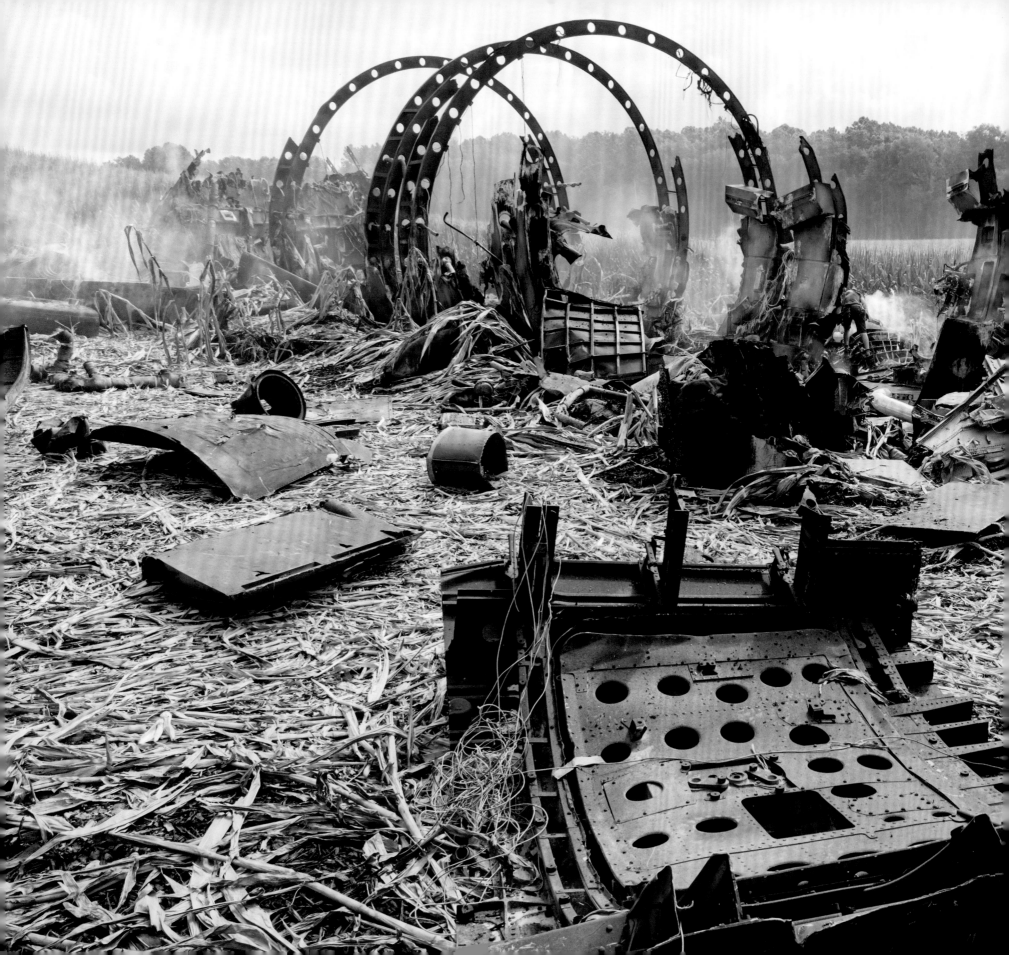

Dwayne Johnson is seasoned at making action movies, but for Naomie Harris, this was totally new. "I was strung up to the ceiling, flying around in a re-created plane. I'd never done that before, and it was tough," she recalls.

As executive producer Marcus Viscidi puts it, "We actually had to blow out the sides of the plane. People with parachutes were being sucked out, and the set was basically destroyed." Producer Hiram Garcia notes, "The minute you see George get put onto this plane, you know it's a bad idea, and we deliver on that bad idea."

LEFT: The wreckage of the destroyed C-17.
INSET: Dr. Kate Caldwell surveys the destruction.
PAGES 92-93: Concept art of the C-17 wreckage.

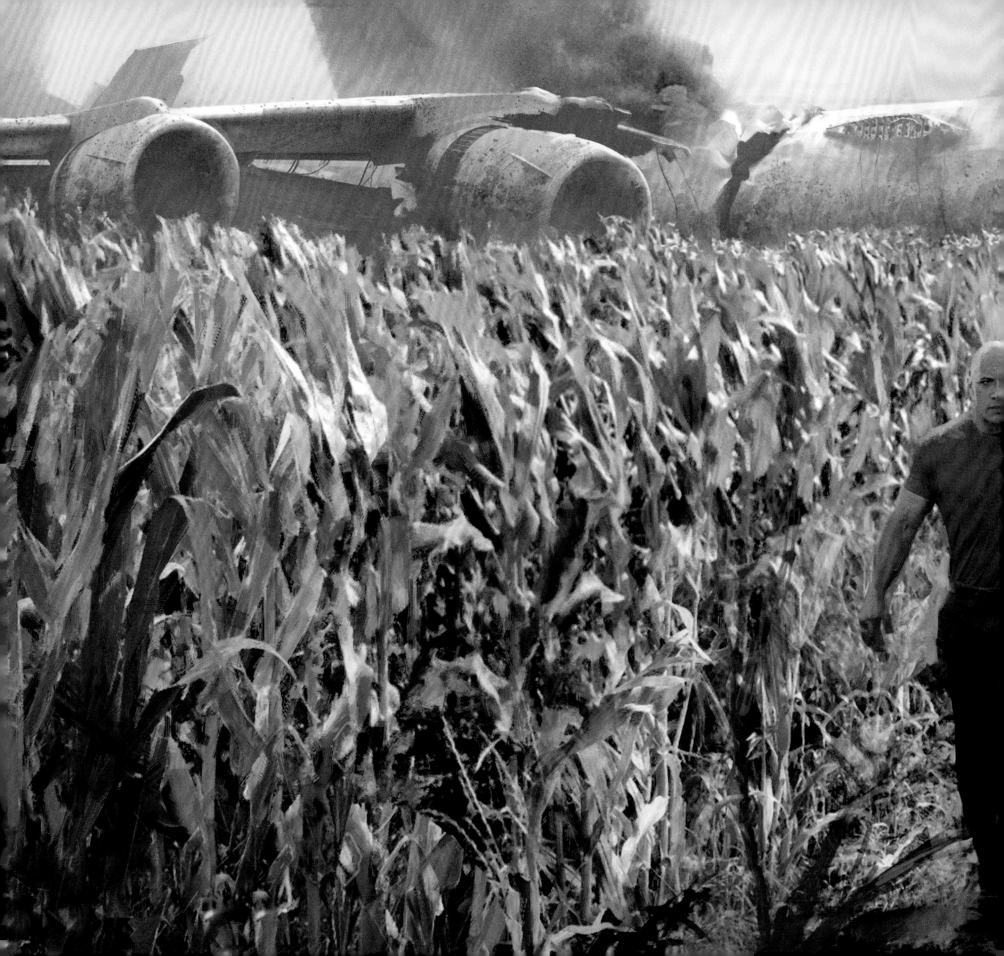

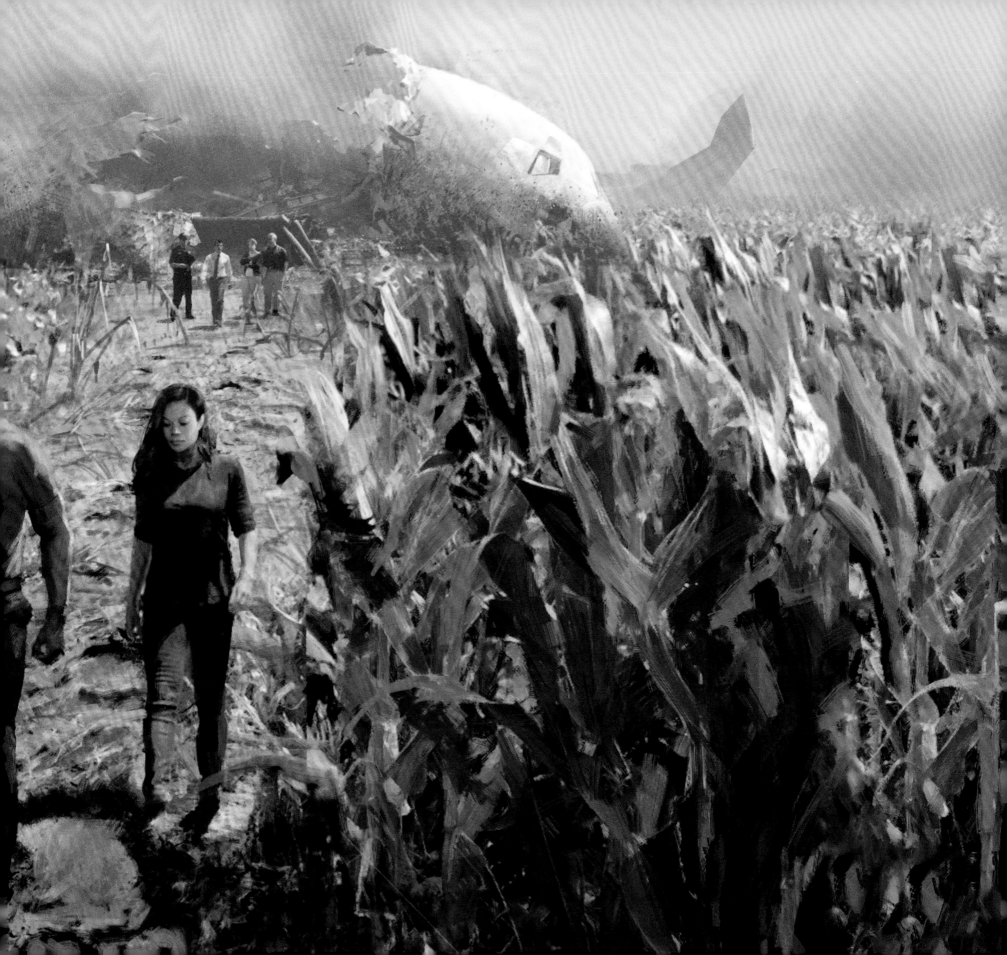

THE MUSIC OF *RAMPAGE*

Similar to so many of the key collaborations behind *Rampage*, the film's soundscape reflects a close rapport between director Brad Peyton and composer Andrew Lockington. Lockington had come to Peyton's attention back in 2008, when the director heard the score the composer had created for the 3-D feature film *Journey to the Center of the Earth*. "His music was so distinctive, and it truly elevated that film," Peyton recalls. When Peyton was preparing to direct *Journey 2: The Mysterious Island*, Lockington was a natural choice. "We had a great working experience on *Journey 2*," notes Peyton. "Since then, every project I've directed and produced, I've done with him."

While many of the movies Peyton and Lockington have collaborated on are epic visual effects movies, Lockington says, "Ninety percent of our conversations are about story and emotions, and we allow that to influence the music." In *Rampage*, Johnson's character Davis is driven to save his friend George. Lockington recalls, "When Brad mentioned that Davis had rescued George in Africa, I thought, 'How can we musically represent that bond?'"

Peyton's goal was to highlight this emotional aspect of the story but also do something that sounded unique. "I knew it was a lofty goal, but it was one I felt driven to achieve, and I knew Andrew would be up for the challenge."

Lockington's musical solution included using the sounds of the Ugandan Children's Choir. As he explains, "About a year ago I spent a few days with an African children's choir of about twenty young kids. They travel the world and sing as part of this remarkable charity. Then, they go back to Uganda and receive schooling for life. There was this amazing sound to these kids." In the *Rampage* score, Lockington adds, "We're using their sound in a different way. Their voices will be textures in the score—it's not going to sound like tribal music."

Lockington also explored ways to connect George to the music, creating what he calls a "musical motif" for the character. "While researching gorillas, I spent a few days with zookeepers. I saw a young gorilla who tapped on some glass, and the keepers said, 'This gorilla has a rhythm.' So the first time we meet George in his enclosure, he also has a rhythmic motif, and that morphs throughout the film and becomes a signifier of him."

ABOVE: Performers from the Ugandan Children's Choir.
RIGHT: Brad Peyton and Andrew Lockington worked closely to develop the sounds of *Rampage*.

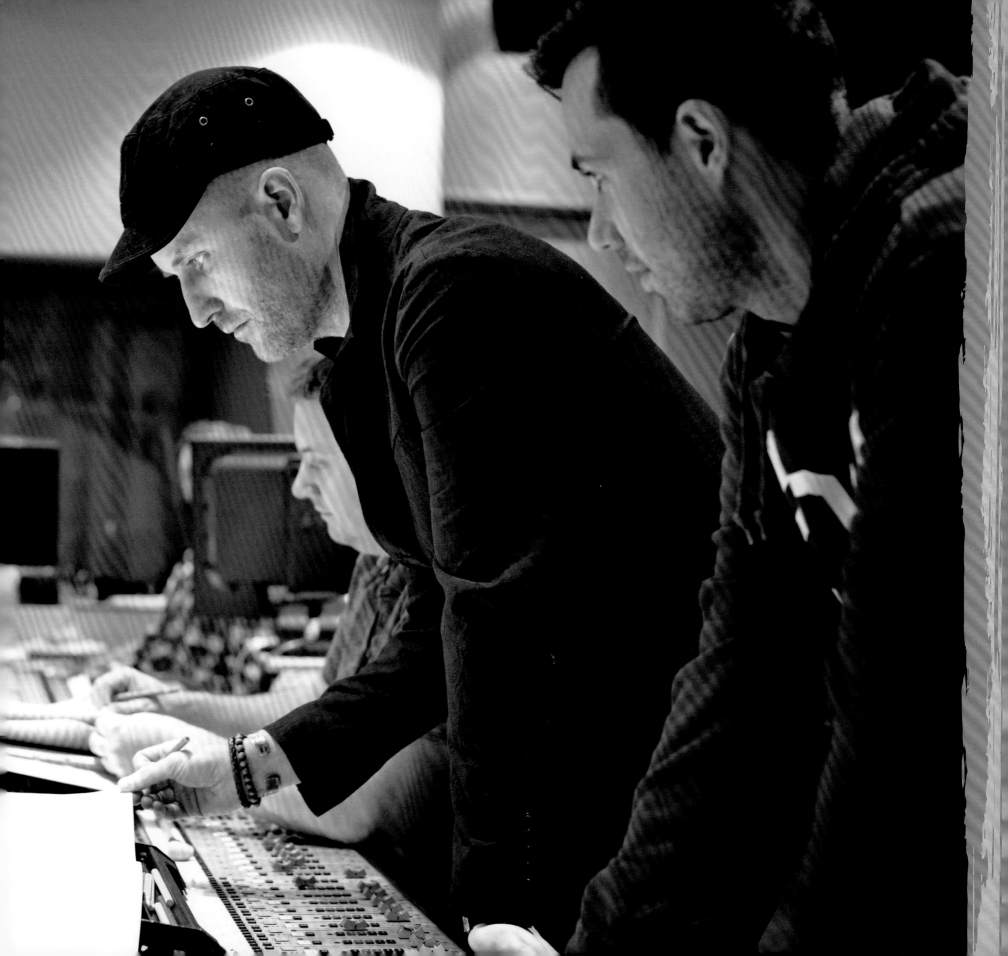

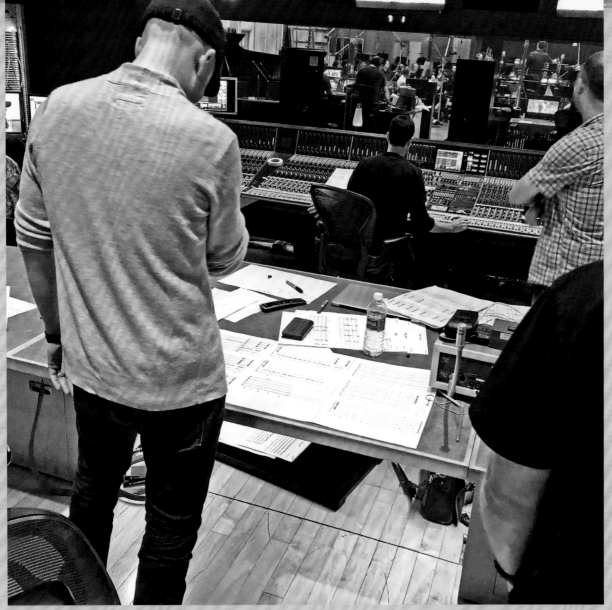

Peyton notes, "I loved the idea of organic music being altered by more synthetic sounds to reflect the idea of the movie—that technology can infest organic organisms and alter them over time. The score is like nothing we've done before because it has both the most basic sounds—literally the sounds of animals and ancient drumming techniques—while also having cutting-edge electronic elements that have never been heard before. The many juxtaposing ideas will deepen the emotional experience of the movie, and steer the visual experiences in different ways than people think we're going—which is both frightening and exhilarating."

"It was a great opportunity to have a real musical clash between natural elements and man-made elements," Lockington adds. The latter elements, which reflect the movie's theme of villains attempting to play God by manipulating DNA, are represented with analog synthesizer sounds. "We put sounds through some really unique analog synthesizers," the composer explains. "They don't have computer chips in them like everything else does. They're literally just transistors and knobs and resistors and cables. They look like they're taken off the set of *Frankenstein* from way back when."

Another benefit to Lockington's strategy is that it helps underscore all the mechanical sounds in *Rampage*, including crashing planes and whirring helicopters. "The electronic element of the manipulated Polynesian drumming does end up having an almost mechanical feeling to it. There are moments where it sounds like a warped helicopter sound," Lockington observes. "One of the best things about this postproduction team—and it's the same team we had on *San Andreas*—is Per Hallberg, who's our sound effects supervisor and designer. He and I had an extraordinary experience on *San Andreas*, where we were able to blur the line between what is music and what are sound effects."

Lockington researched a variety of ape sounds as he explored animal elements for *Rampage*. "There are howler monkeys in Costa Rica that have quite extraordinary melodic patterns that they sing, so I went into the jungle and recorded them. The sound itself was interesting, but when I stretched it out—manipulating two or three seconds into twenty seconds—I got this fascinating, melodic motif that ended up becoming part of the score. As with the Ugandan Children's Choir, my goal was to use it in such a way that people won't necessarily know what it is or where it came from."

The many organic musical elements in *Rampage* also include a bamboo flute and the sounds of Polynesian drumming. "In the beginning of *Rampage*, you hear these sounds in their purest form," the composer explains. "But Brad and I have been playing with the evolution of those sounds, and we remix them in modern ways. With the Polynesian drumming, for example, we give it a 20-percent manipulation, and then 40 percent. You can still recognize the DNA of its origins, but also recognize that it has been 'genetically modified.' It's a parallel to what is happening in the *Rampage* story."

Hallberg, a three-time Oscar winner for his sound editing on *Braveheart*, *The Bourne Ultimatum*, and *Skyfall*, continues to inspire Lockington and Peyton to take those ideas further in *Rampage*. As Lockington explains, "Things like metal tearing away have a musical center to them. I make sure that actually feels like it is at home within the music, as opposed to two contrasting elements. It's so much fun to work on this."

Peyton remarks, "Andrew and I do deep creative dives on the music and spend a lot of time developing sounds and themes. It is a very pure and creative process where we explore and nuance themes for months. We leave no stone unturned and we make it very difficult to sign off on anything until we are certain it makes us feel what we should be feeling or is as provocative as possible. I'm probably as involved in the musical process as much as I'm involved in every other part of the filmmaking process. It's all about having a deep-knowledge understanding of what I'm seeing and hearing. Andrew affords me the time to get inside the musical process with him."

Lockington agrees: "The biggest luxury I have working with Brad is that we trust each other. And that allows us to take risks and run with unique ideas. That's when the magic happens."

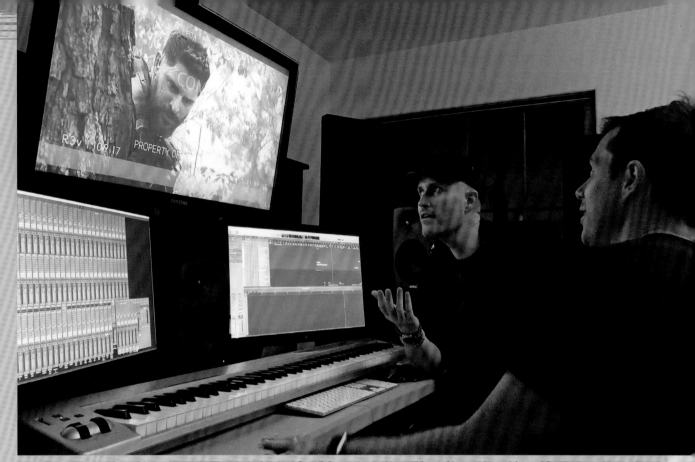

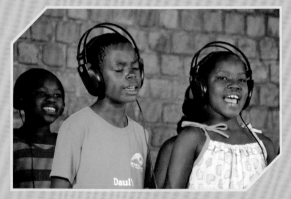

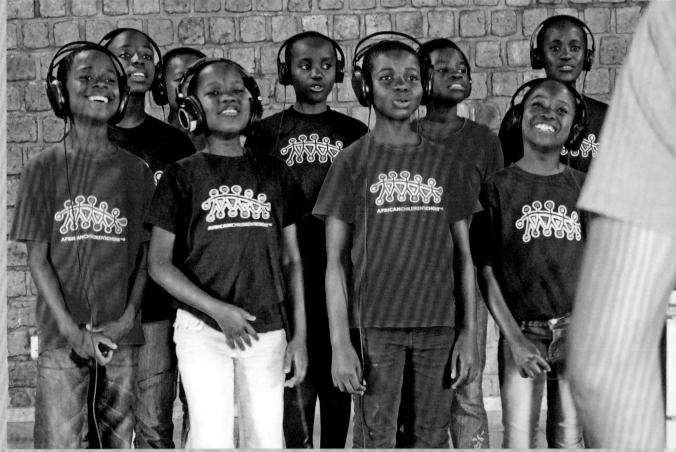

OPPOSITE: Andrew Lockington incorporated numerous unusual sounds in his compositions for *Rampage*, including howler monkeys and Polynesian drumming.

TOP: The music for *Rampage* combines organic and synthetic sounds to create a unique experience.

ABOVE AND RIGHT: Performers from the Ugandan Children's Choir.

CHAPTER 06
THE TOWER BECKONS

AFTER CAUSING THE PLANE to crash, George is now on the run and alone. The pieces start falling into place for Kate, and she finally shares what she knows about Energyne's CRISPR research. Davis is furious about what's happening to George, yet he realizes he needs Kate's knowledge if he hopes to save his friend. "Having seen some of the darker sides of humanity, Davis has a hard time trusting people, which is why he gravitates towards animals," remarks Dwayne Johnson. But if Davis wants to rescue George, he'll have to trust Kate.

Similarly, Naomie Harris feels that humanity is the most important aspect of the story. "George is a gorilla, but he's so humanized that you really fall in love with him," she says. "He was an innocent bystander who got turned into an aggressive being. But underneath, he's still our loveable George, so we're fighting to get him back."

The Wyden siblings have activated a powerful radio signal that is luring the mutant creatures toward Energyne's offices in Chicago's Willis Tower. As Jake Lacy explains, "The DNA of the creatures has been changed so that they respond to this beacon like moths to a light. Claire thinks that there's no point in having a weapon unless you can aim it."

Screenwriter Ryan Engle adds, "If Energyne wanted to attack a military base, they could 'paint' that target with a low-frequency radio wave, and the animals would go there and rampage."

George and the wolf keep following Energyne's beacon toward Willis Tower, and so does the 100-foot-long mutant crocodile swimming beneath the surface of Chicago's waterways, mutated by the serum from a third canister that fell to Earth. Director Brad Peyton recalls, "The Wydens are trying to weaponize DNA, so we had to think like them when we were deciding how to mutate the creatures. They would want strength and aggression, so we looked at which animals have those attributes."

PAGES 98–99: Military vehicles crowd the streets of Chicago during filming.

RIGHT: Concept art of military helicopters converging on Chicago to confront the rampaging creatures.

INSET: A still frame from the previsualization depicting the wolf and a downed helicopter.

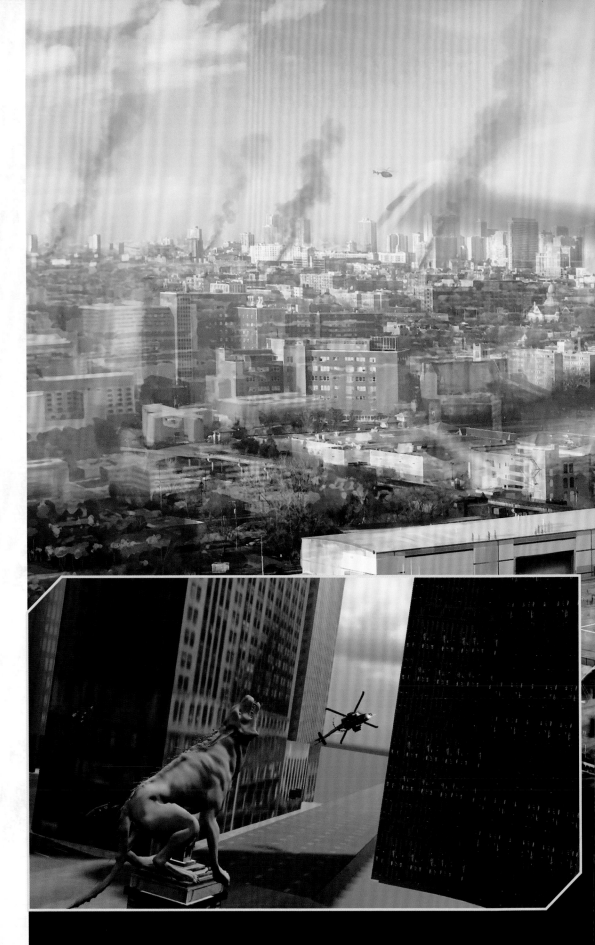

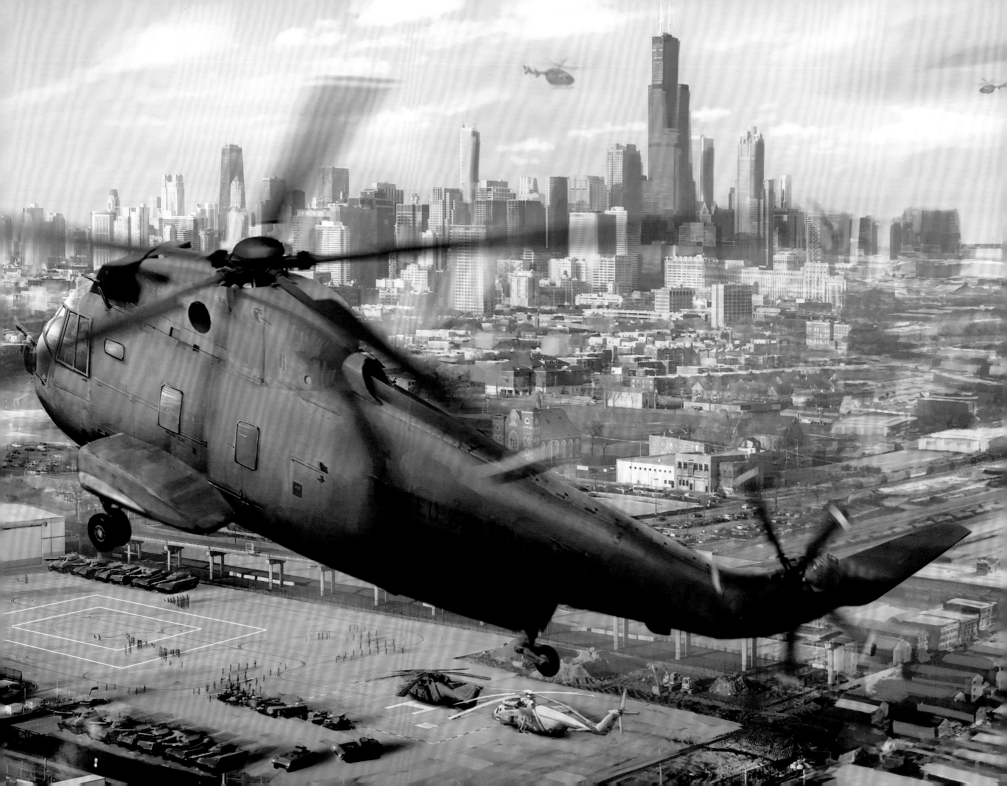

EVOLUTION BY DESIGN

Visual effects supervisor Colin Strause explains the thinking behind how the film's creatures were designed to mutate: "There's a lot of work we had to do with Brad, Barry, and Weta to figure out how George evolves from shot to shot. How do the wounds, dirt levels, and blood levels change? We see the wolf in three phases [of mutation], where George we catch in five, while the crocodile is the biggest surprise at the end because we deliberately do not show its changes."

Producer Beau Flynn adds, "We didn't want them to just change for the sake of changing. We spent a lot of time researching CRISPR and real attributes from other animals. All of the mutations are rooted in biology and aspects found in nature, so the audience can have fun identifying those different features."

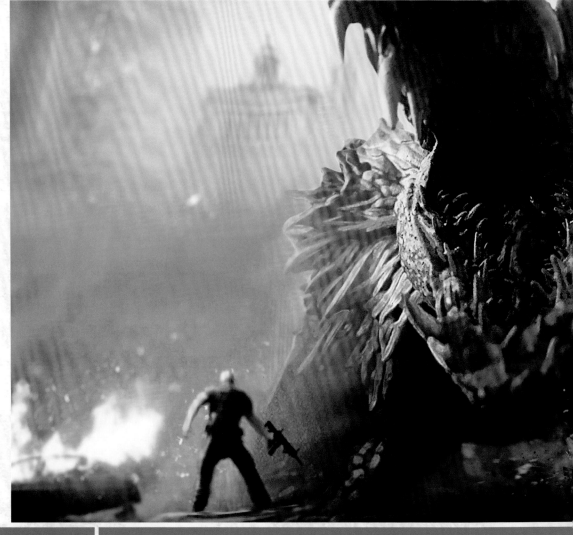

LEFT: Concept art featuring Davis facing down the enormous crocodile.

THESE PAGES: Digital models of the mutated crocodile.

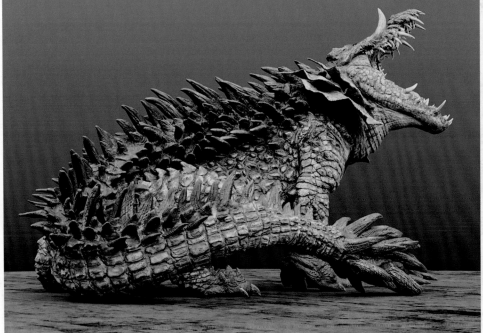

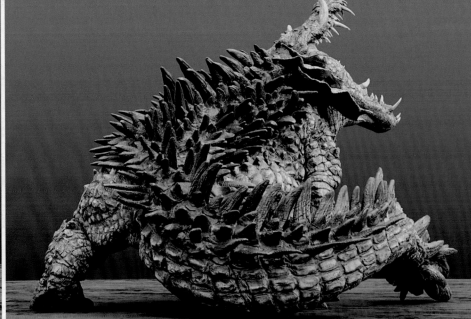

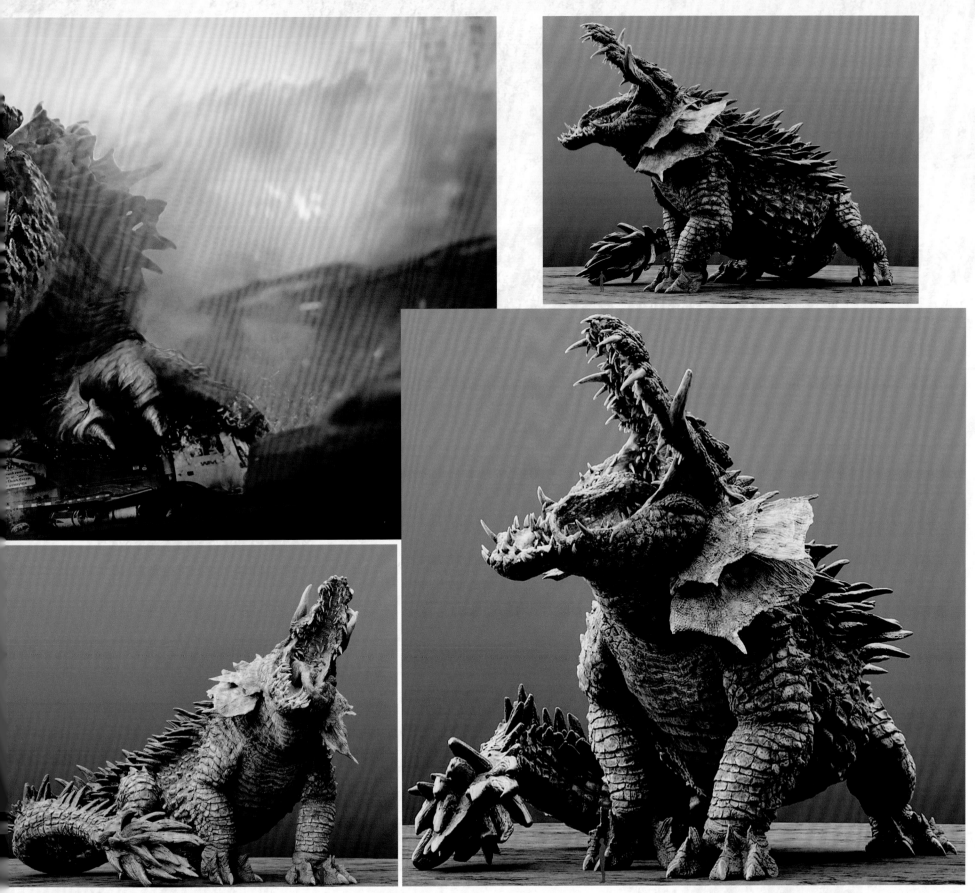

GEORGE
6 ft. tall
500 lb.
0 hrs Exposure
Gorilla enclosure San Diego, Night

GEORGE
12 ft. tall
1,200 lb.
18 hrs Exposure
Gorilla enclosure San Diego, Day

GEORGE
18 ft. tall
18,000 lb.
24 hrs Exposure
Cargo plane crash lands,
George escapes

TOP: A sequence of concept images showing George's dramatic changes across five proposed stages of evolution.

OPPOSITE BOTTOM: A scale comparison showing the creatures' original relative sizes.

"With George, Weta changed the crown on top of his head, but kept his face the same," Strause says. "He is huge, but we kept the overall mechanics of how a gorilla moves. For the wolf, which had a higher dosage of CRISPR, Weta added webbing between its legs, which gave him a sort of flying squirrel gliding ability."

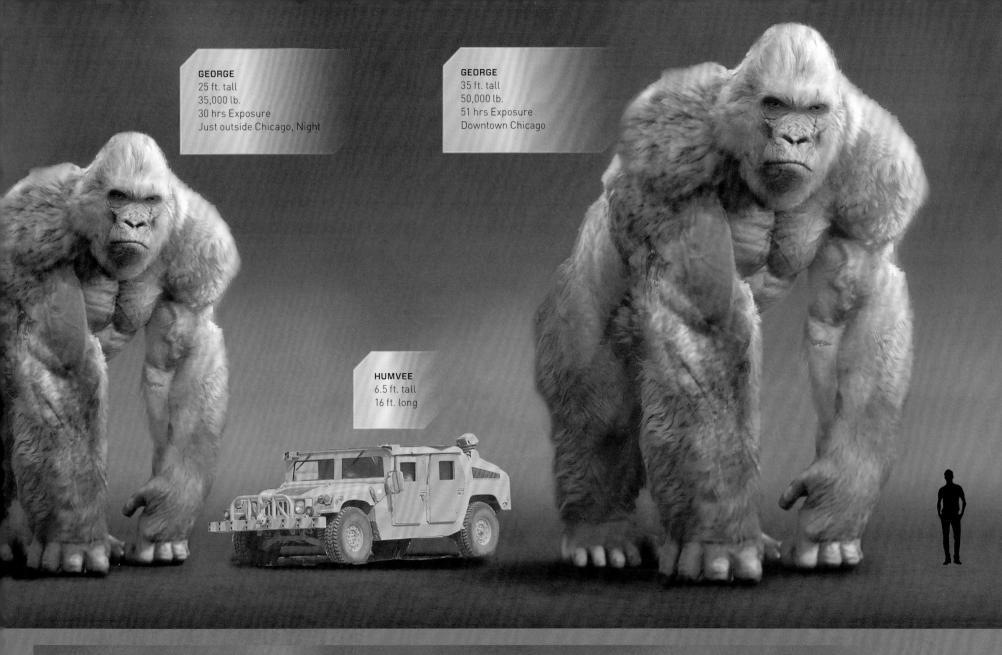

GEORGE
25 ft. tall
35,000 lb.
30 hrs Exposure
Just outside Chicago, Night

GEORGE
35 ft. tall
50,000 lb.
51 hrs Exposure
Downtown Chicago

HUMVEE
6.5 ft. tall
16 ft. long

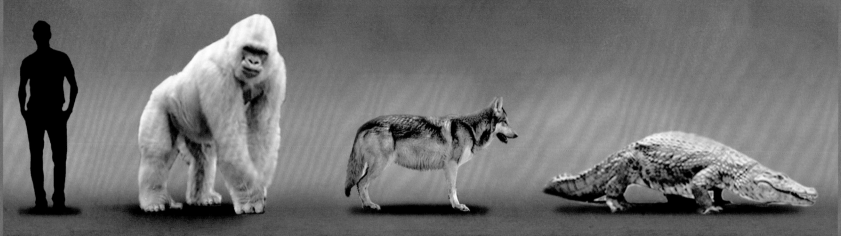

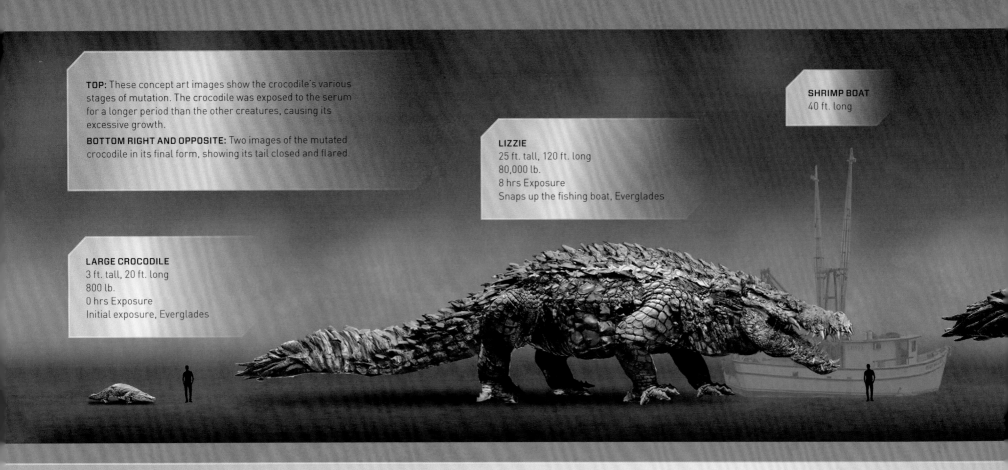

TOP: These concept art images show the crocodile's various stages of mutation. The crocodile was exposed to the serum for a longer period than the other creatures, causing its excessive growth.

BOTTOM RIGHT AND OPPOSITE: Two images of the mutated crocodile in its final form, showing its tail closed and flared.

SHRIMP BOAT
40 ft. long

LIZZIE
25 ft. tall, 120 ft. long
80,000 lb.
8 hrs Exposure
Snaps up the fishing boat, Everglades

LARGE CROCODILE
3 ft. tall, 20 ft. long
800 lb.
0 hrs Exposure
Initial exposure, Everglades

"The crocodile develops gecko-like abilities to climb, as well as different teeth," producer Beau Flynn adds. "The tail is able to flare out and create this incredible weapon."

"We wanted the creatures to be big—as compared to humans—but we didn't want them to be the size of buildings, like Godzilla. It required a lot of design and engineering conversations with Weta Digital, which has a great team of animators," says Strause.

Even as George grew enormous, the Weta team was conscious of maintaining a through-line to the performance that was captured of Jason Liles. As Strause observes, "I don't think the character of George would work if we just treated it as a visual effect. He's not a spaceship; he's a character played by an actor. Even when George becomes huge, we had the performance capture on his face."

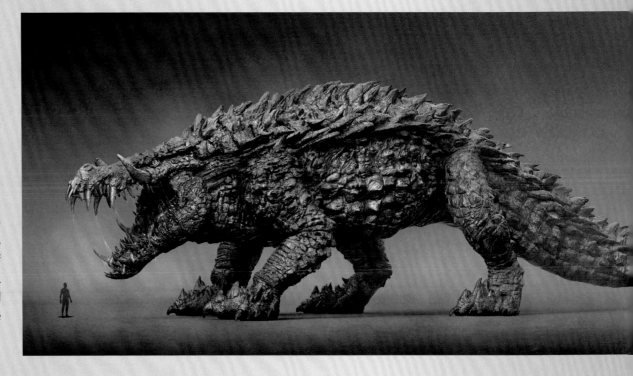

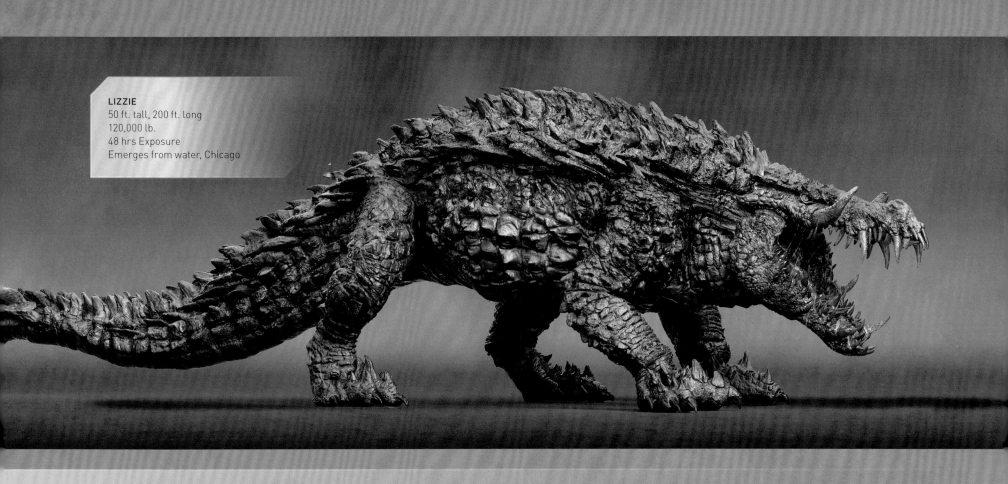

LIZZIE
50 ft. tall, 200 ft. long
120,000 lb.
48 hrs Exposure
Emerges from water, Chicago

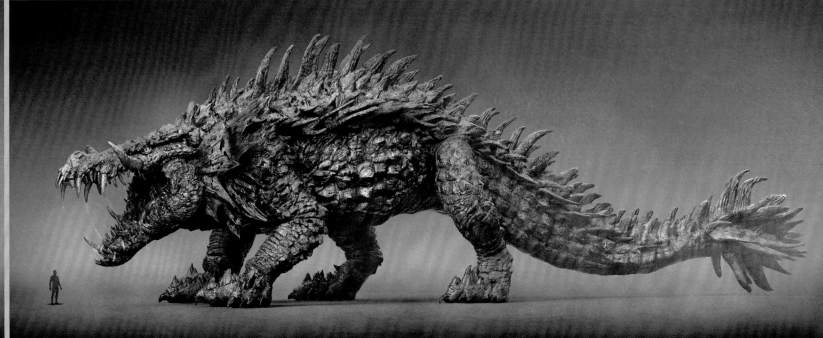

The filmmakers also chose to keep Jason's blue eyes—which would be reasonable for an albino gorilla. This kept a consistency to the character throughout. As Brad Peyton remarks, "It's not just in his eyes, but in his mouth and eyebrow movements—that's all Jason. Even when George became gigantic, Jason was there during filming, standing on a platform so that everyone else in those scenes could act opposite him."

Of course, that interaction got increasingly challenging as George grew to 35 feet tall, recalls Weta visual effects supervisor Erik Winquist. "We had Jason standing up on a crane, but he was still signing, playing scenes with Dwayne."

RIGHT: Concept art showing the wolf's various mutations.

BELOW: A comparison of the three creatures' final forms.

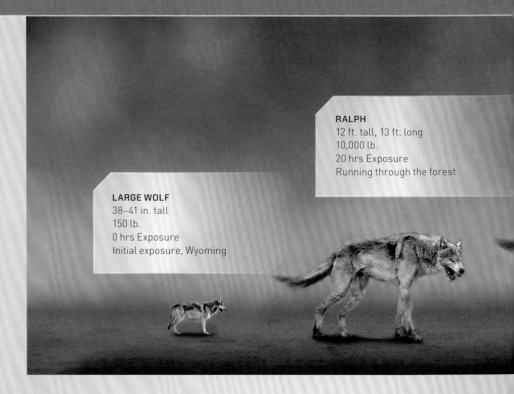

LARGE WOLF
38–41 in. tall
150 lb.
0 hrs Exposure
Initial exposure, Wyoming

RALPH
12 ft. tall, 13 ft. long
10,000 lb.
20 hrs Exposure
Running through the forest

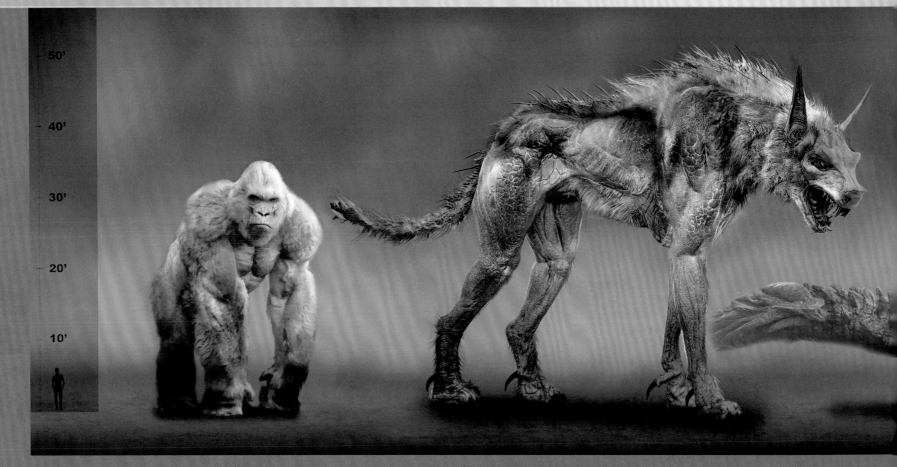

50'

40'

30'

20'

10'

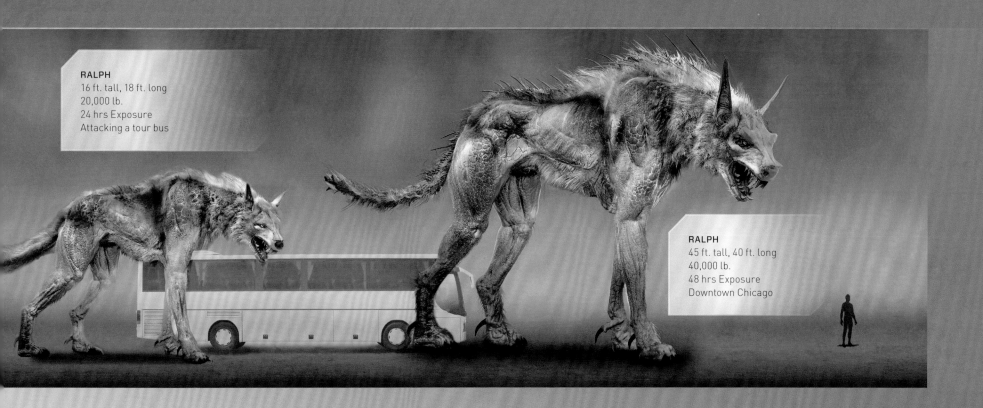

RALPH
16 ft. tall, 18 ft. long
20,000 lb.
24 hrs Exposure
Attacking a tour bus

RALPH
45 ft. tall, 40 ft. long
40,000 lb.
48 hrs Exposure
Downtown Chicago

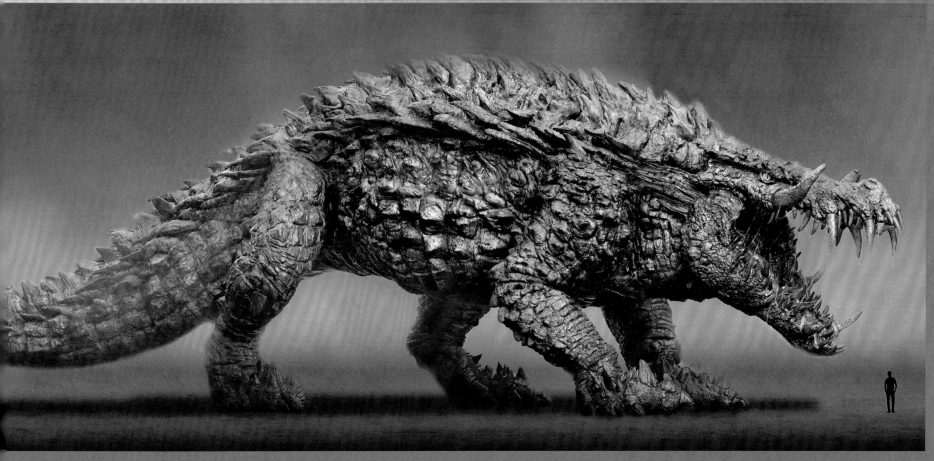

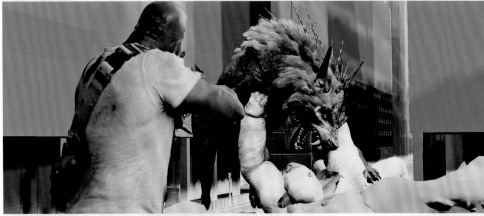

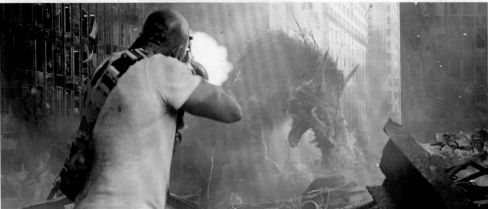

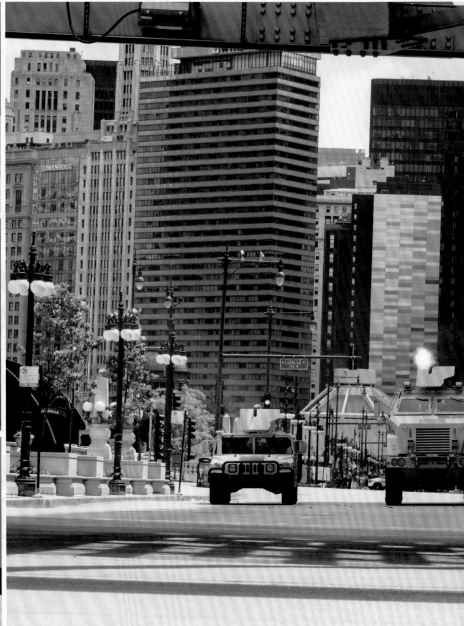

Given the director's actor-centric approach and desire for a film steeped in reality, production designer Barry Chusid and VFX supervisor Colin Strause endeavored to always have something physically real within 50 feet of the actors. Strause remarks, "The more we can have real stuff for the actors to interact with, the better. We actually had relatively few green screen sets in the film. With Willis Tower, we built about 70 percent of the entire rooftop." Chusid adds, "Having the actors be able to touch real things, and see the light and shadows they create is really important—for the performances of the actors *and* the crew."

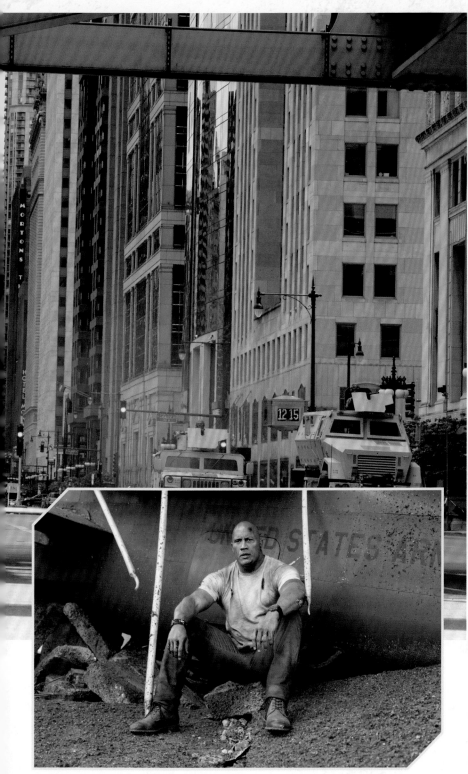

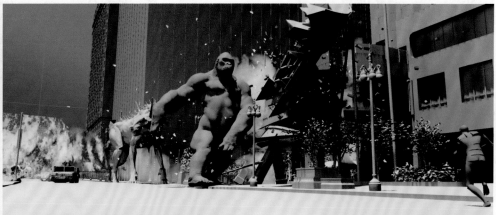

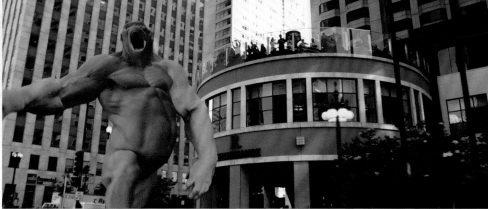

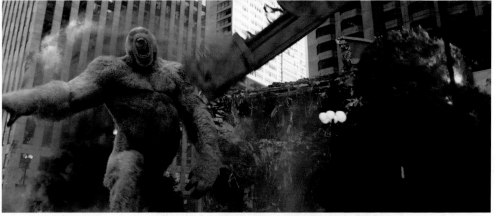

OPPOSITE FAR LEFT: An image sequence showing the previsualization, filming, in-progress visual effects, and final effects as Davis faces off against the wolf.

TOP CENTER: The military prepares to face off against the creatures in the heart of downtown Chicago.

INSET: Dwayne Johnson as Davis Okoye sits amid on-set rubble.

RIGHT: George destroys a building in this series of visual effects images.

Actress Malin Akerman cites Energyne's well-appointed penthouse as an example. "It is beautifully tailored to these billionaires. We actually had a CRISPR scientist come in, and he recognized all the high-end equipment that Energyne should have." Despite being surrounded by the trappings of wealth, Claire's true colors emerge as the approaching mutants get ever closer to Willis Tower. "We realize how crazy she is," Akerman observes, "because she thinks she's watching an incredible demonstration of Energyne's weapons of mass destruction."

Claire, of course, is impeccably clothed, befitting her status as a wealthy CEO. Costume designer Melissa Bruning (whose many credits include *War for the Planet of the Apes*) says, "Claire has so much money, she'd go for designer things. I wanted her to have a flair for fashion. It was actually nice to shop for a character at Neiman Marcus!" In a nod to the original *Rampage* game, in which an iconic character wears a red dress, Bruning made a custom red designer outfit for Claire. "We had to find something that would satisfy fans of the game, but also look like something the actual character would wear."

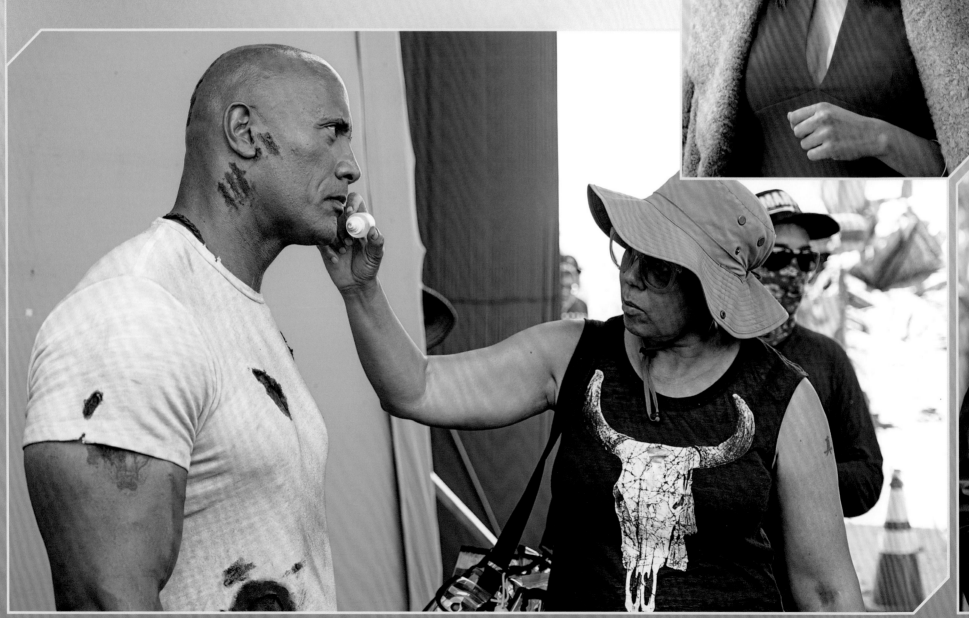

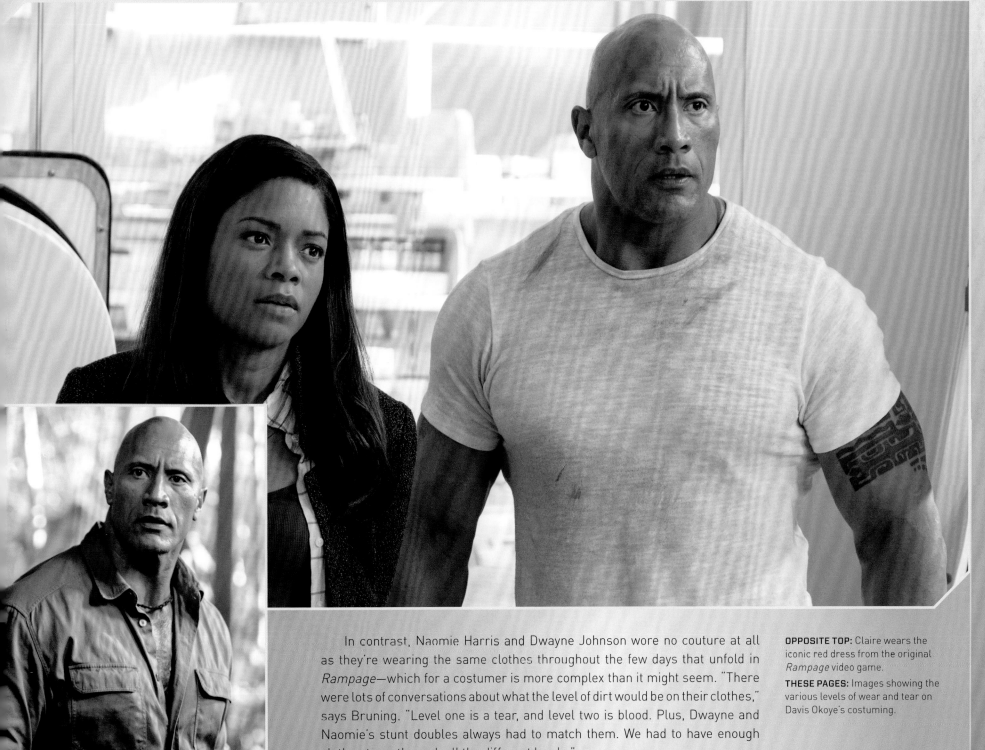

In contrast, Naomie Harris and Dwayne Johnson wore no couture at all as they're wearing the same clothes throughout the few days that unfold in *Rampage*—which for a costumer is more complex than it might seem. "There were lots of conversations about what the level of dirt would be on their clothes," says Bruning. "Level one is a tear, and level two is blood. Plus, Dwayne and Naomie's stunt doubles always had to match them. We had to have enough clothes to go through all the different levels."

By the time Davis and Kate reach Chicago, they already look the worse for wear, but they're not able to rest yet: The military is evacuating the dense urban area, trying to minimize casualties as the rampaging creatures close in.

OPPOSITE TOP: Claire wears the iconic red dress from the original *Rampage* video game.

THESE PAGES: Images showing the various levels of wear and tear on Davis Okoye's costuming.

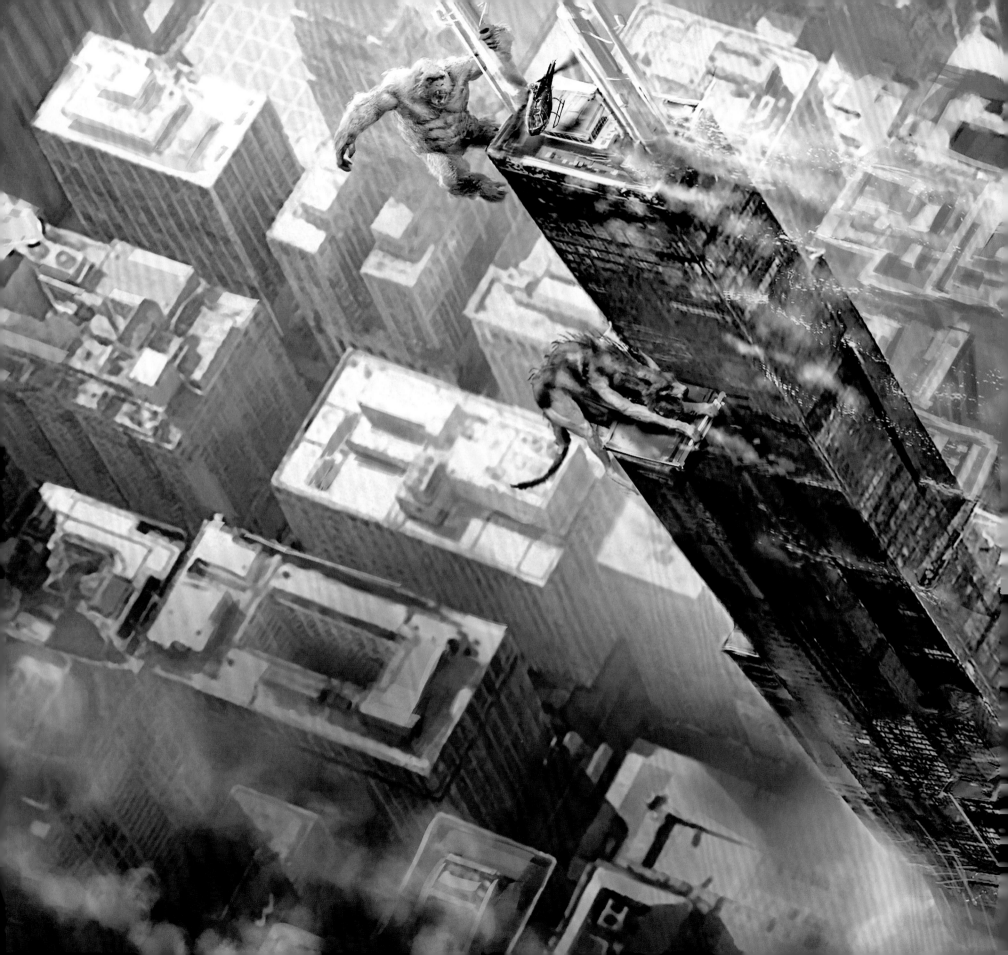

CHAPTER 07
THE FINAL
CONFRONTATION

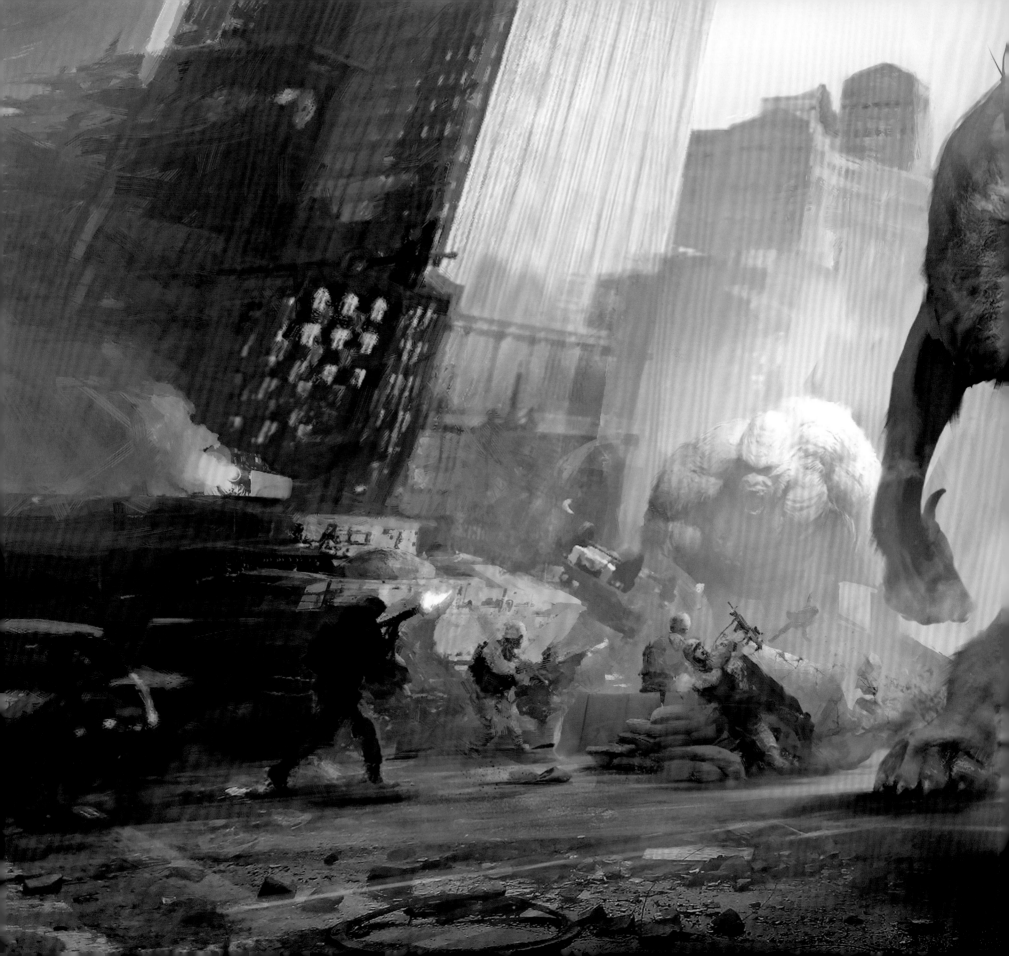

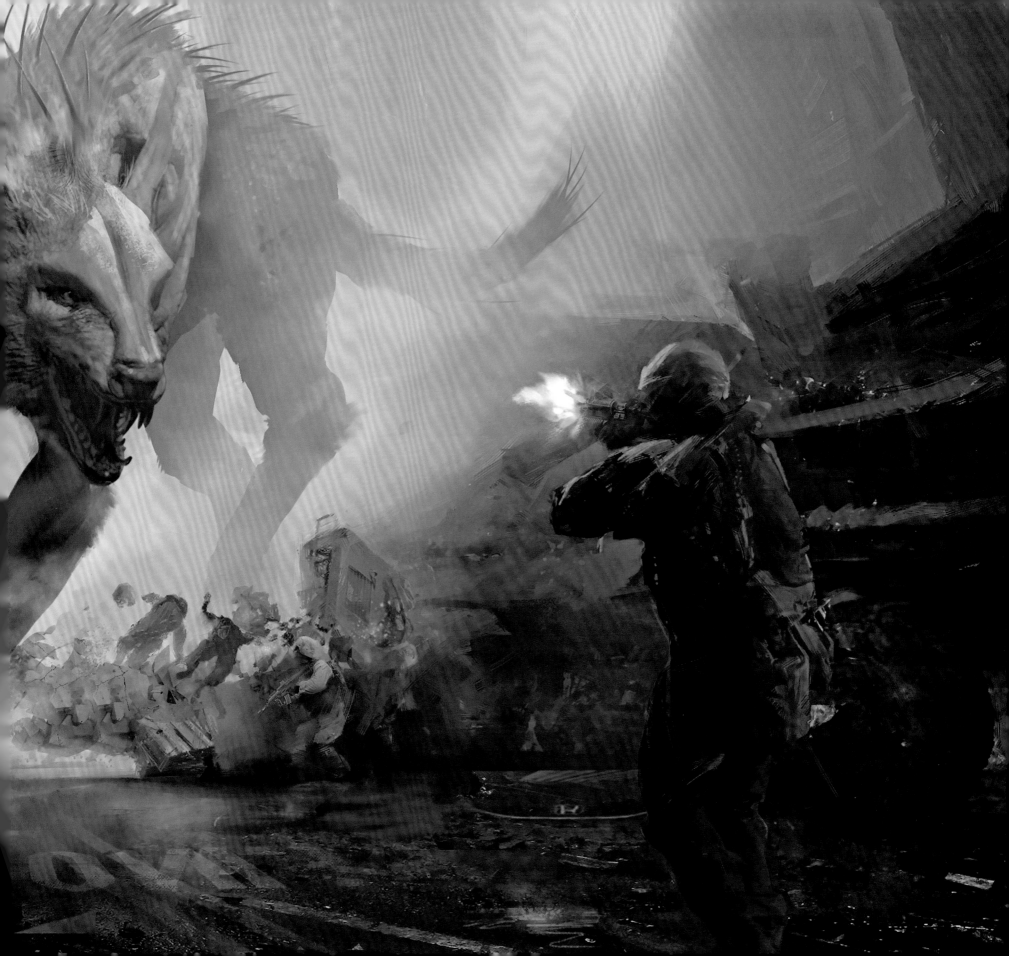

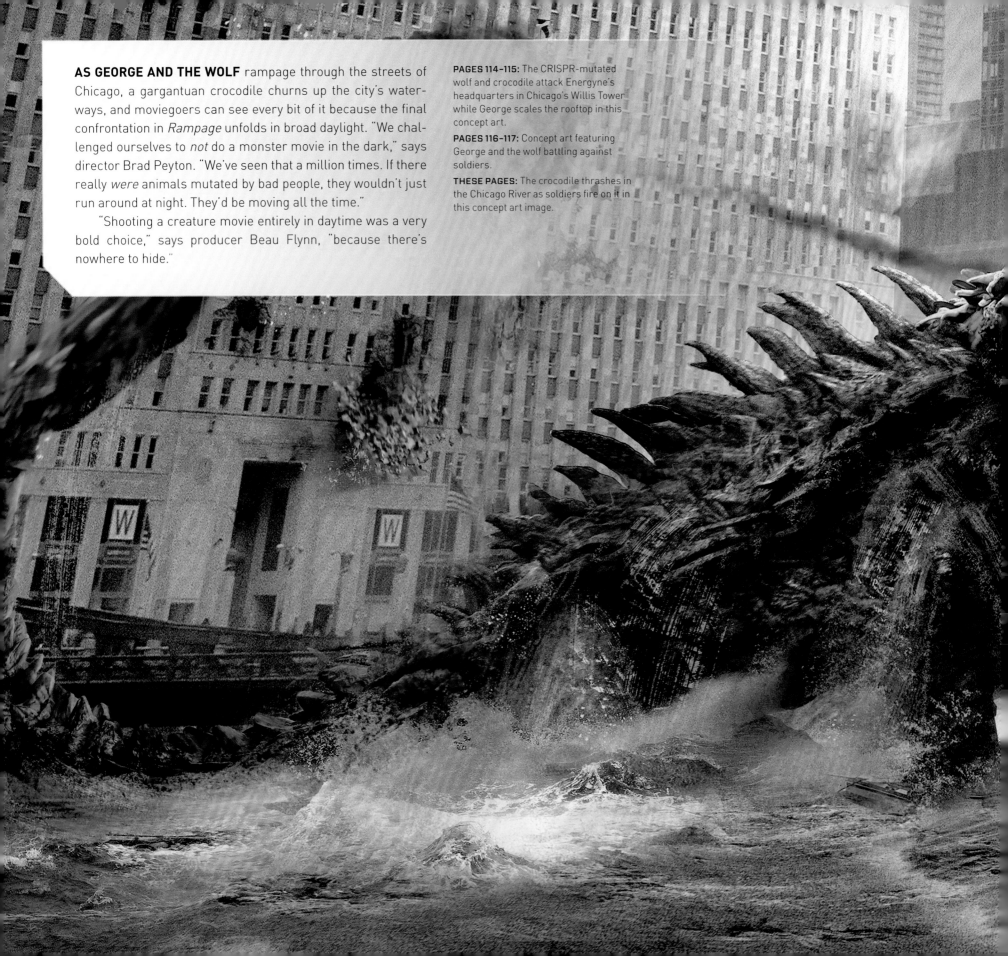

AS GEORGE AND THE WOLF rampage through the streets of Chicago, a gargantuan crocodile churns up the city's water-ways, and moviegoers can see every bit of it because the final confrontation in *Rampage* unfolds in broad daylight. "We challenged ourselves to *not* do a monster movie in the dark," says director Brad Peyton. "We've seen that a million times. If there really *were* animals mutated by bad people, they wouldn't just run around at night. They'd be moving all the time."

"Shooting a creature movie entirely in daytime was a very bold choice," says producer Beau Flynn, "because there's nowhere to hide."

PAGES 114–115: The CRISPR-mutated wolf and crocodile attack Energyne's headquarters in Chicago's Willis Tower while George scales the rooftop in this concept art.

PAGES 116–117: Concept art featuring George and the wolf battling against soldiers.

THESE PAGES: The crocodile thrashes in the Chicago River as soldiers fire on it in this concept art image.

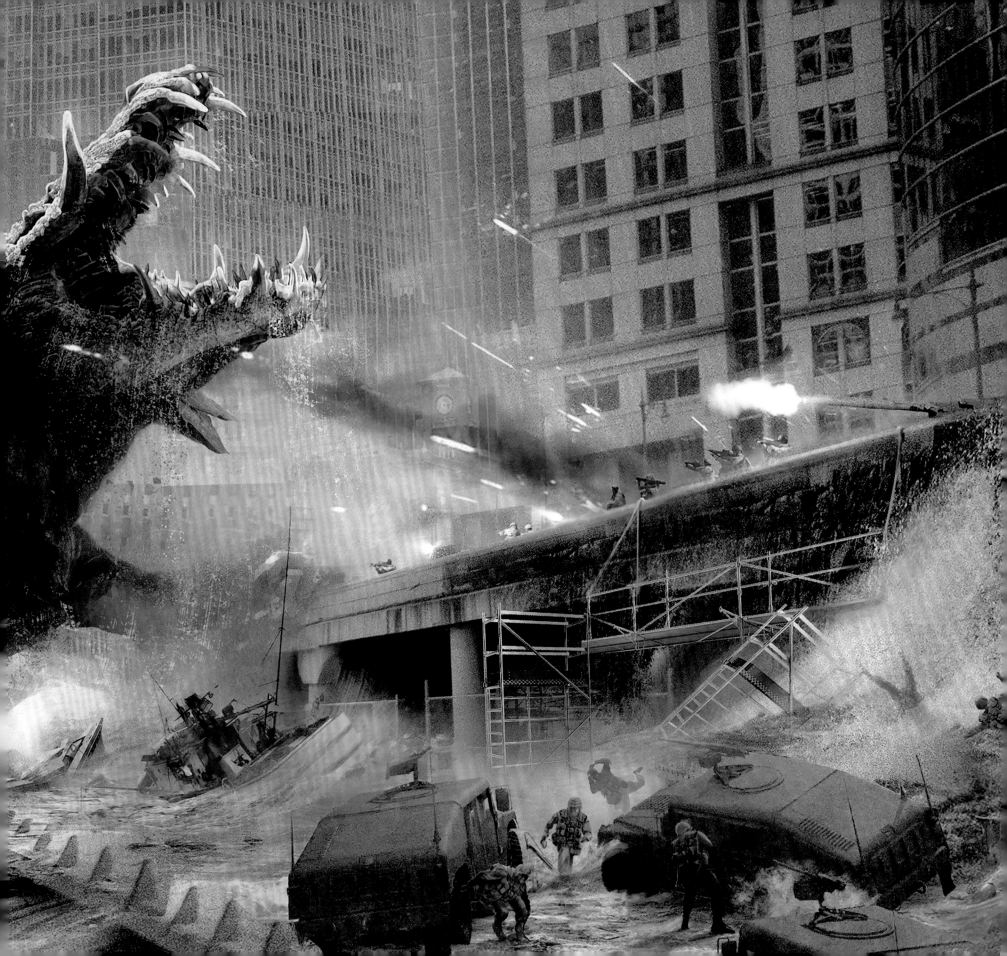

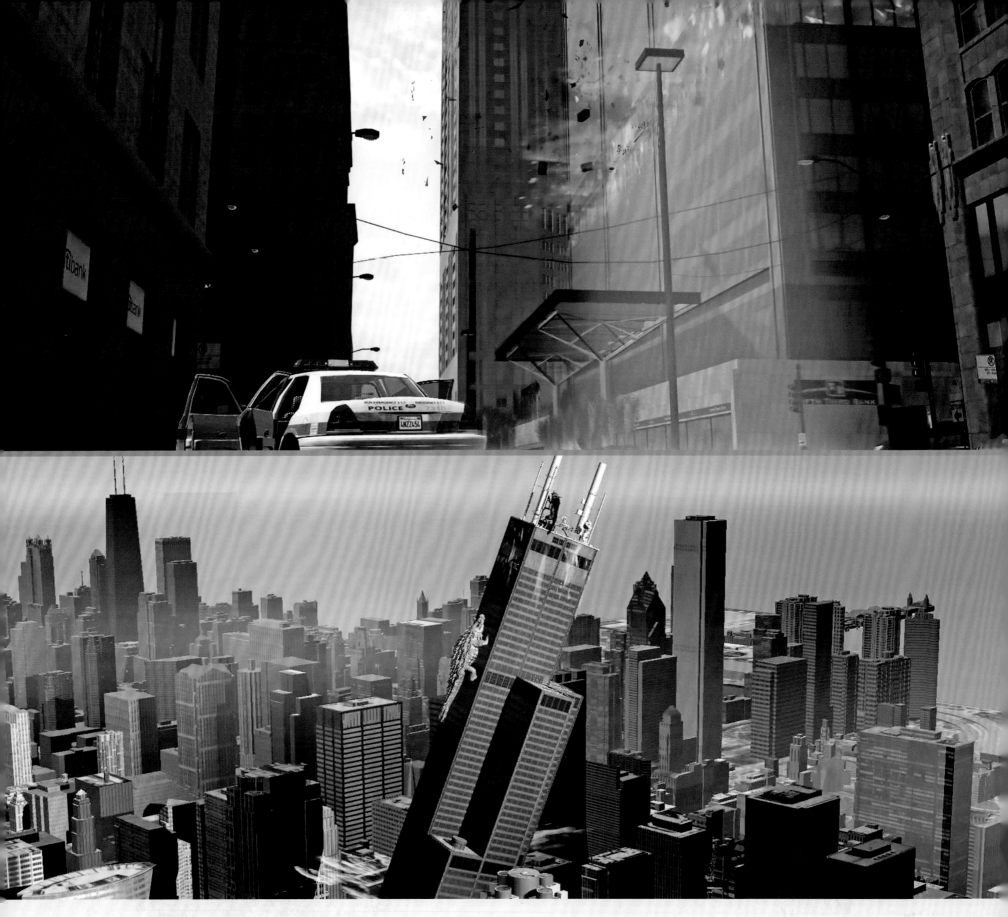

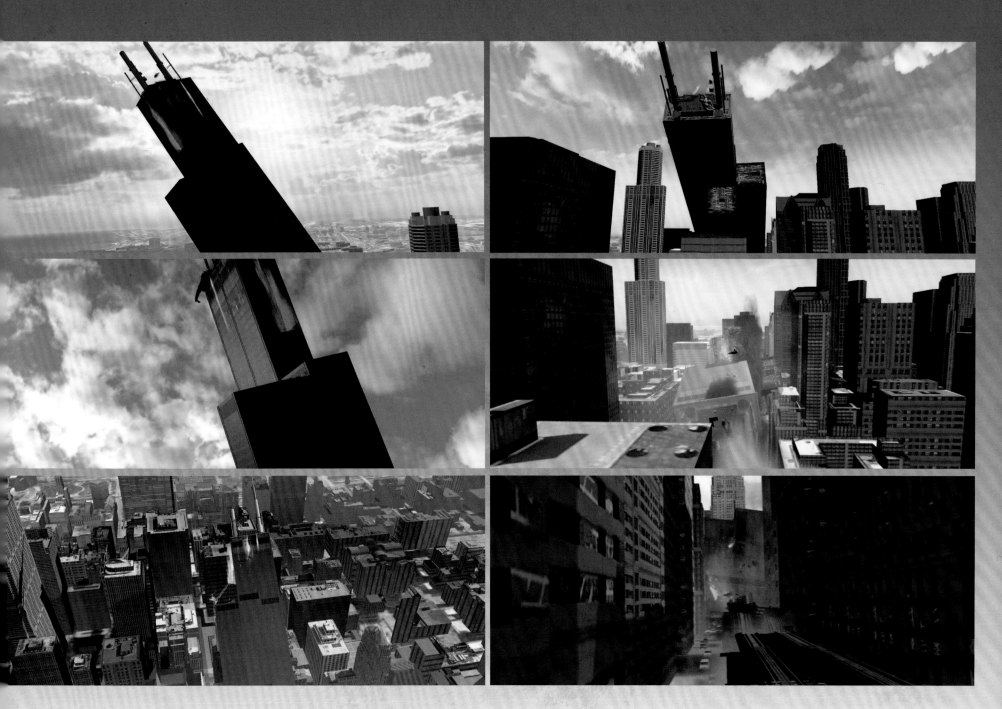

THESE PAGES: Previsualization images of Willis Tower crumbling under the weight of the creatures.

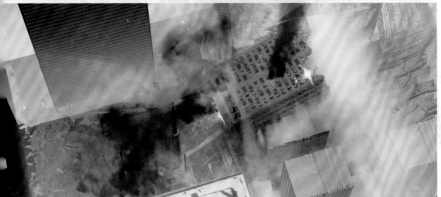

Weta supervisor Erik Winquist admits that depicting these monsters in full daylight made the task more complicated. "We had to make sure that our characters looked photo real from every possible angle. We scrutinized the wolf right up in his face, with saliva dripping off his teeth. We spent months zooming in on that."

The choice also necessitated a great deal of clear aerial photography, explains executive producer Marcus Viscidi. "We needed to be able to show the scope of the city's evacuation. We literally had to shut down Michigan Avenue, the boats on the river going through Chicago, and the bridges going over the river. For certain scenes, the camera flew just 15 feet above the ground." Viscidi notes that helicopter pilot Fred North captured these action shots. "He came around buildings and swooped down very close to the ground and then flew back up, which created the realism we needed. I wasn't even in the helicopter, and I was terrified."

Recreating the downtown buildings themselves required a mix of physical sets and digital extensions. "Almost every set was on some kind of motion base," adds Viscidi. "Even the rooftop of Willis Tower had to shake."

Production designer Barry Chusid recalls, "We planned everything with storyboards and previs, and then built the sets. Allan [Poppleton, the stunt supervisor] was figuring out the stunt choreography as we were building things. He had a warehouse where we literally mocked buildings up with cardboard boxes. Jonas Kirk, our construction coordinator, and his sculptors and mold makers actually built parts made out of foam so that stunt guys could bang into them and not get hurt. There was a 'dance' of different departments working together."

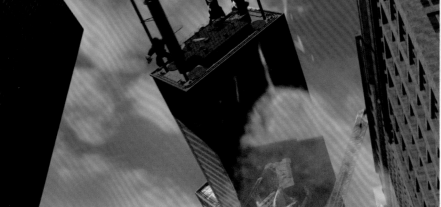

OPPOSITE TOP: A reference image of the crocodile hide is held up during filming.
OPPOSITE BOTTOM AND ABOVE: The filmmakers examined the structure and geography of Willis Tower while planning this sequence.
TOP: The crew filming in Chicago.

All of this effort was essential to depict the destruction of the city when the mutant creatures attacked. Visual effects supervisor Colin Strause was keenly focused on how the buildings would come apart, since his team at Los Angeles's Hydraulx studios would be responsible for the digital destruction. "Everything had to move," says Strause. "When George started ripping stuff apart, we had real pieces of debris that could be thrown near the actors. That looks more realistic because the actors are *reacting* and not just acting."

Naomie Harris remembers that well. "I thought I'd have to *imagine* the building shaking. But oh no," she laughs. "Bits of the building were falling off and it was all shaking. You got to *live* it, which really helps your performance."

Prior to filming, Brad Peyton showed the actors a previs of these complex shots to help them understand the action. "It's a three-dimensional blueprint," the director explains. "It's a visual representation that the actors and the crew can lock onto. When actors are running around in an environment that isn't completely real, or will have large amounts of augmentation added later, I can show them what they're going for. I imagine that when Naomie Harris was a young girl deciding to become an actress, she didn't picture herself in front of a green screen talking to an imaginary gorilla that's five stories tall. When you give someone information, they can just let go, and act."

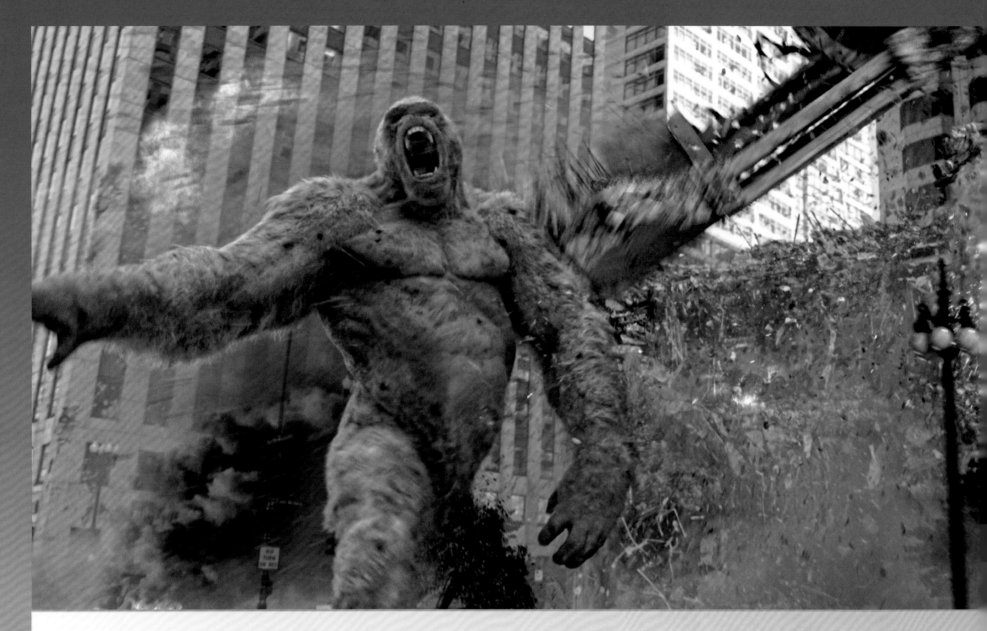

For his part, Dwayne Johnson knew what to expect from VFX movie-making: "When you are ultimately going against a 100-foot-long croco-dile, a gigantic wolf, and an albino gorilla that stands multiple stories tall, great imagination is required."

Cinematographer Jaron Presant, who also shot second unit on *San Andreas*, explains, "The VFX guys had iPads showing 360-degree virtual reality sets. So you could stand in a spot on a set and see all of Chicago—where the buildings were and how tall the characters were. When we wanted to frame up to George, we could see how tall he was."

VFX supervisor Colin Strause notes, "It's not all these big omnipotent 'god cams' as we call them, where you just got the wide city shots. Brad wants it to be about character, character, character. He wants [viewers]

to experience what Dwayne's experiencing and show it from his charac-ter's perspective."

Jaron Presant recalls, "One of the key things that Brad spoke about early on, and we were committed to, was making sure that we always had something [in frame] that gives you perspective. In studying mon-ster movies, if all you see are a couple of monsters battling, you don't have a sense of scale. We always wanted to have a sense of scale. When you're looking at the animals, you want to have streetlights or cars in the foreground that give you that sense of scale. So we can sense how big these things are. When the audience loses that they lose a big piece of the story."

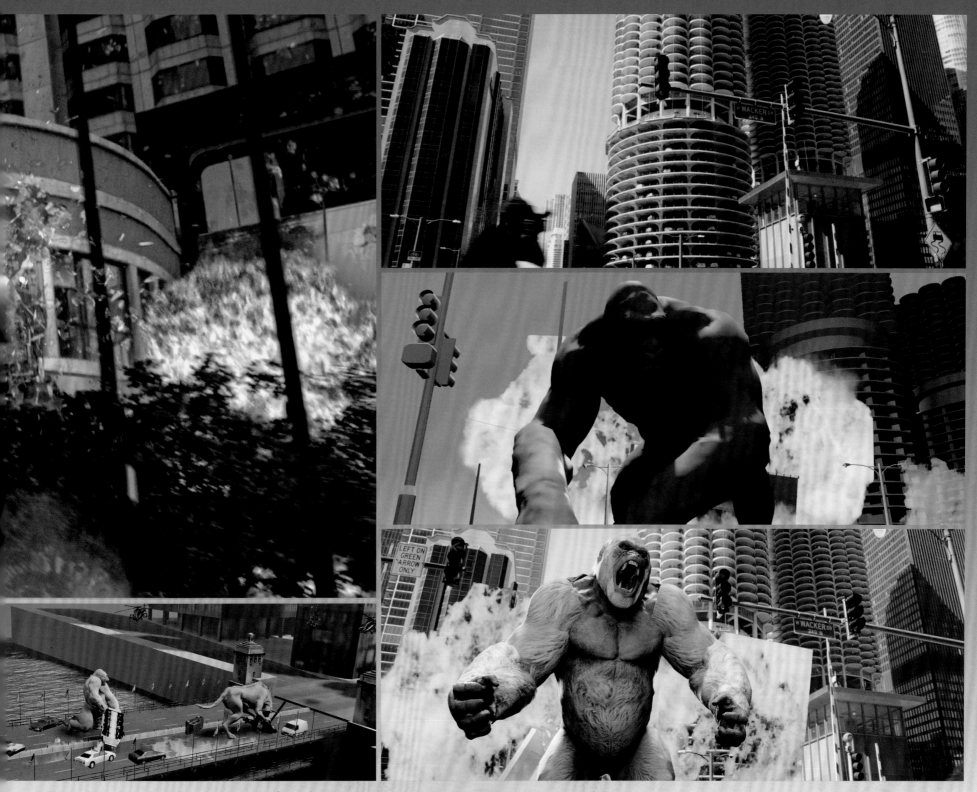

OPPOSITE: A completed visual effects image showing George in a rage.

ABOVE: Previsualization of George and the wolf destroying cars.

RIGHT: A visual effects progression sequence showing the fully mutated George in a rage.

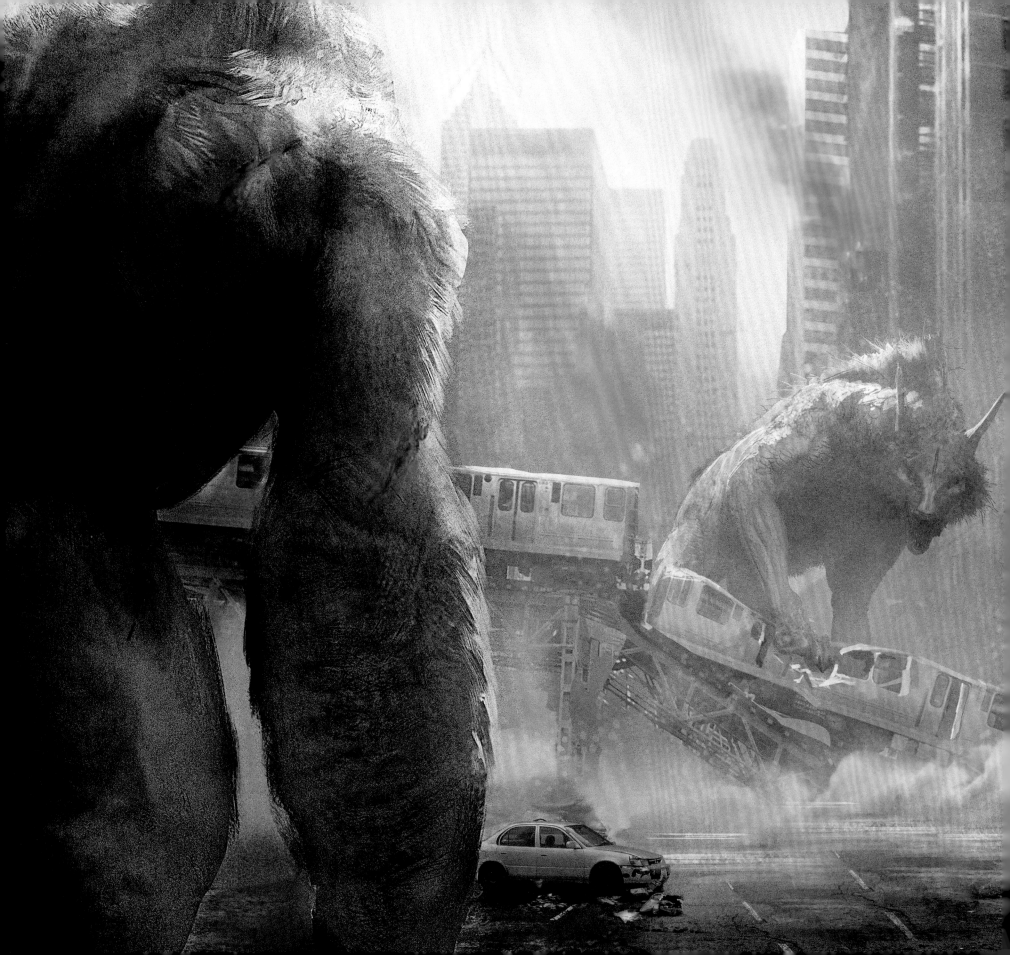

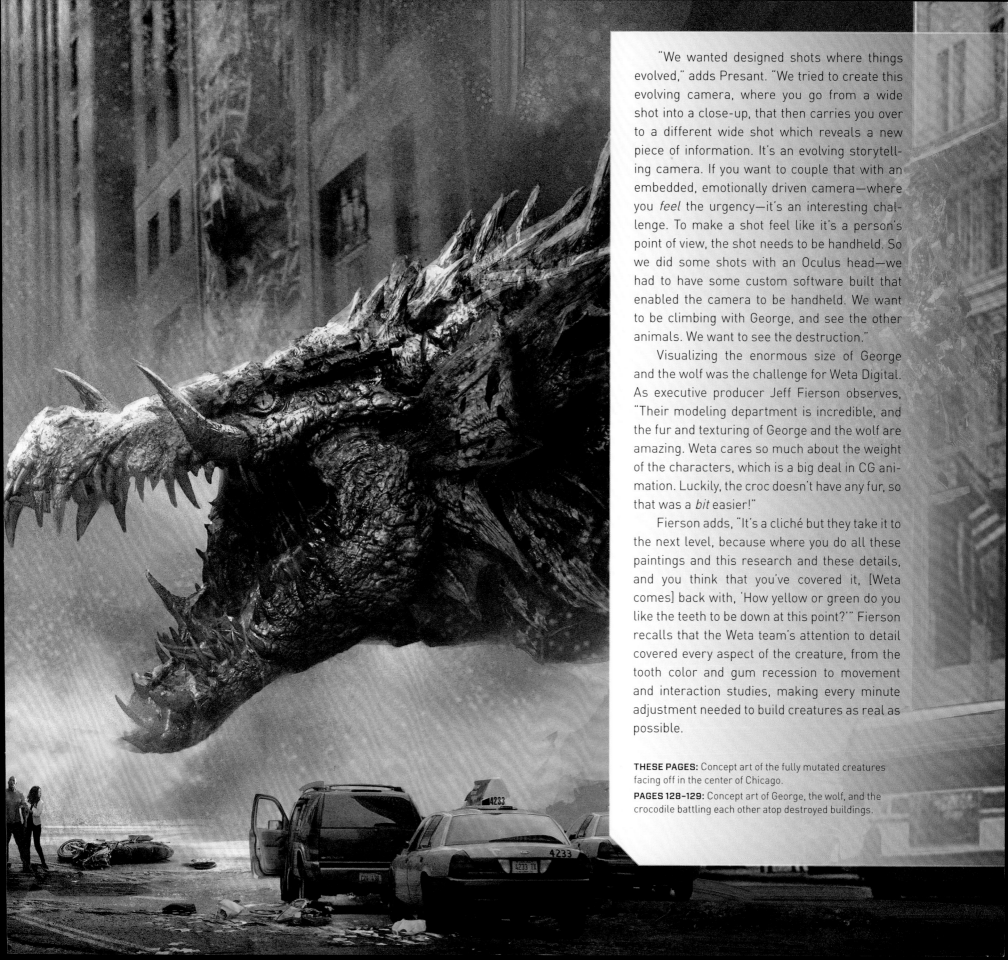

"We wanted designed shots where things evolved," adds Presant. "We tried to create this evolving camera, where you go from a wide shot into a close-up, that then carries you over to a different wide shot which reveals a new piece of information. It's an evolving storytelling camera. If you want to couple that with an embedded, emotionally driven camera—where you *feel* the urgency—it's an interesting challenge. To make a shot feel like it's a person's point of view, the shot needs to be handheld. So we did some shots with an Oculus head—we had to have some custom software built that enabled the camera to be handheld. We want to be climbing with George, and see the other animals. We want to see the destruction."

Visualizing the enormous size of George and the wolf was the challenge for Weta Digital. As executive producer Jeff Fierson observes, "Their modeling department is incredible, and the fur and texturing of George and the wolf are amazing. Weta cares so much about the weight of the characters, which is a big deal in CG animation. Luckily, the croc doesn't have any fur, so that was a *bit* easier!"

Fierson adds, "It's a cliché but they take it to the next level, because where you do all these paintings and this research and these details, and you think that you've covered it, [Weta comes] back with, 'How yellow or green do you like the teeth to be down at this point?'" Fierson recalls that the Weta team's attention to detail covered every aspect of the creature, from the tooth color and gum recession to movement and interaction studies, making every minute adjustment needed to build creatures as real as possible.

THESE PAGES: Concept art of the fully mutated creatures facing off in the center of Chicago.

PAGES 128-129: Concept art of George, the wolf, and the crocodile battling each other atop destroyed buildings.

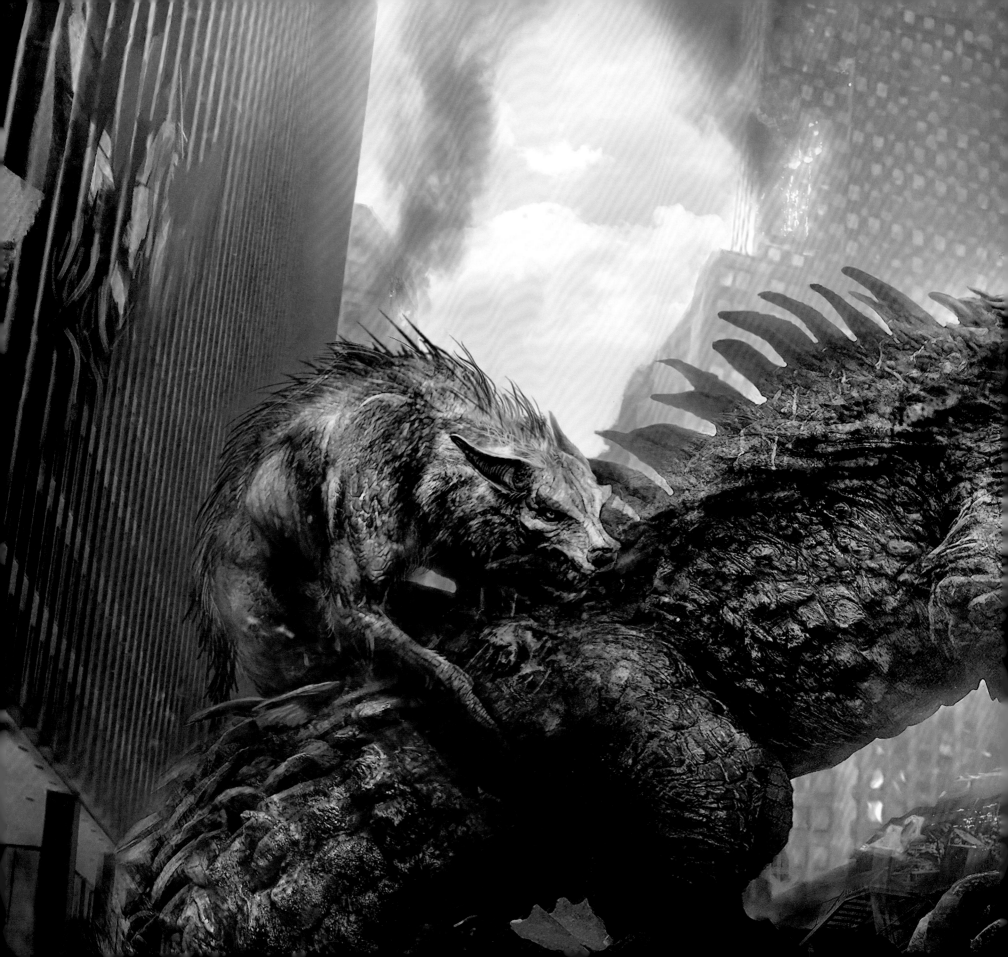

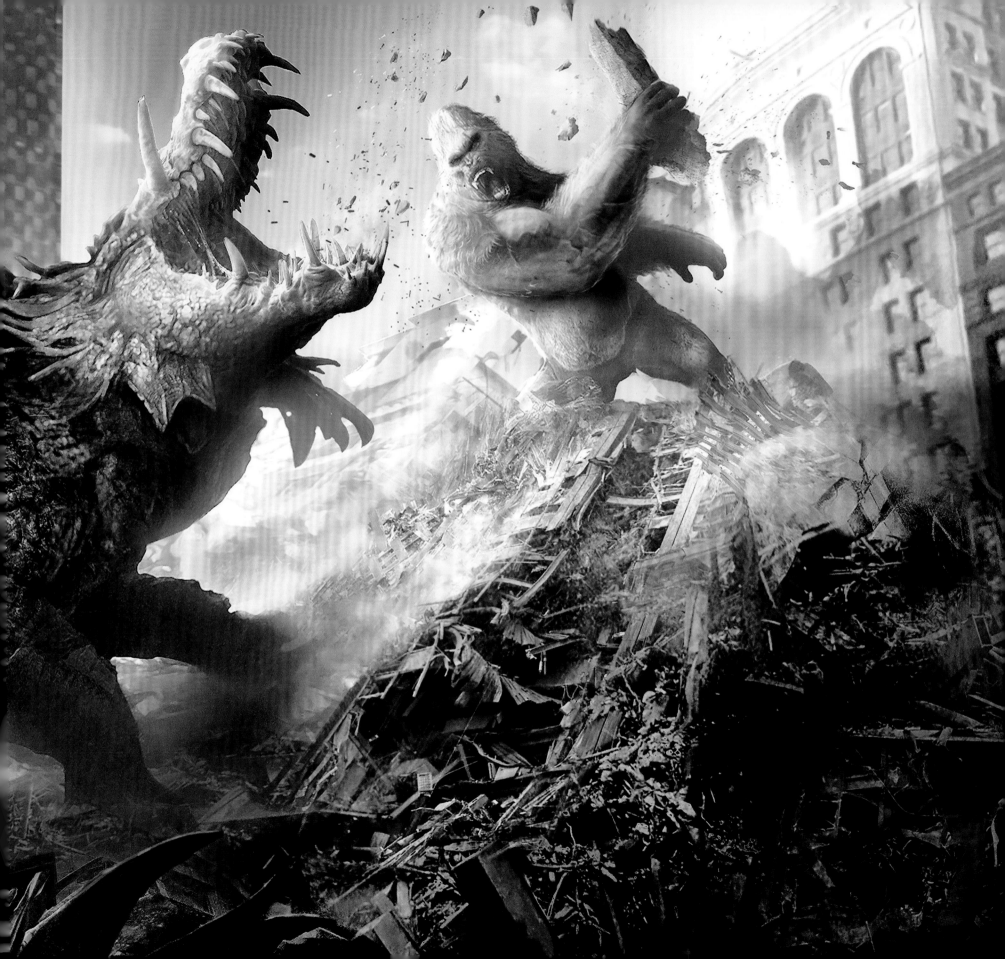

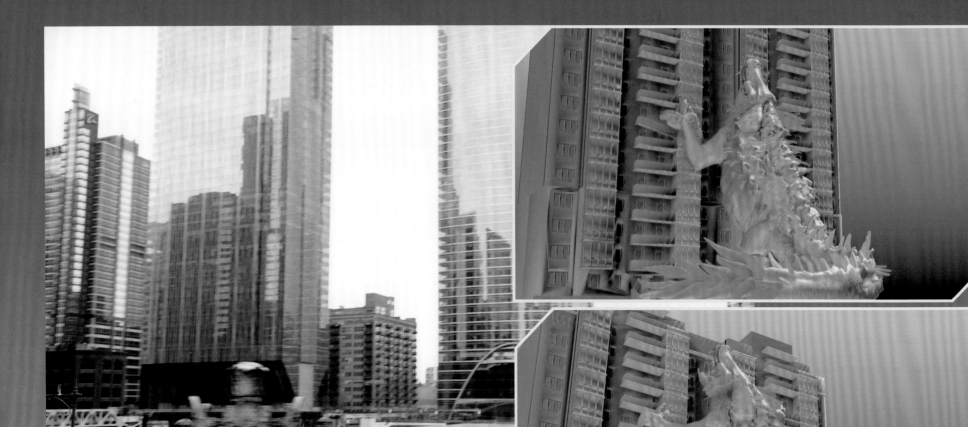

Movement studies were especially important in wider city shots. As the crocodile swims into Chicago and toward Willis Tower, it does more than displace huge amounts of water. Producer John Rickard notes, "When it is coming through the streets, its tail is literally scraping the sides of buildings. It just doesn't care."

Colin Strause adds, "We did motion studies on how the creatures move through the cities, and the croc's definitely been the biggest challenge. George is sort of like a juggernaut and can just run and put his shoulder through things. The wolf is speed and hopping, jumping on five- or six-story-tall buildings. The crocodile was a whole different level because it's basically the width of a four- or five-lane road."

ABOVE AND OPPOSITE: An image sequence showing the Chicago location reference, previsualization, in-progress effects, and final image of the crocodile leaping from the river.

INSETS: Previsualization images of the crocodile exhibiting gecko-like climbing abilities.

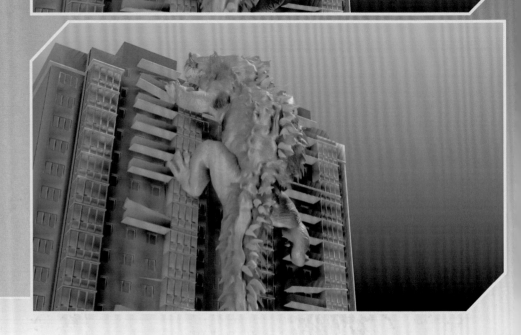

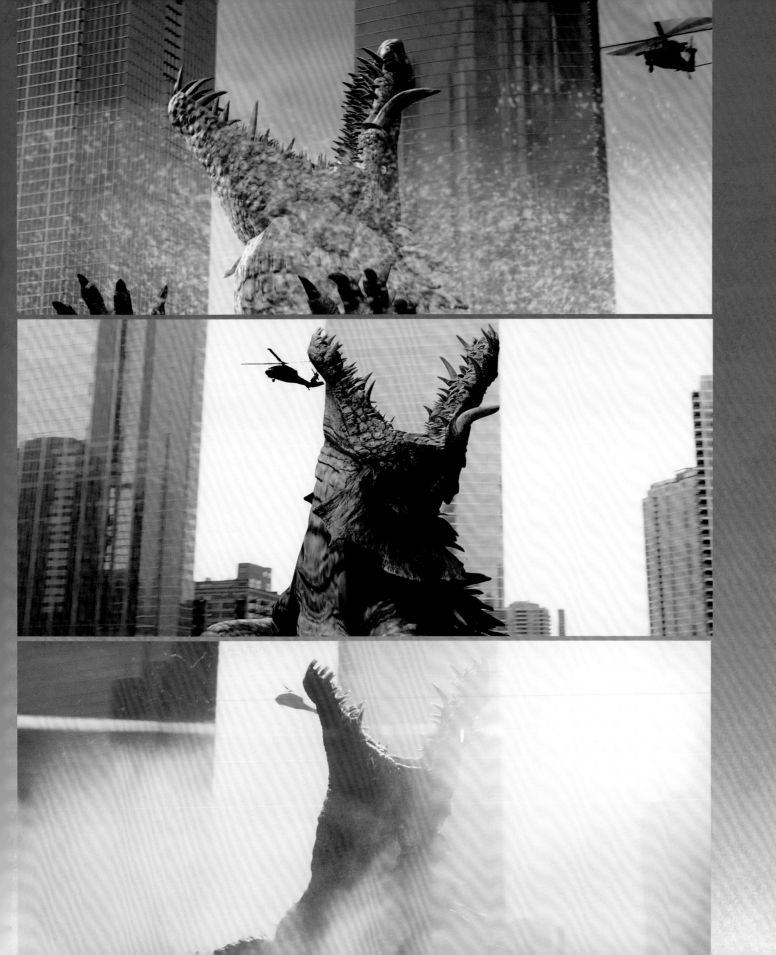

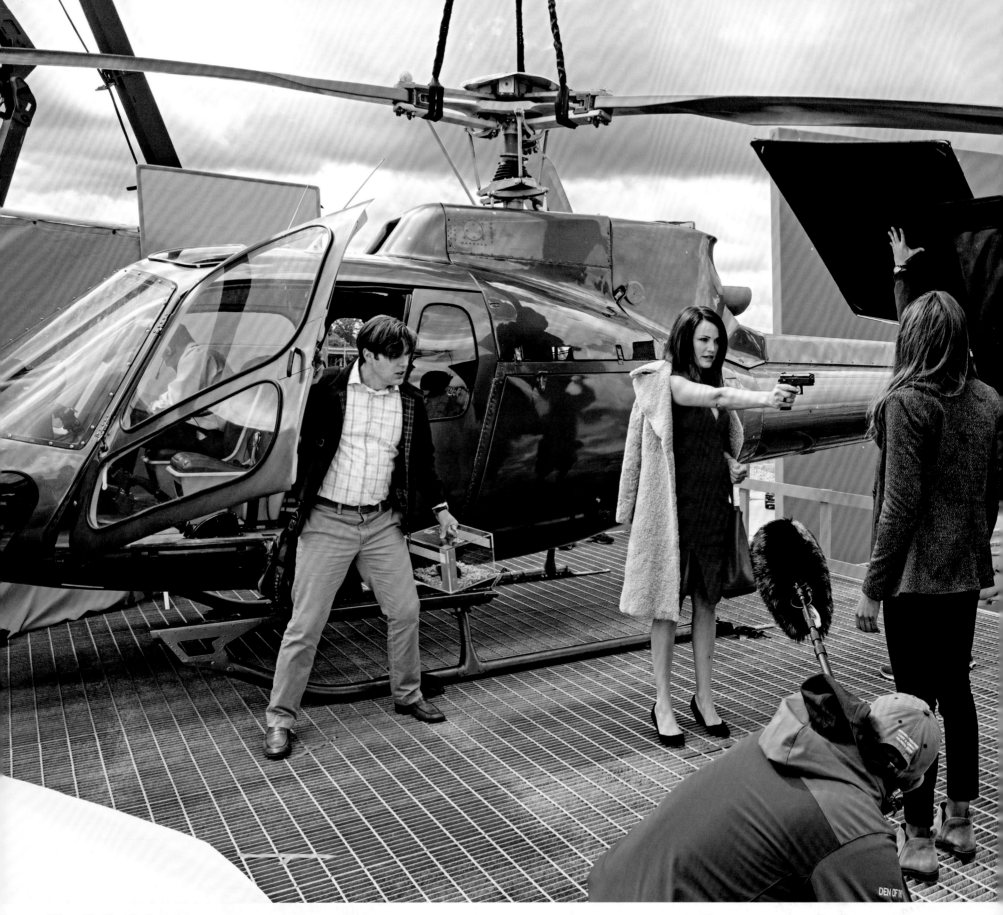

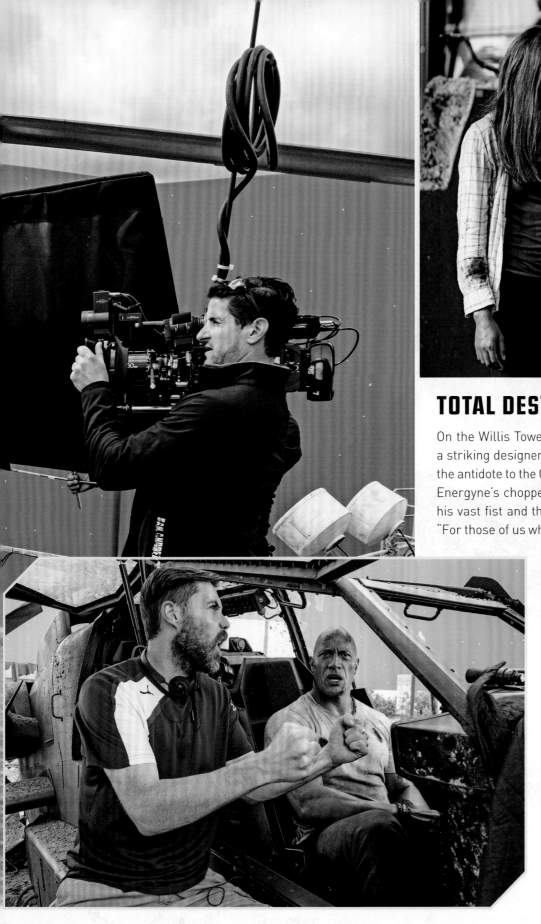

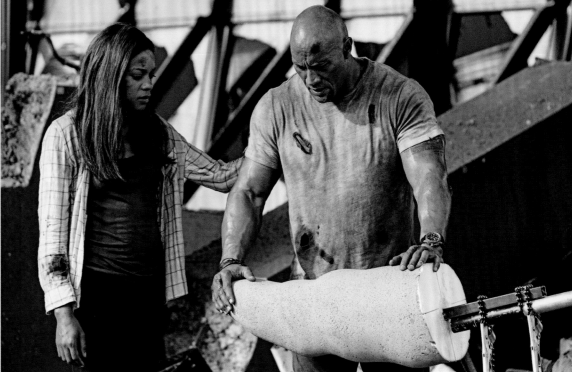

TOTAL DESTRUCTION

On the Willis Tower heliport, Claire Wyden attempts to escape. Dressed in a striking designer red dress, Claire carries a purse into which Kate shoves the antidote to the CRISPR pathogen. George thwarts her escape by crushing Energyne's chopper, and amidst the chaos, he grabs Claire with a swipe of his vast fist and then drops her—*and* the healing antidote—into his mouth. "For those of us who remember the original *Rampage* game," says producer Beau Flynn, "The gorilla swallowing the woman in the red dress is the ultimate Easter egg."

Stunt supervisor Allan Poppleton recalls the shot happily. "We made a green mock gorilla finger that one of our stunt guys could wear on his arm. We had the actress and the stunt guy in a green suit on a cable, and then we pulled both of them up into the air. I enjoy trying to come up with ways that we can help actors perform with creatures that aren't actually there."

The battle rages on as the crocodile's force begins to topple the building. VFX supervisor Colin Strause observes, "The outside of Willis Tower isn't load-bearing. It just supports the glass facade. The middle is where the main core of the structure is. The crocodile doesn't get that high up but it cuts through [to the core] around the thirtieth and the fortieth floors. That's when the floors literally start imploding—it's like someone cut [through] the bottom of a tree—and that's what [causes] the building to actually start to come down."

LEFT: Claire (Malin Akerman) and Brett Wyden (Jake Lacy) attempt to escape from the Willis Tower rooftop.

TOP: A mock gorilla finger was created for actors to interact with.

INSET: Brad Peyton directs Dwayne Johnson.

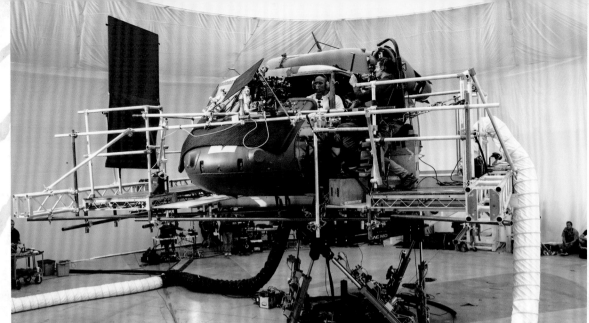

Production designer Barry Chusid notes, "We analyzed when the Willis Tower comes down, we looked at what buildings it would hit, and then we started doing research into actually what those buildings were, and what their building materials actually were, and tried to duplicate them as best we could."

As the building begins falling, Davis and Kate climb aboard the Wydens' crippled chopper, and literally "ride" it down to the ground. Jason Presant says, "While the helicopter was falling, it was spinning around, so we had to have light spinning around it. As they fall, they go into a giant cloud of dust and debris." All the while, the audience plummets with them. Brad Peyton stresses, "It's like you're riding an avalanche. I wanted to embed you in the event, rather than having you witness something happening over *there*."

When Davis and Kate emerge from the rubble, they find George able to sign to Davis once again. He is still gigantic, and this final confrontation accomplished a rare feat: Dwayne Johnson looks dwarfed by the sheer scale of the destruction. Brad Peyton recalls with a smile, "Someone in the crew said, 'You're the only person who's ever made Dwayne Johnson look small.' I think Dwayne got a kick out of this too. He had to do things he'd never done before, like jumping into buildings and facing creatures one hundred times his size. He usually dwarfs everyone else!"

Johnson concludes, "I've had the opportunity to do some really cool things in my films. I've ridden a tsunami and punched an earthquake in the face. But surviving three monsters taking down Willis Tower and destroying Chicago ranks pretty high up there for me."

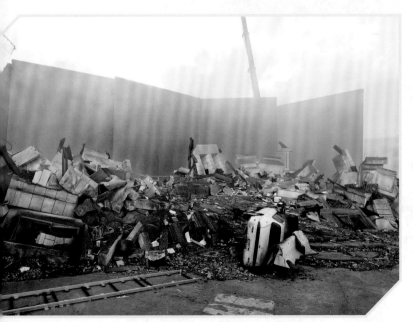

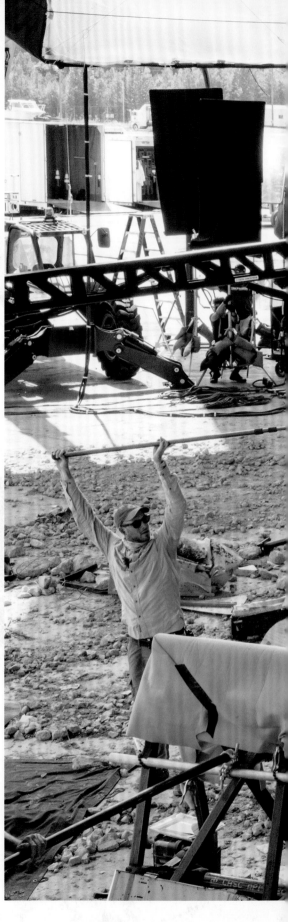

TOP: Johnson aboard a helicopter rig atop a motion base.

LEFT: A set featuring rubble and an overturned vehicle.

RIGHT: Dwayne Johnson as Davis Okoye continues to sign to his enormous gorilla friend. The green foam hand gives perspective on how large George has grown.

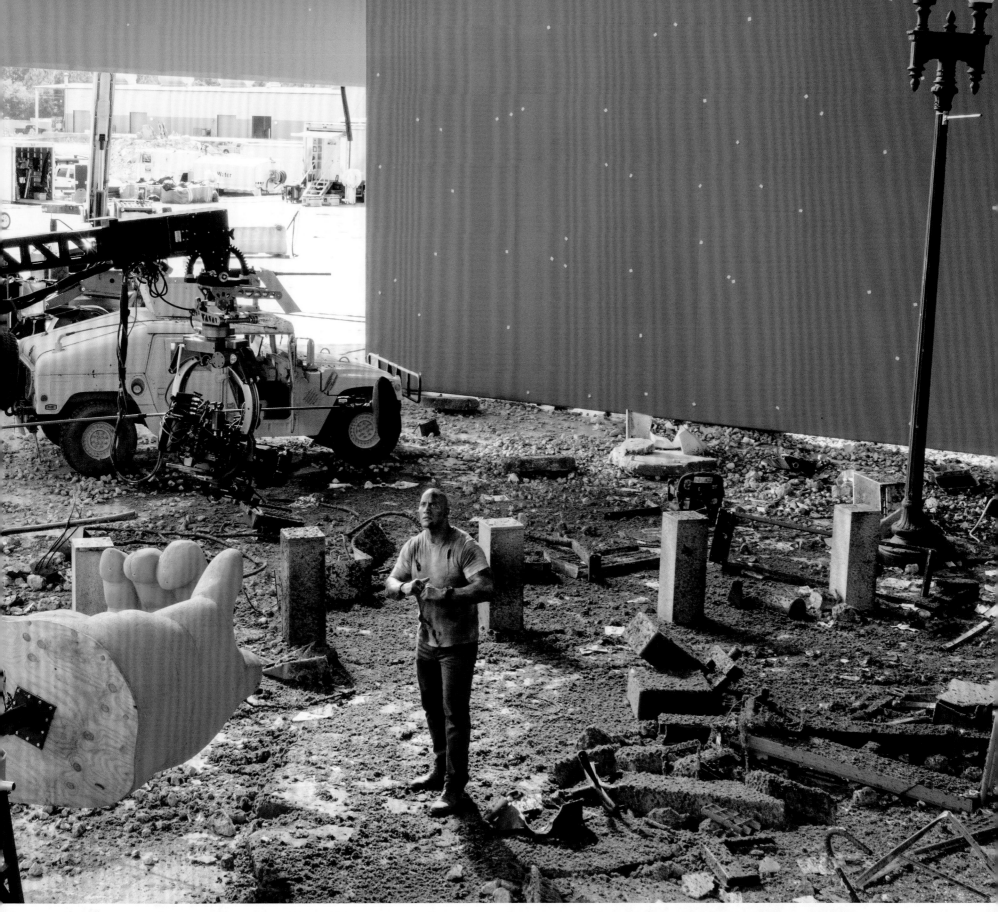

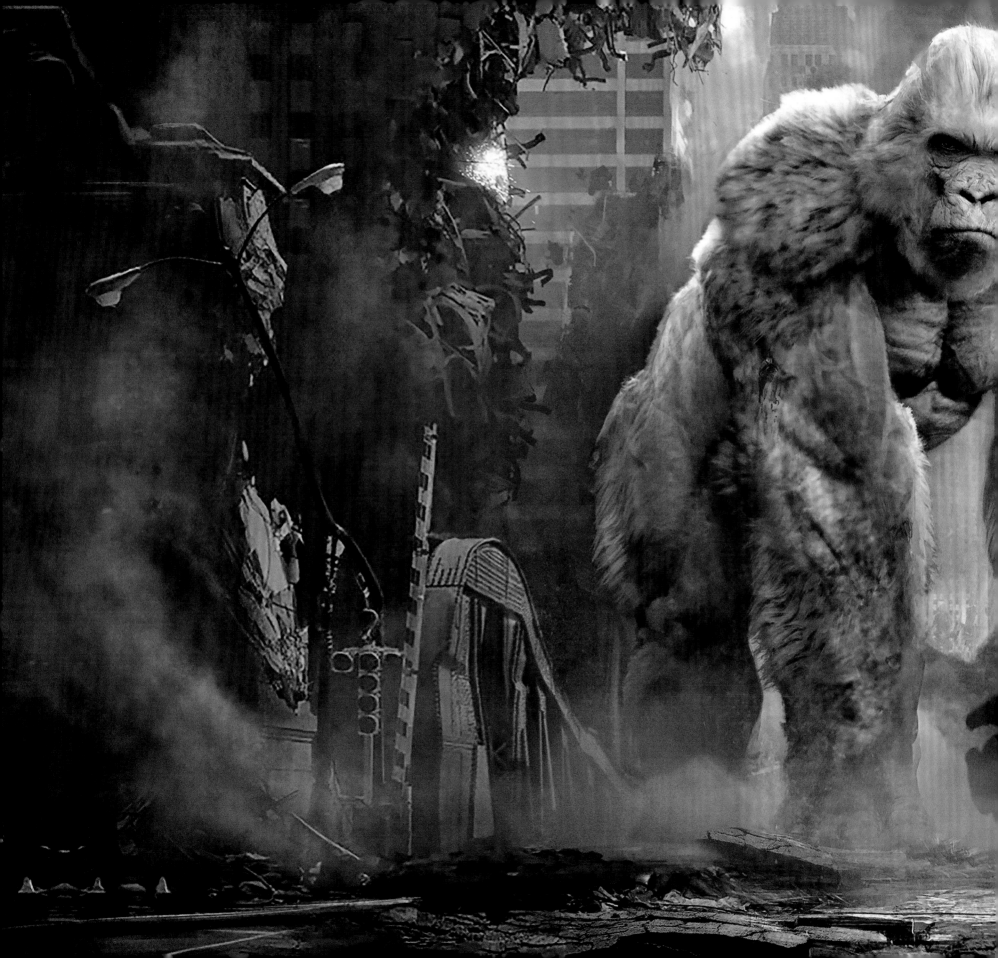

CHAPTER 08
CONCLUSION

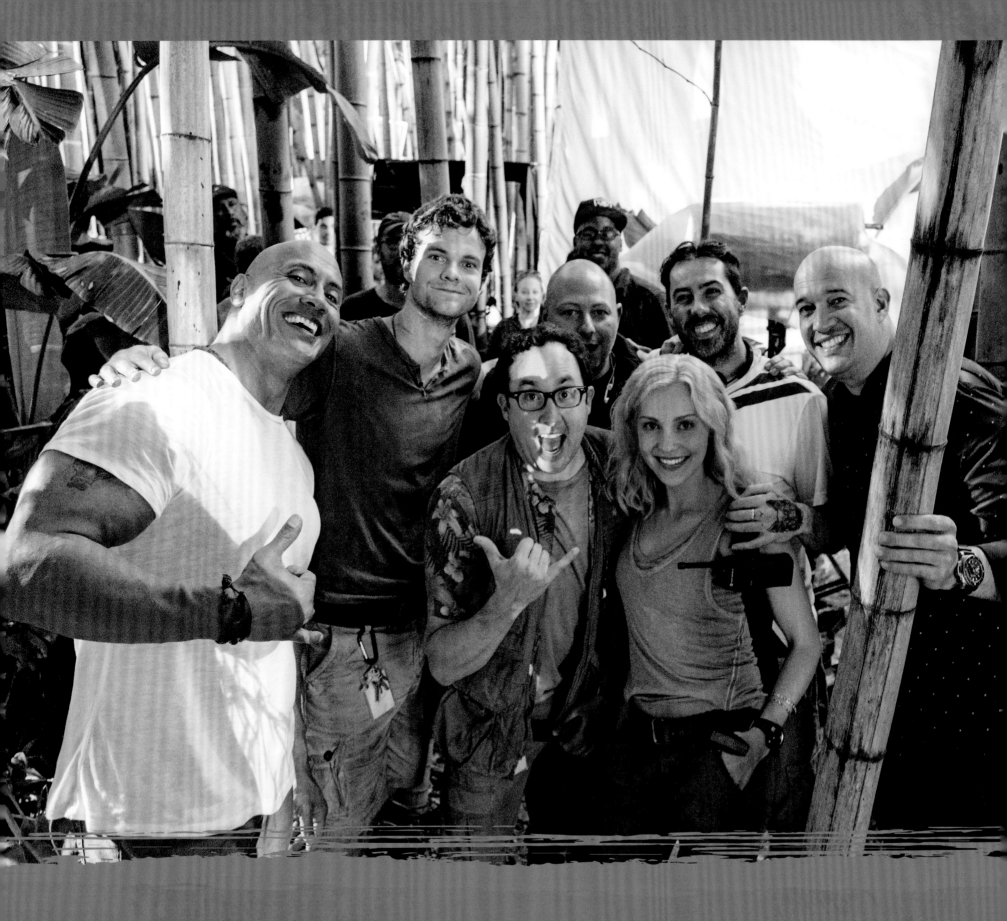

"DWAYNE JOHNSON IS A RARE SPECIMEN," says producer Beau Flynn, reflecting on the emotional relationship between Davis and George. "From the outside he may appear tough, but he's also one of the most intelligent, thoughtful, and sensitive people I've ever met. Why would we not want to present that side of him in his movies? That's a big part of what makes him so incredibly successful."

Summing up the unique collaboration that Flynn, Johnson, producer Hiram Garcia, and director Brad Peyton have enjoyed on three feature films thus far, Peyton remarks, "We have a similar work ethic and it's built on a foundation of respect and trust. That goes a long way when you're making a movie. I think it allows us to get the best from each other. We drive each other to do the best we can. I think audiences see and appreciate that."

Garcia adds, "The group's shared belief of 'the best idea wins' becomes invaluable when striving to create the absolute best version of the movie we can create."

Since visual effects were so essential to creating the complexities of *Rampage*, Peyton valued his relationships with experts like VFX supervisor Colin Strause, composer Andrew Lockington, stunt supervisor Allan Poppleton, and production designer Barry Chusid. The opportunity to work for the first time with Weta Digital only extended Peyton's vision for what was possible with CG creature animation. "I think Weta was really excited by the challenge of taking three vastly mutating creatures and changing their scale dramatically in one ninety-minute movie. It was something they hadn't done before. They added details to our shots that reinvigorated the images all over again."

The performance-capture artistry in *Rampage* is also one of the biggest takeaways from this filmmaking experience for Peyton. "Somewhere down the road, if film continues to trend the way the way it's going," Peyton muses, "I won't be shocked if the acting of these performers is given the attention and respect that it deserves."

The interaction between Dwayne Johnson as Davis and Jason Liles as George also proved to be a great motivator for cast members like Naomie Harris, who is known primarily for dramatic films without this level of visual effects. As Harris puts it, "I just absolutely fell in love with George. I also fell in love with how strong and intelligent and well-rounded my character was. You don't get a lot of female characters like that. I think it's so rare that an actor can be part of an action movie where there's so much heart to it as well. When you get an action movie plus heart and soul, that's what people really connect with."

PAGES 136–137: Concept art featuring George and Davis.
THESE PAGES: The cast and crew of *Rampage*.

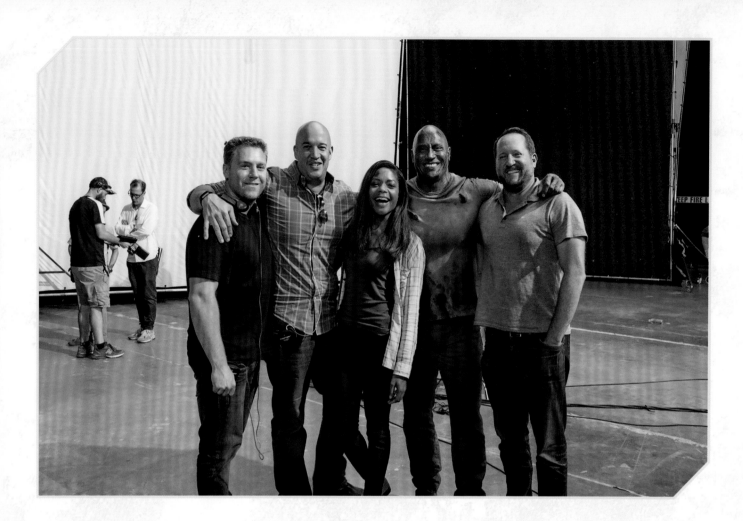

The combination of great emotion and stunning effects makes for what producer Hiram Garcia calls "a helluva ride." Audiences will be able to see that on giant IMAX screens worldwide, and some will even get to see *Rampage* converted into 3-D stereo. As Dwayne Johnson notes, "When people see the amazing details in this movie, it's gonna be game over."

Director Brad Peyton had that prospect in mind while filming *Rampage*. "My style of shooting involves a lot of moving camerawork, going in front of and in back of a character, which is fundamentally good for 3-D stereo. We have also shot in stereo in the past, with *Journey 2: Mysterious Island*. Before shooting that movie, I mapped out all the moments that would be three-dimensional. So I've carried that experience into the movies I've done since then, which have all been converted into stereo."

The team has a lot of memories to take away from the making of *Rampage*, but Johnson in particular has a very tangible memento of the experience. At the film's wrap party, Peyton gifted Johnson with a vintage version of the original *Rampage* arcade game. Peyton later noticed that Johnson posted an image of it on his Instagram account: "Dwayne even brought it with him on the next movie he is shooting. He set up the game so that he can constantly play it and not have to feed it quarters!"

"I'm proud to say I'm still the best damn *Rampage* player out there," says Johnson.

LEFT: Dwayne Johnson and Brad Peyton with the vintage *Rampage* arcade game Peyton gifted Johnson.
TOP: Actors Dwayne Johnson and Naomie Harris with producers John Rickard, Hiram Garcia, and Beau Flynn.

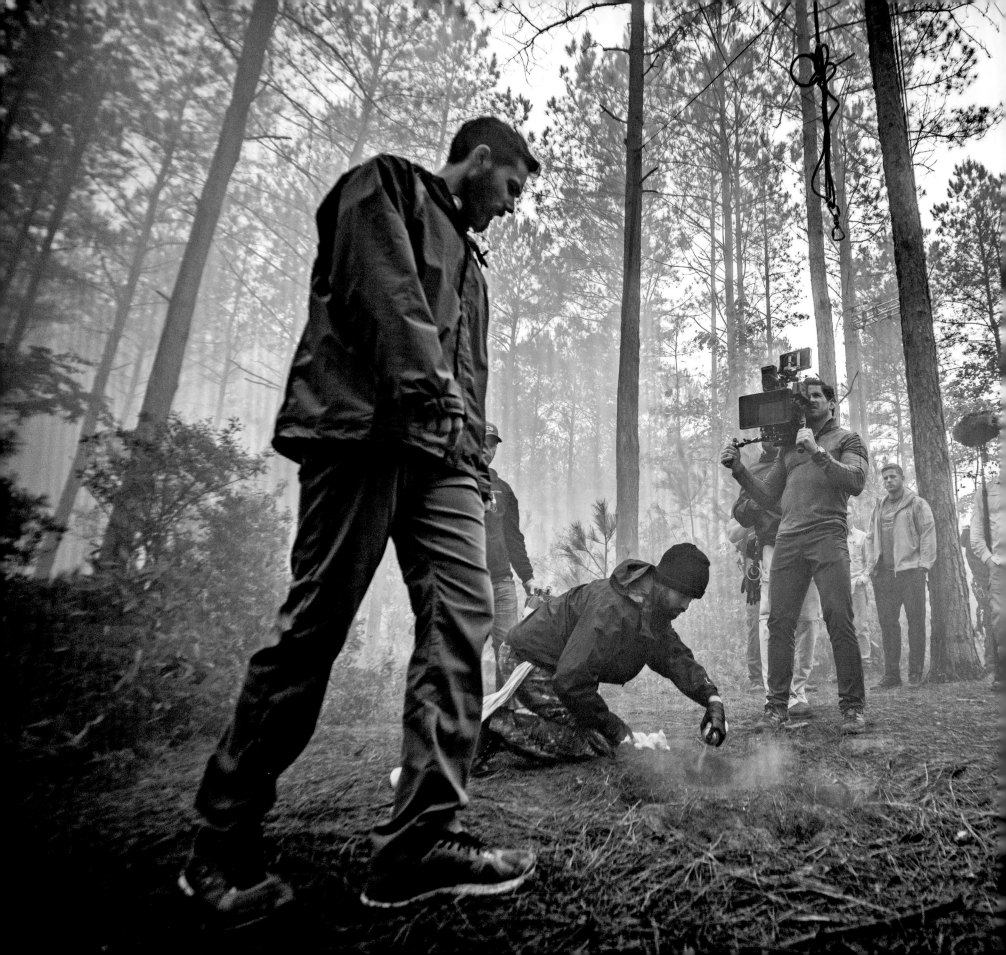

IMAGE GALLERY: CAPTURING *RAMPAGE*

On-Set Images Taken by Producer Hiram Garcia

"Being a producer in the film industry has afforded me the privilege of seeing many wonderful things and traveling to many great places. When you are on the road as much as we are, you gravitate toward pastimes that allow you to connect and share moments with loved ones who can't be with you. For me, that hobby has become telling stories through pictures. *Rampage*, in particular, had so many special moments that I wanted to share with family as well as our amazing fans on social media. People love a peek behind the curtain, so it's been a blast for me to express myself creatively via the images I take, and I hope fans enjoy this special behind-the-scenes look into the art and making of *Rampage*."

LEFT: The cast and crew prepare the mutated wolf's track.

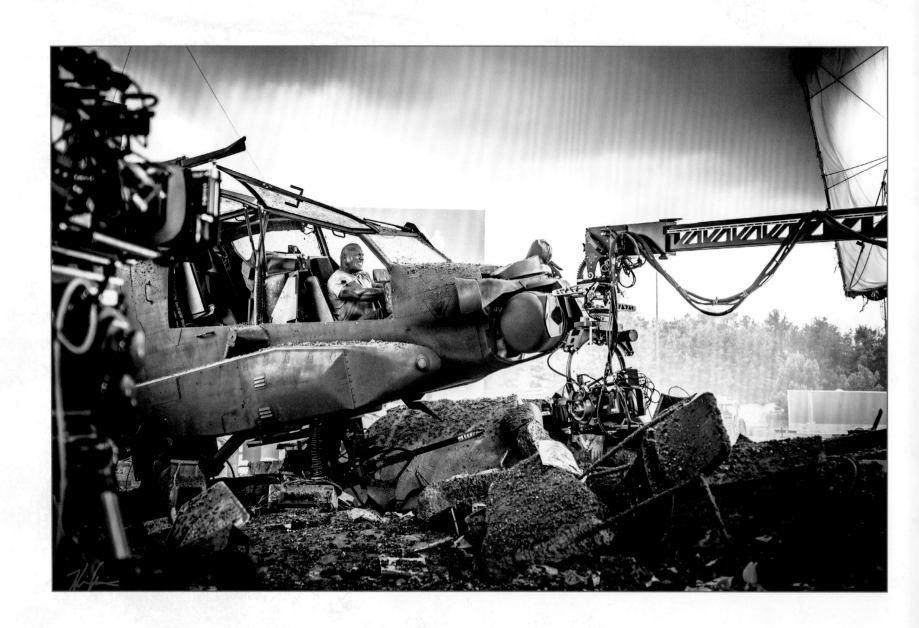

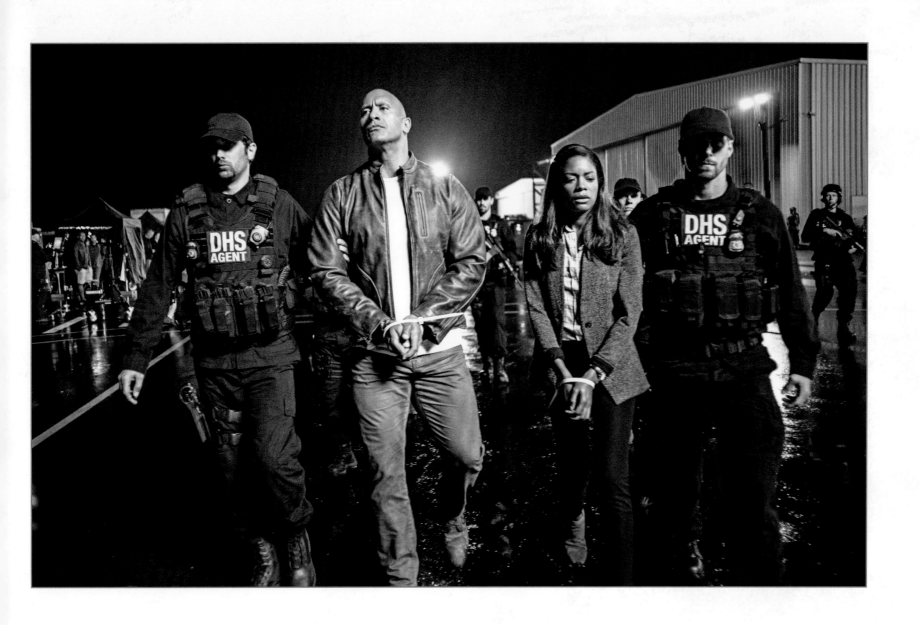

OPPOSITE: Dwayne Johnson filming in the helicopter.

THIS PAGE: Davis and Kate are escorted by Department of Homeland Security agents.

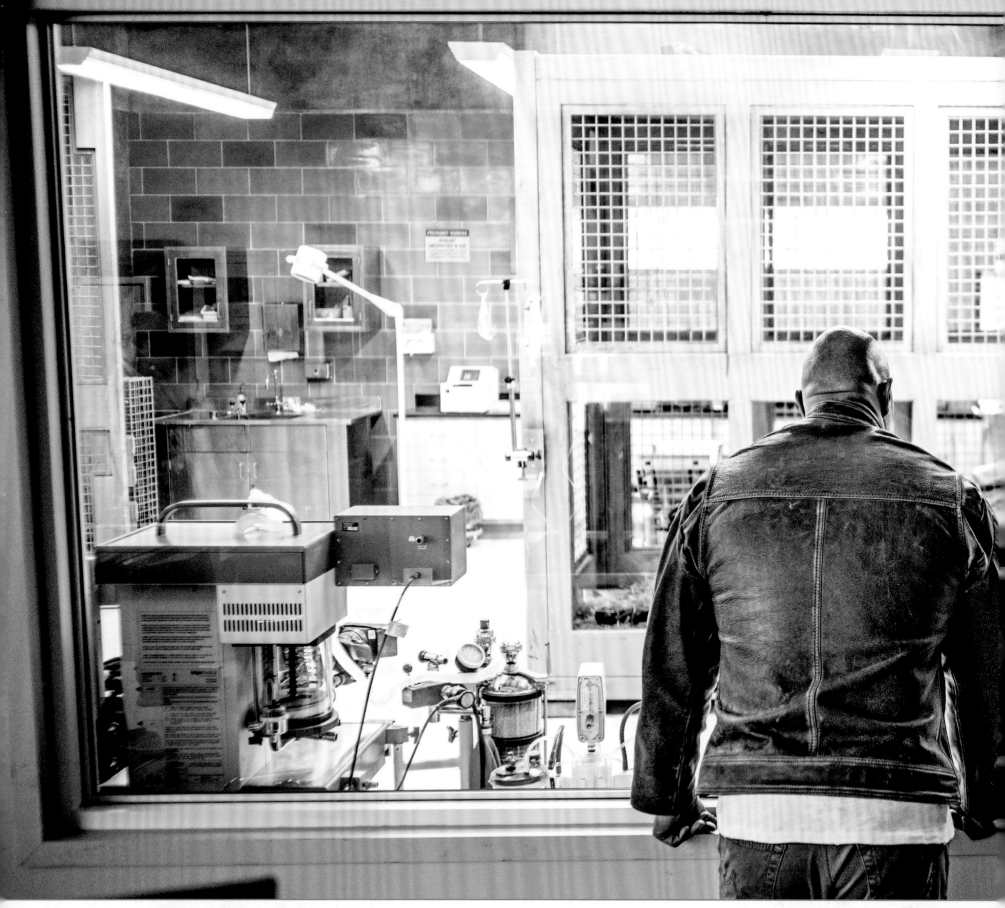

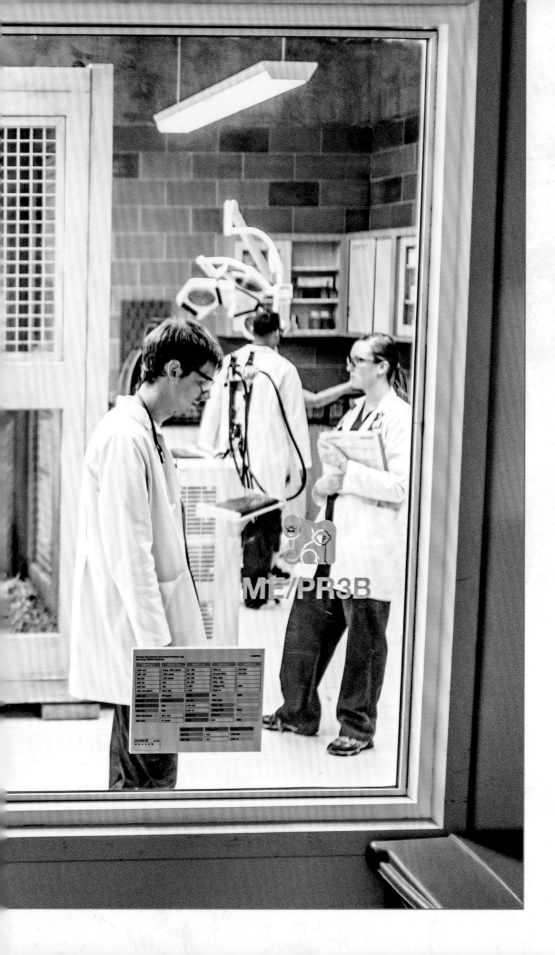

THESE PAGES: Davis looks at the cage holding his sick friend George.

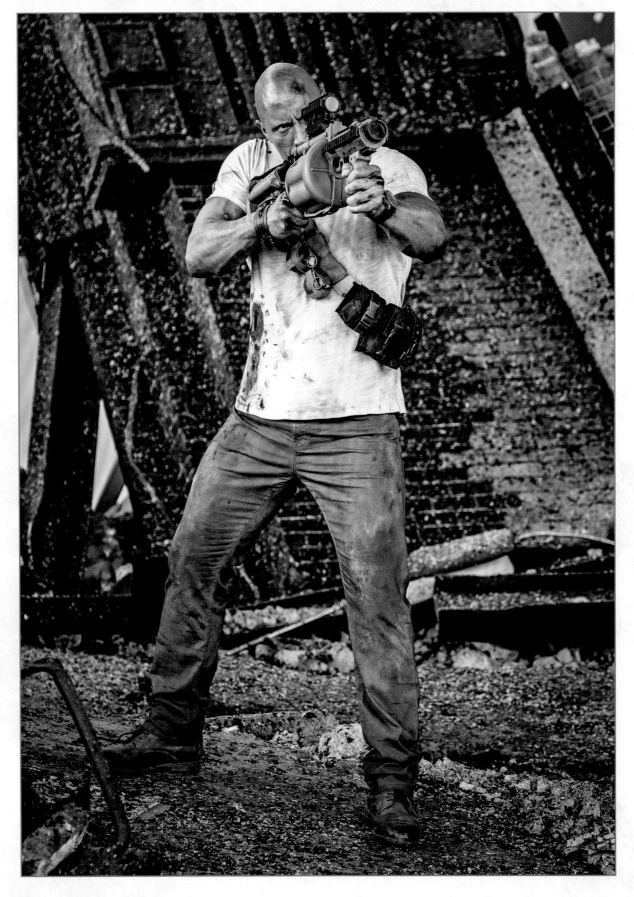

THIS PAGE: Davis is prepared to do battle against the enormous mutated creatures.

OPPOSITE: Dwayne Johnson between takes in the helicopter cockpit.

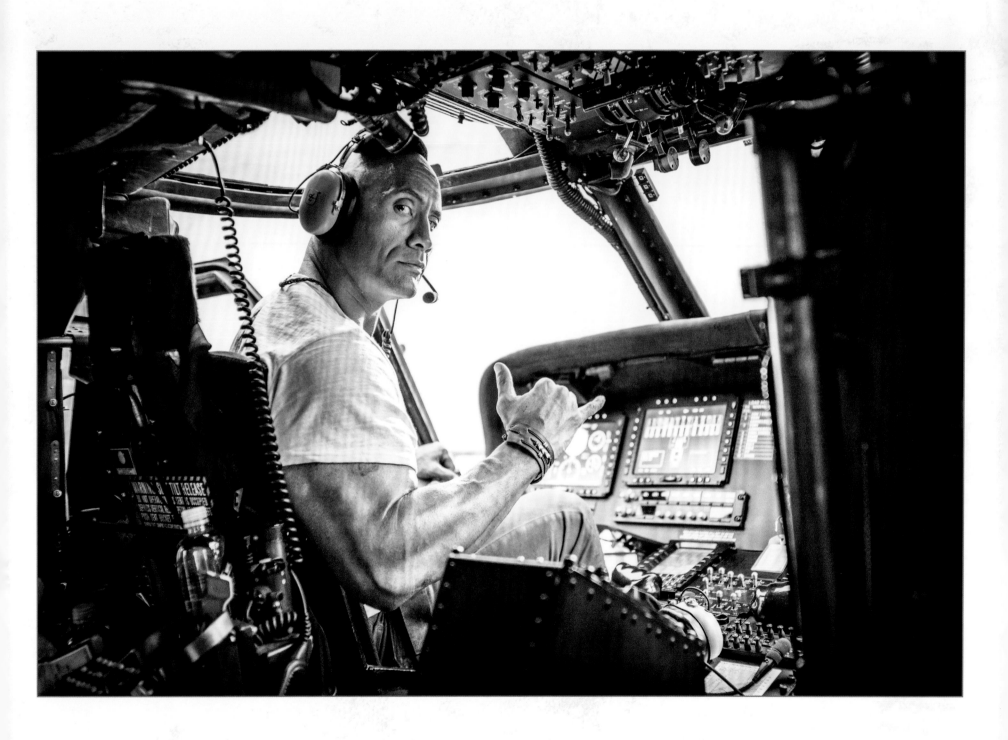

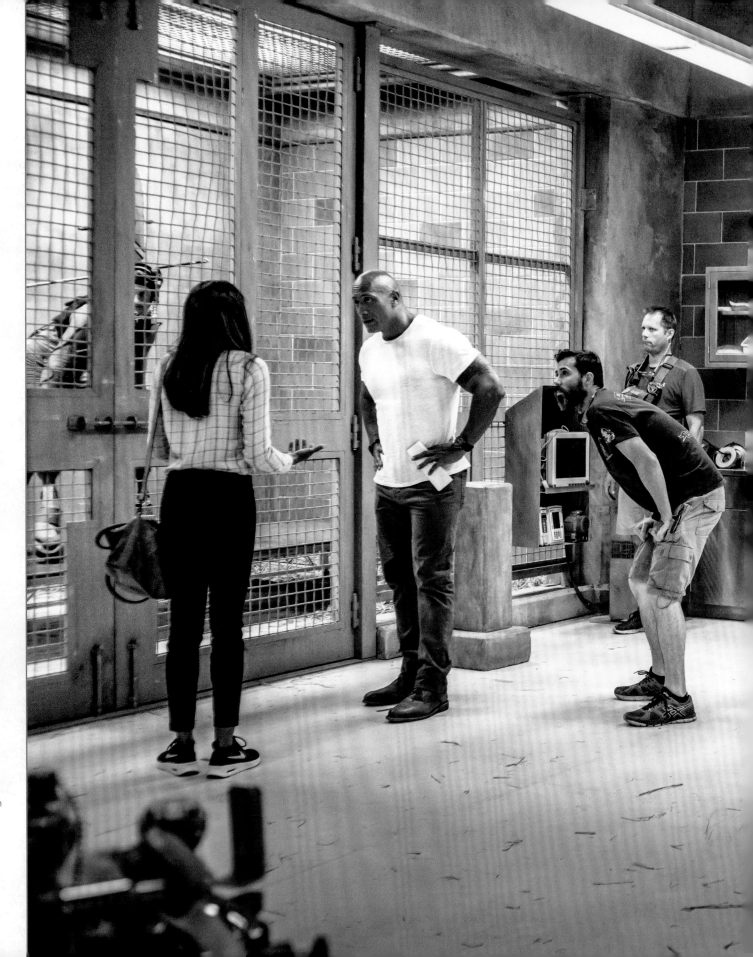

THESE PAGES: Brad Peyton directs Naomie Harris and Dwayne Johnson as the crew looks on.

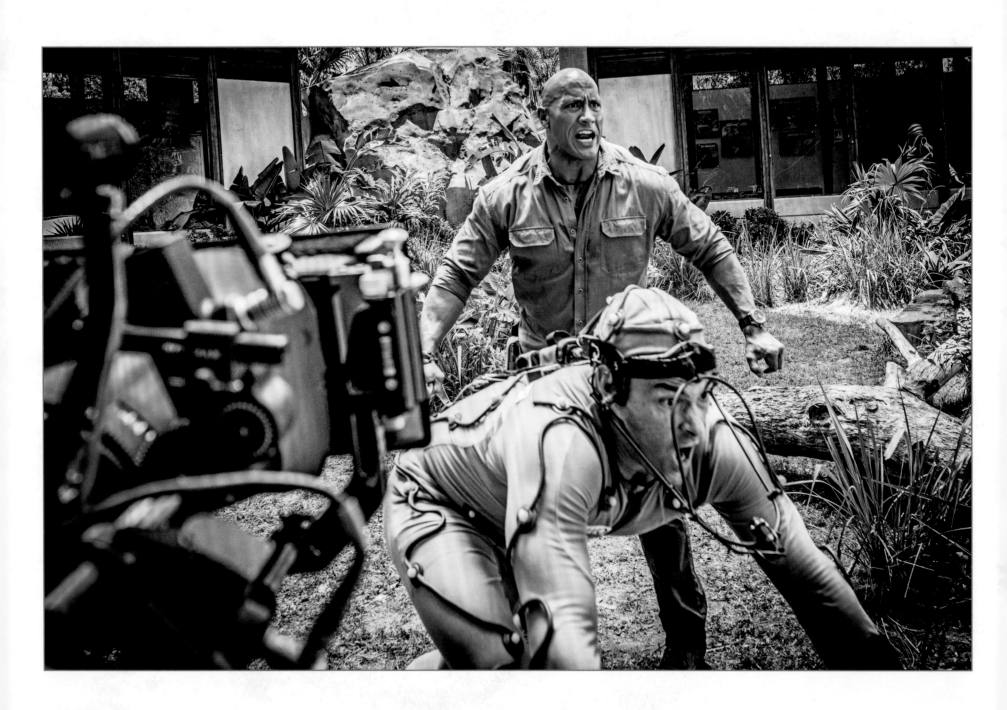

OPPOSITE: Dwayne Johnson and Vincent Roxburgh performing motion capture as an ape named Paavo.

THIS PAGE: Production designer Barry Chusid and crew on location.

THIS PAGE: Brad Peyton holding a clapboard.
OPPOSITE: Jeffrey Dean Morgan, Dwayne Johnson, and Naomie Harris.

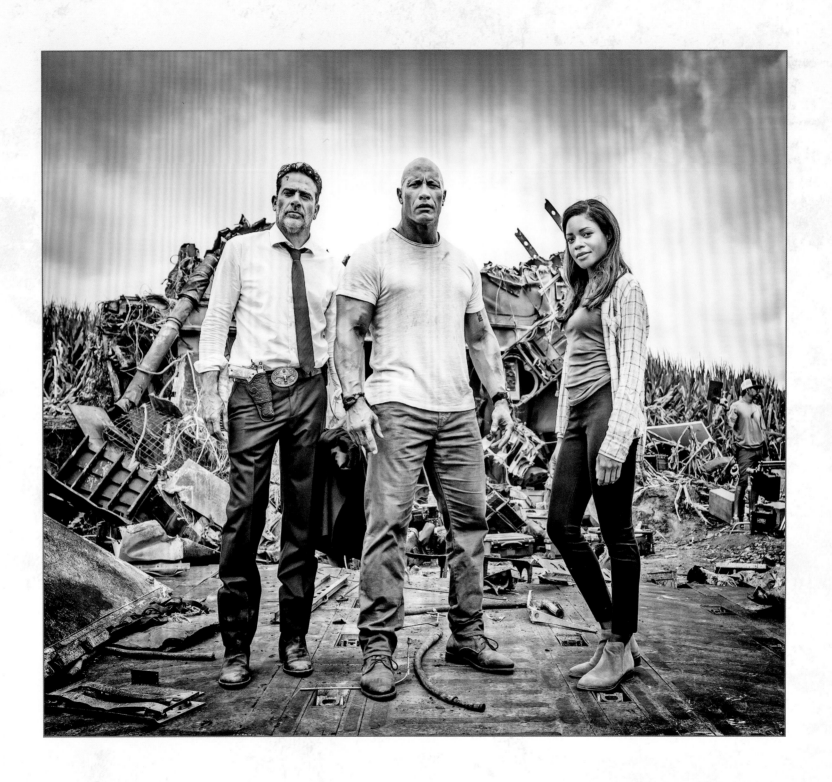

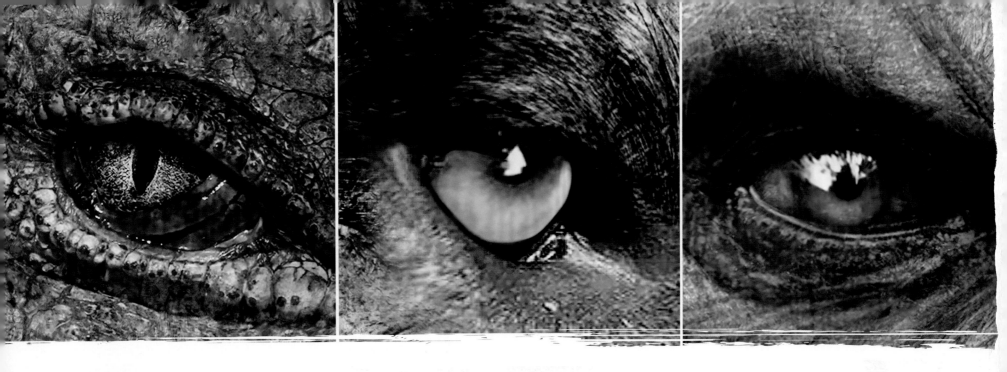

INSIGHT
EDITIONS

PO Box 3088
San Rafael, CA 94912
www.insighteditions.com

Find us on Facebook: www.facebook.com/InsightEditions

Follow us on Twitter: @insighteditions

 Copyright 2018 Warner Bros. Entertainment. *RAMPAGE* and all related
characters and elements © & ™ Warner Bros. Entertainment Inc. (s18)

Pages 94 and 97: Ugandan Children's Choir photos courtesy of Shuter Sweet
Photography.
Page 95: Photo courtesy of Neil Parfitt.
Page 96: Photo courtesy of Jennifer Adler.

All rights reserved. Published by Insight Editions, San Rafael, California, in 2018.

No part of this book may be reproduced in any form without written permission
from the publisher.

ISBN: 978-1-68383-210-2

Publisher: Raoul Goff
Associate Publisher: Vanessa Lopez
Art Director: Chrissy Kwasnik
Designer: Ashley Quackenbush
Senior Editor: Amanda Ng
Managing Editor: Alan Kaplan
Editorial Assistant: Maya Alpert
Senior Production Editor: Rachel Anderson
Production Manager: Greg Steffen

Acknowledgements: Thank you to Brad Peyton, Dwayne Johnson, Beau Flynn, John
Rickard, Hiram Garcia, Wendy Jacobson, Robert McGlinchey, Emma Whittard, Amy
Weingartner, Josh Anderson, Spencer Douglas, Ashley Bol, and all of the cast and crew
of the *Rampage* movie who gave up their valuable time to help with this publication.

Special thanks to: Carolyn Blackwood, Cathy Nam, Marcus Viscidi, Jeffrey Fierson,
Barry Chusid, Colin Strause, Erik Winquist, Jaron Presant, Allan Poppleton, Melissa
Bruning, Andrew Lockington, JD Schwalm, Darin Read, Kenny Krauss, Ozzie Scott,
Jeremy Mittleman, Jill Flanders, Sam Greenberg, Rebecca Sale, Tony Barbera, Daniele
Dohring, Nick Gligor, and the *Rampage* team at Warner Bros.

Insight Editions, in association with Roots of Peace, will plant two trees for each tree
used in the manufacturing of this book. Roots of Peace is an internationally renowned
humanitarian organization dedicated to eradicating land mines worldwide and convert-
ing war-torn lands into productive farms and wildlife habitats. Roots of Peace will plant
two million fruit and nut trees in Afghanistan and provide farmers there with the skills
and support necessary for sustainable land use.

Manufactured in China by Insight Editions

10 9 8 7 6 5 4 3 2 1